A Reference Guide to Eastern Art History Including Buddhist, Bhutanese, Cambodian, Chinese, Indian and Indonesian Arts

Gabrielle Dantz

The role of the book within our culture is changing. The change is brought on by new ways to acquire & use content, the rapid dissemination of information and real-time peer collaboration on a global scale. Despite these changes one thing is clear--"the book" in it's traditional form continues to play an important role in learning and communication. The book you are holding in your hands utilizes the unique characteristics of the Internet -- relying on web infrastructure and collaborative tools to share and use resources in keeping with the characteristics of the medium (user-created, defying control, etc.)--while maintaining all the convenience and utility of a real book.

Contents

Articles

Indonesian Art

References

Overview

Eastern art history

See also: History of Painting, Asian art, and Outline of painting history

Art history series
Prehistoric art
Ancient art history
Western art history
Eastern art history
Islamic art history
Western painting
History of painting
Art history

Eastern art history is devoted to the arts of the Far East and includes a vast range of influences from various cultures and religions. The emphasis is on art history amongst many diverse cultures in Asia. Developments in Eastern art historically parallel those in Western art, in general a few centuries earlier. African art, Islamic art, Indian art, Korean Art, Chinese art, and Japanese art each had significant influence on Western art, and, vice-versa.

Buddhist art

Main article: Buddhist art

See also: Thangka and Bhutanese art

Buddhist art originated in the Indian subcontinent in the centuries following the life of the historical Gautama Buddha in the 6th to 5th century BCE, before evolving through its contact with other cultures and its diffusion through the rest of Asia and the world. Buddhist art traveled with believers as the dharma spread, adapted, and evolved in each new host country. It developed to the north through Central Asia and into Eastern Asia to form the Northern branch of Buddhist art, and to the east as far as Southeast Asia to form the Southern branch of Buddhist art. In India, Buddhist art flourished and even influenced the development of Hindu art, until Buddhism nearly disappeared in India around the 10th century due in part to the vigorous expansion of Islam alongside Hinduism.

In various spiritual traditions, mandalas may be employed for focusing attention of aspirants and adepts, a spiritual teaching tool, for establishing a sacred space and as an aid to meditation and trance induction. Its symbolic nature can help one "to access progressively deeper levels of the unconscious, ultimately assisting the meditator to experience a mystical sense of oneness with the ultimate unity from which the cosmos in all its manifold forms arises." The psychoanalyst Carl Jung saw the mandala as *"a representation of the center of the unconscious self,"* and believed his paintings of mandalas enabled him to identify emotional disorders and work towards wholeness in personality.

Bhutanese art

Main article: Bhutanese art

Bhutanese art is similar to the art of Tibet. Both are based upon Vajrayana Buddhism, with its pantheon of divine beings.

The major orders of Buddhism in Bhutan are Drukpa Kagyu and Nyingma. The former is a branch of the Kagyu School and is known for paintings documenting the lineage of Buddhist masters and the 70 Je Khenpo (leaders of the Bhutanese monastic establishment). The Nyingma order is known for images of Padmasambhava, who is credited with introducing Buddhism into Bhutan in the 7th century. According to legend, Padmasambhava hid sacred treasures for future Buddhist masters, especially Pema Lingpa, to find. The treasure finders (*tertön*) are also frequent subjects of Nyingma art.

Each divine being is assigned special shapes, colors, and/or identifying objects, such as lotus, conch-shell, thunderbolt, and begging bowl. All sacred images are made to exact specifications that have remained remarkably unchanged for centuries.

Bhutanese art is particularly rich in bronzes of different kinds that are collectively known by the name *Kham-so* (made in Kham) even though they are made in Bhutan, because the technique of making them was originally imported from the eastern province of Tibet called Kham. Wall paintings and sculptures, in these regions, are formulated on the principal ageless ideals of Buddhist art forms. Even though their

emphasis on detail is derived from Tibetan models, their origins can be discerned easily, despite the profusely embroidered garments and glittering ornaments with which these figures are lavishly covered. In the grotesque world of demons, the artists apparently had a greater freedom of action than when modeling images of divine beings.

The arts and crafts of Bhutan that represents the exclusive "spirit and identity of the Himalayan kingdom' is defined as the art of *Zorig Chosum*, which means the "thirteen arts and crafts of Bhutan"; the thirteen crafts are carpentry, painting, paper making, blacksmithery, weaving, sculpting and many other crafts. The Institute of Zorig Chosum in Thimphu is the premier institution of traditional arts and crafts set up by the Government of Bhutan with the sole objective of preserving the rich culture and tradition of Bhutan and training students in all traditional art forms; there is another similar institution in eastern Bhutan known as Trashi Yangtse. Bhutanese rural life is also displayed in the 'Folk Heritage Museum' in Thimphu. There is also a 'Voluntary Artists Studio' in Thimphu to encourage and promote the art forms among the youth of Thimphu. The thirteen arts and crafts of Bhutan and the institutions established in Thimphu to promote these art forms are:

Cambodian art

Main articles: Culture of Cambodia, Visual arts of Cambodia, and Khmer sculpture

Cambodian art and the culture of Cambodia has had a rich and varied history dating back many centuries and has been heavily influenced by India. In turn, Cambodia greatly influenced Thailand, Laos and vice versa. Throughout Cambodia's long history, a major source of inspiration was from religion. Throughout nearly two millennium, a Cambodians developed a unique Khmer belief from the syncreticism of indigenous animistic beliefs and the Indian religions of Buddhism and Hinduism. Indian culture and civilization, including its language and arts reached mainland Southeast Asia around the 1st century A.D. Its is generally believed that seafaring merchants brought Indian customs and culture to ports along the gulf of Thailand and the Pacific while trading with China. The first state to benefit from this was Funan. At various times, Cambodia culture also absorbed elements from Javanese, Chinese, Lao, and Thai cultures.

Visual arts of Cambodia

The history of Visual arts of Cambodia stretches back centuries to ancient crafts; Khmer art reached its peak during the Angkor period. Traditional Cambodian arts and crafts include textiles, non-textile weaving, silversmithing, stone carving, lacquerware, ceramics, wat murals, and kite-making. Beginning in the mid-20th century, a tradition of modern art began in Cambodia, though in the later 20th century both traditional and modern arts declined for several reasons, including the killing of artists by the Khmer Rouge. The country has experienced a recent artistic revival due to increased support from governments, NGOs, and foreign tourists.

Khmer sculpture refers to the stone sculpture of the Khmer Empire, which ruled a territory based on modern Cambodia, but rather larger, from the 9th to the 13th century. The most celebrated examples are found in Angkor, which served as the seat of the empire.

By the 7th century, Khmer sculpture begins to drift away from its Hindu influences — pre-Gupta for the Buddhist figures, Pallava for the Hindu figures — and through constant stylistic evolution, it comes to develop its own originality, which by the 10th century can be considered complete and absolute. Khmer sculpture soon goes beyond religious representation, which becomes almost a pretext in order to portray court figures in the guise of gods and goddesses. But furthermore, it also comes to constitute a means and end in itself for the execution of stylistic refinement, like a kind of testing ground. We have already seen how the social context of the Khmer kingdom provides a second key to understanding this art. But we can also imagine that on a more exclusive level, small groups of intellectuals and artists were at work, competing among themselves in mastery and refinement as they pursued a hypothetical perfection of style.

The gods we find in Khmer sculpture are those of the two great religions of India, Buddhism and Hinduism. And they are always represented with great iconographic precision, clearly indicating that learned priests supervised the execution of the works. Nonetheless, unlike those Hindu images which repeat an idealized stereotype, these images are treated with great realism and originality because they depict living models: the king and his court. The true social function of Khmer art was, in fact, the glorification of the aristocracy through these images of the gods embodied in the princes. In fact, the cult of the "deva-raja" required the development of an eminently aristocratic art in which the people were supposed to see the tangible proof of the sovereign's divinity, while the aristocracy took pleasure in seeing itself — if, it's true, in idealized form — immortalized in the splendour of intricate adornments, elegant dresses and extravagant jewelry.

The sculptures are admirable images of a gods, royal and imposing presences, though not without feminine sensuality, makes us think of important persons at the courts, persons of considerable power. The artists who sculpted the stones doubtless satisfied the primary objectives and requisites demanded by the persons who commissioned them. The sculptures represent the chosen divinity in the orthodox manner and succeeds in portraying, with great skill and expertise, high figures of the courts in all of their splendour, in the attire, adornments and jewelry of a sophisticated beauty.

Chinese art

Main articles: Chinese art, Chinese painting, Chinese ceramics, Chinese jade, and East Asian calligraphy

Chinese art (Chinese: 中國藝術/中国艺术) has varied throughout its ancient history, divided into periods by the ruling dynasties of China and changing technology. Different forms of art have been influenced by great philosophers, teachers, religious figures and even political leaders. Chinese art encompasses fine arts, folk arts and performance arts. Chinese art is art, whether modern or ancient,

that originated in or is practiced in China or by Chinese artists or performers.

Panorama of *Along the River During Qingming Festival*, an 18th century reproduction of the 12th century original by Chinese artist Zhang Zeduan; Note: scroll starts from the right

In the Song Dynasty, poetry was marked by a lyric poetry known as Ci (詞) which expressed feelings of desire, often in an adopted persona. Also in the Song dynasty, paintings of more subtle expression of landscapes appeared, with blurred outlines and mountain contours which conveyed distance through an impressionistic treatment of natural phenomena. It was during this period that in painting, emphasis was placed on spiritual rather than emotional elements, as in the previous period. Kunqu, the oldest extant form of Chinese opera developed during the Song Dynasty in Kunshan, near present-day Shanghai. In the Yuan dynasty, painting by the Chinese painter Zhao Mengfu (趙孟頫) greatly influenced later Chinese landscape painting, and the Yuan dynasty opera became a variant of Chinese opera which continues today as Cantonese opera.

Indian art

Main articles: Indian art, Indian painting, and Rangoli

Indian art can be classified into specific periods each reflecting certain religious, political and cultural developments. The earliest examples of are the petroglyphs such as found in Bhimbetka, some of them being older than 5500 BC. The production of such works continued for several millennia with later examples, from the 7th century being the carved pillars of Ellora, Maharashtra state. Other examples are the frescoes of Ajanta and Ellora Caves. Specific periods:

- Hinduism and Buddhism of the ancient period (3500 BCE-present)
- Islamic ascendancy (712-1757 CE)
- The colonial period (1757–1947)
- Independence and the postcolonial period (Post-1947)
- Modern and Postmodern art in India

One of the most popular art forms in India is called Rangoli. It is a form of sandpainting decoration that uses finely ground white powder and colours, and is used commonly outside homes in India.

he visual arts (sculpture, painting and architecture) are tightly interrelated with the non-visual arts. According to Kapila Vatsyayan, "Classical Indian architecture, sculpture, painting, literature (kaavya), music and dancing evolved their own rules conditioned by their respective media, but they shared with one another not only the underlying spiritual beliefs of the Indian religio-philosophic mind, but also the procedures by which the relationships of the symbol and the spiritual states were worked out in detail."

Insight into the unique qualities of Indian art is best achieved through an understanding of the philosophical thought, the broad cultural history, social, religious and political background of the artworks.

Indonesian art

Main article: Indonesian culture

Indonesian art and culture has been shaped by long interaction between original indigenous customs and multiple foreign influences. Indonesia is central along ancient trading routes between the Far East and the Middle East, resulting in many cultural practices being strongly influenced by a multitude of religions, including Hinduism, Buddhism, Confucianism and Islam, all strong in the major trading cities. The result is a complex cultural mixture very different from the original indigenous cultures. Indonesia is not generally known for paintings, aside from the intricate and expressive Balinese paintings, which often express natural scenes and themes from the traditional dances.

Other exceptions include indigenous Kenyah paint designs based on, as commonly found among Austronesian cultures, endemic natural motifs such as ferns, trees, dogs, hornbills and human figures. These are still to be found decorating the walls of Kenyah Dayak longhouses in East Kalimantan's Apo Kayan region.

Calligraphy, mostly based on the Qur'an, is often used as decoration as Islam forbids naturalistic depictions. Some foreign painters have also settled in Indonesia. Modern Indonesian painters use a wide variety of styles and themes.

Indonesia has a long-he Bronze and Iron Ages, but the art-form particularly flourished from the 8th century to 10th century, both as stand-alone works of art, and also incorporated into temples.

Most notable are the hundreds of meters of relief sculpture at the temple of Borobodur in central Java. Approximately two miles of exquisite relief sculpture tell the story of the life of Buddha and illustrate his teachings. The temple was originally home to 504 statues of the seated Buddha. This site, as with others in central Java, show a clear Indian influence.

Japanese art

Main articles: Japanese art, Japanese painting, Ukiyo-e, Japanese sculpture, Ryukyuan lacquerware, East Asian calligraphy, List of National Treasures of Japan (paintings), and List of National Treasures of Japan (sculptures)

Japanese art and architecture is works of art produced in Japan from the beginnings of human habitation there, sometime in the 10th millennium BC, to the present. Japanese art covers a wide range of art styles and media, including ancient pottery, sculpture in wood and bronze, ink painting on silk and paper, and a myriad of other types of works of art; from ancient times until the contemporary 21st century.

Ukiyo, meaning "floating world", refers to the impetuous young culture that bloomed in the urban centers of Edo (modern-day Tokyo), Osaka, and Kyoto that were a world unto themselves. It is an ironic allusion to the homophone term "Sorrowful World" (憂き世), the earthly plane of death and rebirth from which Buddhists sought release. The art form rose to great popularity in the metropolitan

culture of Edo (Tokyo) during the second half of the 17th century, originating with the single-color works of Hishikawa Moronobu in the 1670s. At first, only India ink was used, then some prints were manually colored with a brush, but in the 18th century Suzuki Harunobu developed the technique of polychrome printing to produce *nishiki-e*.

Japanese painting (画 *Kaiga*) is one of the oldest and most highly refined of the Japanese arts, encompassing a wide variety of genre and styles. As with the history of Japanese arts in general, the history Japanese painting is a long history of synthesis and competition between native Japanese aesthetics and adaptation of imported ideas.

The origins of painting in Japan date well back into Japan's prehistoric period. Simple stick figures and geometric designs can be found on Jōmon period pottery and Yayoi period (300 BC – 300 AD) *dotaku* bronze bells. Mural paintings with both geometric and figurative designs have been found in numerous tumulus from the Kofun period (300-700 AD).

Ancient **Japanese sculpture** was mostly derived from the idol worship in Buddhism or animistic rites of Shinto deity. In particular, sculpture among all the arts came to be most firmly centered around Buddhism. Materials traditionally used were metal—especially bronze—and, more commonly, wood, often lacquered, gilded, or brightly painted. By the end of the Tokugawa period, such traditional sculpture - except for miniaturized works - had largely disappeared because of the loss of patronage by Buddhist temples and the nobility.

Korean Art

Main articles: Korean art, Korean painting, and East Asian calligraphy

Korean art is noted for its traditions in pottery, music, calligraphy, painting, sculpture, and other genres, often marked by the use of bold color, natural forms, precise shape and scale, and surface decoration.

While there are clear and distinguishing differences between three independent cultures, there are significant and historical similarities and interactions between the arts of Korea, China and Japan.

The study and appreciation of Korean art is still at a formative stage in the West. Because of Korea's position between China and Japan, Korea was seen as a mere conduit of Chinese culture to Japan. However, recent scholars have begun to acknowledge Korea's own unique art, culture and important role in not only transmitting Chinese culture but assimilating it and creating a unique culture of its own. *An art given birth to and developed by a nation is its own art.*

Generally the history of **Korean painting** is dated to approximately 108 C.E., when it first appears as an independent form. Between that time and the paintings and frescoes that appear on the Goryeo dynasty tombs, there has been little research. Suffice to say that til the Joseon dynasty the primary influence was Chinese painting though done with Korean landscapes, facial features, Buddhist topics, and an emphasis on celestial observation in keeping with the rapid development of Korean astronomy.

Throughout the history of Korean painting, there has been a constant separation of monochromatic works of black brushwork on very often mulberry paper or silk; and the colourful folk art or *min-hwa*, ritual arts, tomb paintings, and festival arts which had extensive use of colour.

This distinction was often class-based: scholars, particularly in Confucian art felt that one could see colour in monochromatic paintings within the gradations and felt that the actual use of colour coarsened the paintings, and restricted the imagination. Korean folk art, and painting of architectural frames was seen as brightening certain outside wood frames, and again within the tradition of Chinese architecture, and the early Buddhist influences of profuse rich thalo and primary colours inspired by Art of India.

Laotian art

Main article: Laotian art

Laotian art includes ceramics, Buddhist sculpture, and music.

Lao Buddhist sculptures were created in a large variety of material including gold, silver and most often bronze. Brick-and-mortar also was a medium used for colossal images, a famous of these is the image of *Phya Vat* (16th century) in Vientiane, although a renovation completely altered the appearance of the sculpture, and it no longer resembles a Lao Buddha. Wood is popular for small, votive Buddhist images that are often left in caves. Wood is also very common for large, life-size standing images of the Buddha. The most famous two sculptures carved in semi-precious stone are the Phra Keo (The Emerald Buddha) and the Phra Phuttha Butsavarat. The Phra Keo, which is probably of Xieng Sen (Chiang Saen) origin, is carved from a solid block of jade. It rested in Vientiane for two hundred years before the Siamese carried it away as booty in the late eighteenth century. Today it serves as the palladium of the Kingdom of Thailand, and resides at the Grand Palace in Bangkok. The Phra Phuttha Butsavarat, like the Phra Keo, is also enshrined in its own chapel at the Grand Palace in Bangkok. Before the Siamese seized it in the early nineteenth century, this crystal image was the palladium of the Lao kingdom of Champassack.

Many mostly wooden **Buddhist sculptures** have been assembled inside the Pak Ou caves.

Many beautiful **Lao Buddhist sculptures** are carved right into the Pak Ou caves. Near *Pak Ou* (mouth of the Ou river) the *Tham Ting* (lower cave) and the *Tham Theung* (upper cave) are near Luang Prabang, Laos. They are a magnificent group of caves that are only accessible by boat, about two hours upstream from the center of Luang Prabang, and have recently become more well known and frequented by tourists.The caves are noted for their impressive Buddhist and Lao style sculptures carved into the cave walls, and hundreds of discarded Buddhist figures laid out over the floors and wall shelves. They were put there as their owners did not wish to destroy them, so a difficult journey is made to the caves to place their unwanted statue there.

Thai art

Main article: Thai art

Thai art and visual art was traditionally and primarily Buddhist and Royal Art. Sculpture was almost exclusively of Buddha images, while painting was confined to illustration of books and decoration of buildings, primarily palaces and temples. Thai Buddha images from different periods have a number of distinctive styles. Contemporary Thai art often combines traditional Thai elements with modern techniques.

Traditional Thai paintings showed subjects in two dimensions without perspective. The size of each element in the picture reflected its degree of importance. The primary technique of composition is that of apportioning areas: the main elements are isolated from each other by space transformers. This eliminated the intermediate ground, which would otherwise imply perspective. Perspective was introduced only as a result of Western influence in the mid-19th century.

The most frequent narrative subjects for paintings were or are: the Jataka stories, episodes from the life of the Buddha, the Buddhist heavens and hells, and scenes of daily life.

The Sukhothai period began in the 14th century in the Sukhothai kingdom. Buddha images of the Sukhothai period are elegant, with sinuous bodies and slender, oval faces. This style emphasized the spiritual aspect of the Buddha, by omitting many small anatomical details. The effect was enhanced by the common practice of casting images in metal rather than carving them. This period saw the introduction of the "walking Buddha" pose.

Sukhothai artists tried to follow the canonical defining marks of a Buddha, as they are set out in ancient Pali texts: Skin so smooth that dust cannot stick to it; Legs like a deer; Thighs like a banyan tree; Shoulders as massive as an elephant's head; Arms round like an elephant's trunk, and long enough to touch the knees; Hands like lotuses about to bloom; Fingertips turned back like petals; head like an egg; Hair like scorpion stingers; Chin like a mango stone; Nose like a parrot's beak; Earlobes lengthened by the earrings of royalty; Eyelashes like a cow's; Eyebrows like drawn bows.

Sukhothai also produced a large quantity of glazed ceramics in the Sawankhalok style, which were traded throughout south-east Asia.

Tibetan art

In Tibet, many Buddhists carve mantras into rocks as a form of devotion.

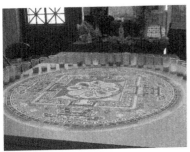

Tibetan Buddhist Sand mandala displaying its materials

Main articles: Tibetan art and Sand mandala

Tibetan art refers to the art of Tibet and other present and former Himalayan kingdoms (Bhutan, Ladakh, Nepal, and Sikkim). Tibetan art is first and foremost a form of sacred art, reflecting the over-riding influence of Tibetan Buddhism on these cultures. The Sand Mandala (tib: *kilkhor*) is a Tibetan Buddhist tradition which symbolises the transitory nature of things. As part of Buddhist canon, all things material are seen as transitory. A sand mandala is an example of this, being that once it has been built and its accompanying ceremonies and viewing are finished, it is systematically destroyed.

As Mahayana Buddhism emerged as a separate school in the 4th century BC it emphasized the role of bodhisattvas, compassionate beings who forego their personal escape to Nirvana in order to assist others. From an early time various bodhisattvas were also subjects of statuary art. Tibetan Buddhism, as an offspring of Mahayana Buddhism, inherited this tradition. But the additional dominating presence of the Vajrayana (or Buddhist tantra) may have had an overriding importance in the artistic culture. A common bodhisattva depicted in Tibetan art is the deity Chenrezig (Avalokitesvara), often portrayed as a thousand-armed saint with an eye in the middle of each hand, representing the all-seeing compassionate one who hears our requests. This deity can also be understood as a Yidam, or 'meditation Buddha' for Vajrayana practice.

Tibetan Buddhism contains Tantric Buddhism, also known as Vajrayana Buddhism for its common symbolism of the *vajra*, the diamond thunderbolt (known in Tibetan as the dorje). Most of the typical Tibetan Buddhist art can be seen as part of the practice of tantra. Vajrayana techniques incorporate many visualizations/imaginations during meditation, and most of the elaborate tantric art can be seen as aids to these visualizations; from representations of meditational deities (yidams) to mandalas and all kinds of ritual implements.

A visual aspect of Tantric Buddhism is the common representation of wrathful deities, often depicted with angry faces, circles of flame, or with the skulls of the dead. These images represent the *Protectors* (Skt. dharmapala) and their fearsome bearing belies their true compassionate nature. Actually their wrath represents their dedication to the protection of the dharma teaching as well as to the protection of the specific tantric practices to prevent corruption or disruption of the practice. They are most

importantly used as wrathful psychological aspects that can be used to conquer the negative attitudes of the practitioner.

Historians note that Chinese painting had a profound influence on Tibetan painting in general. Starting from the 14th and 15th century, Tibetan painting had incorporated many elements from the Chinese, and during the 18th century, Chinese painting had a deep and far-stretched impact on Tibetan visual art. According to Giuseppe Tucci, by the time of the Qing Dynasty, "a new Tibetan art was then developed, which in a certain sense was a provincial echo of the Chinese 18th century's smooth ornate preciosity."

Vietnamese art

Main article: Vietnamese art

Vietnamese art is from one of the oldest of such cultures in the Southeast Asia region. A rich artistic heritage that dates to prehistoric times and includes: silk painting, sculpture, pottery, ceramics, woodblock prints, architecture, music, dance and theatre.

Traditional Vietnamese art is art practiced in Vietnam or by Vietnamese artists, from ancient times (including the elaborate Dong Son drums) to post-Chinese domination art which was strongly influenced by Chinese Buddhist art, among other philosophies such as Taoism and Confucianism. The art of Champa and France also played a smaller role later on.

The Chinese influence on Vietnamese art extends into Vietnamese pottery and ceramics, calligraphy, and traditional architecture. Currently, Vietnamese lacquer paintings have proven to be quite popular.

The **Nguyễn Dynasty**, the last ruling dynasty of Vietnam (c. 1802-1945), saw a renewed interest in ceramics and porcelain art. Imperial courts across Asia imported Vietnamese ceramics.

Despite how highly developed the performing arts (such as imperial court music and dance) became during the Nguyễn Dynasty, some view other fields of arts as beginning to decline during the latter part of the Nguyễn Dynasty.

Beginning in the 19th century, Modern Art and French artistic influences spread into Vietnam. In the early 20th century, the École Supérieure des Beaux Arts de l'Indochine (Indochina College of Arts) was founded to teach European methods and exercised influence mostly in the larger cities, such as Hanoi and Ho Chi Minh City.

Travel restrictions imposed on the Vietnamese during France's 80-year rule of Vietnam and the long period of war for national independence meant that very few Vietnamese artists were able to train or work outside of Vietnam. A small number of artists from well-to-do backgrounds had the opportunity to go to France and make their careers there for the most part. Examples include Le Thi Luu, Le Pho, Mai Trung Thu, Le Van De, Le Ba Dang and Pham Tang.

Modern Vietnamese artists began to utilize French techniques with many traditional mediums such as silk, lacquer, etc., thus creating a unique blend of eastern and western elements.

Vietnamese calligraphy

Main article: East Asian calligraphy

Calligraphy has had a long history in Vietnam, previously using Chinese characters along with Chu Nom. However, most modern Vietnamese calligraphy instead uses the Roman-character based Quoc Ngu, which has proven to be very popular.

In the past, with literacy in the old character-based writing systems of Vietnam being restricted to scholars and elites, calligraphy nevertheless still played an important part in Vietnamese life. On special occasions such as the Lunar New Year, people would go to the village teacher or scholar to make them a calligraphy hanging (often poetry, folk sayings or even single words). People who could not read or write also often commissioned scholars to write prayers which they would burn at temple shrines.

Eastern art gallery

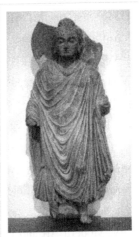

Standing Buddha sculpture, ancient region of Gandhara, northern Pakistan, 1st century CE, Musée Guimet

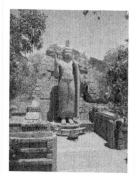

The Buddha statue of Avukana, 5th century, Sri Lanka

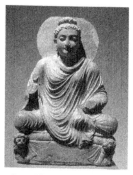

Seated Buddha, Gandhara, 2nd century CE

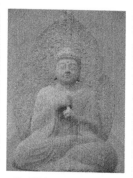

Buddhist sculpture Silla Dynasty, 9th century AD, Korean

Song Dynasty porcelain bottle with iron pigment over transparent colorless glaze, 11th century, Chinese

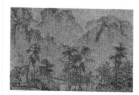

Autumn in the River Valley, Guo Xi (c. 1020-1090 AD), 1072 AD, Chinese

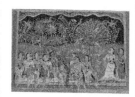

Gita Govinda manuscript c. 1500, Prince of Wales Museum, Bombay, India

Genji Monogatari, Tosa Mitsuoki, (1617–1691), Japanese

An underworld messenger, Joseon Dynasty, Korean

After Rain at Mt. Inwang, Cheong Seon (1676–1759), Korean

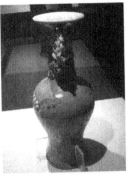

Chrysanthemum styled porcelain vase, Ming Dynasty, 1368-1644 AD, Chinese

See also

- Scythian art
- Laotian art
- History of painting
- History of Chinese art
- Culture of the Song Dynasty
- Ming Dynasty painting
- Tang Dynasty art
- Lacquerware
- Mandala
- Emerald Buddha
- Urushi-e
- Asian art
- Gautama Buddha
- Buddhism and Hinduism
- List of National Treasures of Japan (paintings)
- List of National Treasures of Japan (sculptures)

External links

- Chinese Art and Galleries [1] at China Online Museum
- Asian Art [2] at the Metropolitan Museum of Art
- Freer Gallery of Art and Arthur M. Sackler Gallery at the Smithsonian Institution [3]

Buddhist Art

Buddhist art

Part of a series on
Buddhism
Outline · **Portal**

History
Timeline · Councils
Gautama Buddha
Disciples
Later Buddhists

Dharma or **Concepts**
Four Noble Truths
Dependent Origination
Impermanence
Suffering · Middle
Way
Non-self · Emptiness
Five Aggregates
Karma · Rebirth
Samsara · Cosmology

Practices
Three Jewels
Precepts · Perfections
Meditation · Wisdom
Noble Eightfold Path
Wings to Awakening
Monasticism · Laity

Nirvāṇa
Four Stages · Arhat
Buddha · Bodhisattva

Schools · **Canons**
Theravāda · Pali
Mahāyāna · Chinese
Vajrayāna · Tibetan

Countries and
Regions

Buddhist art originated on the Indian subcontinent following the historical life of Siddhartha Gautama, 6th to 5th century BC, and thereafter evolved by contact with other cultures as it spread throughout Asia and the world.

Buddhist art followed believers as the dharma spread, adapted, and evolved in each new host country. It developed to the north through Central Asia and into Eastern Asia to form the Northern branch of Buddhist art, and to the east as far as Southeast Asia to form the Southern branch of Buddhist art. In India, Buddhist art flourished and even influenced the development of Hindu art, until Buddhism nearly disappeared in India around the 10th century due in part to the vigorous expansion of Islam alongside Hinduism.

Pre-iconic phase (5th century - 1st century BCE)

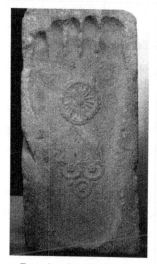

Footprint of the Buddha. 1st century, Gandhara.

During the 2nd to 1st century BCE, sculptures became more explicit, representing episodes of the Buddha's life and teachings. These took the form of votive tablets or friezes, usually in relation to the decoration of stupas. Although India had a long sculptural tradition and a mastery of rich iconography, the Buddha was never represented in human form, but only through Buddhist symbolism. This period may have been aniconic.

This reluctance towards anthropomorphic representations of the Buddha, and the sophisticated development of aniconic symbols to avoid it (even in narrative scene where other human figures would appear), seems to be connected to 70 of the Buddha's sayings, reported in the Dighanikaya, that disfavored representations of himself after the extinction of his body. This tendency remained as late as the 2nd century CE in the southern parts of India, in the art of the Amaravati school (see: Mara's assault on the Buddha). It has been argued that earlier anthropomorphic representations of the Buddha may have been made of wood and may have perished since then. However, no related archaeological evidence has been found.

Iconic phase (1st century AD – present)

Anthropomorphic representations of the Buddha started to emerge from the 1st century AD in Northern India. The two main centers of creation have been identified as Gandhara in today's North West Frontier Province, in Pakistan, and the region of Mathura, in central northern India.

The art of Gandhara benefited from centuries of interaction with Greek culture since the conquests of Alexander the Great in 332 BC and the subsequent establishment of the Greco-Bactrian and Indo-Greek Kingdoms, leading to the development of Greco-Buddhist art. Gandharan Buddhist sculpture displays Greek artistic influence, and it has been suggested that the concept of the "man-god" was essentially inspired by Greek mythological culture. Artistically, the Gandharan school of sculpture is said to have contributed wavy hair, drapery covering both shoulders, shoes and sandals, acanthus leaf decorations, etc.

The art of Mathura tends to be based on a strong Indian tradition, exemplified by the anthropomorphic representation of divinities such as the Yaksas, although in a style rather archaic compared to the later representations of the Buddha. The Mathuran school contributed clothes covering the left shoulder of thin muslin, the wheel on the palm, the lotus seat, etc.

Mathura and Gandhara also strongly influenced each other. During their artistic florescence, the two regions were even united politically under the Kushans, both being capitals of the empire. It is still a matter of debate whether the anthropomorphic representations of Buddha was essentially a result of a local evolution of Buddhist art at Mathura, or a consequence of Greek cultural influence in Gandhara through the Greco-Buddhist syncretism.

This iconic art was characterized from the start by a realistic idealism, combining realistic human features, proportions, attitudes and attributes, together with a sense of perfection and serenity reaching to the divine. This expression of the Buddha as both man and God became the iconographic canon for subsequent Buddhist art.

Buddhist art continued to develop in India for a few more centuries. The pink sandstone sculptures of Mathura evolved during the Gupta period (4th to 6th century) to reach a very high fineness of execution and delicacy in the modeling. The art of the Gupta school was extremely influential almost everywhere in the rest of Asia. By the 10th century, Buddhist art creation was dying out in India, as Hinduism and Islam ultimately prevailed.

As Buddhism expanded outside of India from the 1st century AD, its original artistic package blended with other artistic influences, leading to a progressive differentiation among the countries adopting the faith.

- A **Northern route** was established from the 1st century CE through Central Asia, Tibet, Bhutan, China, Korea, Japan and Vietnam, in which Mahayana Buddhism prevailed.
- A **Southern route**, where Theravada Buddhism dominated, went through Myanmar, Sri Lanka, Thailand, Cambodia, and Laos.

Northern Buddhist art

The Silk Road transmission of Buddhism to Central Asia, China and ultimately Korea and Japan started in the 1st century CE with a semi-legendary account of an embassy sent to the West by the Chinese Emperor Ming (58-75 AD). However, extensive contacts started in the 2nd century CE, probably as a consequence of the expansion of the Kushan Empire into the Chinese territory of the Tarim Basin, with the missionary efforts of a great number of Central Asian Buddhist monks to Chinese lands. The first missionaries and translators of Buddhists scriptures into Chinese, such as Lokaksema, were either Parthian, Kushan, Sogdian or Kuchean.

Central Asian missionary efforts along the Silk Road were accompanied by a flux of artistic influences, visible in the development of Serindian art from the 2nd through the 11th century AD in the Tarim Basin, modern Xinjiang. Serindian art often derives from the Greco-Buddhist art of the Gandhara district of what is now Pakistan, combining Indian, Greek and Roman influences. Silk Road Greco-Buddhist artistic influences can be found as far as Japan to this day, in architectural motifs, Buddhist imagery, and a select few representations of Japanese gods.

The art of the northern route was also highly influenced by the development of Mahāyāna Buddhism, an inclusive branch of Buddhism characterized by the adoption of new texts, in addition to the traditional āgamas, and a shift in the understanding of Buddhism. Mahāyāna goes beyond the traditional Early Buddhist ideal of the release from suffering (duḥkha) of arhats, and emphasizes the bodhisattva path. The Mahāyāna sutras elevate the Buddha to a transcendent and infinite being, and feature a pantheon of bodhisattvas devoting themselves to the Six Perfections, ultimate knowledge (Prajñāpāramitā), enlightenment, and the liberation of all sentient beings. Northern Buddhist art thus tends to be characterized by a very rich and syncretic Buddhist pantheon, with a multitude of images of the various buddhas, bodhisattvas, and heavenly beings (devas).

Afghanistan

Buddhist art in Afghanistan (old Bactria) persisted for several centuries until the spread of Islam in the 7th century. It is exemplified by the Buddhas of Bamyan. Other sculptures, in stucco, schist or clay, display very strong blending of Indian post-Gupta mannerism and Classical influence, Hellenistic or possibly even Greco-Roman.

Although Islamic rule was somewhat tolerant of other religions "of the Book", it showed little tolerance for Buddhism, which was perceived as a religion depending on "idolatry". Human figurative art forms also being prohibited under Islam, Buddhist art suffered numerous attacks, which culminated with the systematic destructions by the Taliban regime. The Buddhas of Bamyan, the sculptures of Hadda, and many of the remaining artifacts at the Afghanistan museum have been destroyed.

The multiple conflicts since the 1980s also have led to a systematic pillage of archaeological sites apparently in the hope of reselling in the international market what artifacts could be found.

Central Asia

Central Asia long played the role of a meeting place between China, India and Persia. During the 2nd century BCE, the expansion of the Former Han to the West led to increased contact with the Hellenistic civilizations of Asia, especially the Greco-Bactrian Kingdom.

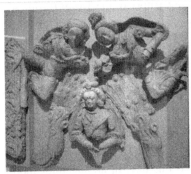

Serindian art, 6th-7th century terracotta, Tumshuq (Xinjiang).

Thereafter, the expansion of Buddhism to the North led to the formation of Buddhist communities and even Buddhist kingdoms in the oasis of Central Asia. Some Silk Road cities consisted almost entirely of Buddhist stupas and monasteries, and it seems that one of their main objectives was to welcome and service travelers between East and West.

The eastern part of Central Asia (Chinese Turkestan (Tarim Basin, Xinjiang) in particular has revealed an extremely rich Serindian art (wall paintings and reliefs in numerous caves, portable paintings on canvas, sculpture, ritual objects), displaying multiple influences from Indian and Hellenistic cultures. Works of art reminiscent of the Gandharan style, as well as scriptures in the Gandhari script Kharoshti have been found. These influences were rapidly absorbed however by the vigorous Chinese culture, and a strongly Chinese particularism develops from that point.

See also: Dunhuang, Mogao Caves, Kingdom of Khotan, Silk Road, Silk Road transmission of Buddhism

China

Buddhism arrived in China around the 1st century AD, and introduced new types of art into China, particularly in the area of statuary. Receiving this distant religion, strong Chinese traits were incorporated into Buddhist art.

Northern Dynasties

In the 5th to 6th centuries, the Northern Dynasties, developed rather symbolic and abstract modes of representation, with schematic lines. Their style is also said to be solemn and majestic. The lack of corporeality of this art, and its distance from the original Buddhist objective of expressing the pure ideal of enlightenment in an accessible and realistic manner, progressively led to a change towards more naturalism and realism, leading to the expression of Tang Buddhist art.

Sites preserving Northern Wei Dynasty Buddhist sculpture:

- Longmen Grottoes, Henan
- Bingling Temple, Gansu

Tang Dynasty

Following a transition under the Sui Dynasty, Buddhist sculpture of the Tang evolved towards a markedly life-like expression. Because of the dynasty's openness to foreign influences, and renewed exchanges with Indian culture due to the numerous travels of Chinese Buddhist monks to India, Tang dynasty Buddhist sculpture assumed a rather classical form, inspired by the Indian art of the Gupta period. During that time, the Tang capital of Chang'an (today's Xi'an) became an important center for Buddhism. From there Buddhism spread to Korea, and Japanese embassies of Kentoshi from Korea helped it gain a foothold in Japan.

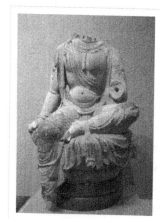

However, foreign influences came to be negatively perceived in China towards the end of the Tang dynasty. In the year 845, the Tang emperor Wuzong outlawed all "foreign" religions (including Christian Nestorianism, Zoroastrianism and Buddhism) in order to support the indigenous religion, Taoism. He confiscated Buddhist possessions, and forced the faith to go underground, therefore affecting the development of the religion and its arts in China.

Chán Buddhism however, as the origin of Japanese Zen, continued to prosper for some centuries, especially under the Song Dynasty (960-1279), when Chan monasteries were great centers of culture and learning.

Tang Bodhisattva.

The popularization of Buddhism in China has made the country home to one of the richest collections of Buddhist arts in the world. The Mogao Caves near Dunhuang and the Bingling Temple caves near Yongjing in Gansu province, the Longmen Grottoes near Luoyang in Henan province, the Yungang Grottoes near Datong in Shanxi province, and the Dazu Rock Carvings near Chongqing municipality are among the most important and renowned Buddhist sculptural sites. The Leshan Giant Buddha, carved out of a hillside in the 8th century during the Tang Dynasty and looking down on the confluence of three rivers, is still the largest stone Buddha statue in the world.

See also: Buddhism in China, Longmen Grottoes, Mogao Caves, Yungang Grottoes, Henan, Tang Dynasty art, Bingling Temple

Korea

See also: Buddhism in Korea, Korean Buddhist sculpture, and Korean art

Korean Buddhist art generally reflects an interaction between other Buddhist influences and a strongly original Korean culture. Additionally, the art of the steppes, particularly Siberian and Scythian influences, are evident in early Korean Buddhist art based on the excavation of artifacts and burial goods such as Silla royal crowns, belt buckles, daggers, and comma-shaped gogok. The style of this indigenous art was geometric, abstract and richly adorned with a characteristic "barbarian" luxury.

Although many other influences were strong, Korean Buddhist art, "bespeaks a sobriety, taste for the right tone, a sense of abstraction but also of colours that curiously enough are in line with contemporary taste" (Pierre Cambon, *Arts asiatiques- Guimet'*).

Three Kingdoms of Korea

The first of the Three Kingdoms of Korea to officially receive Buddhism was Goguryeo in 372. However, Chinese records and the use of Buddhist motifs in Goguryeo murals indicate the introduction of Buddhism earlier than the official date. The Baekje Kingdom officially recognized Buddhism in 384. The Silla Kingdom, isolated and with no easy sea or land access to China, officially adopted Buddhism in 535 although the foreign religion was known in the kingdom due to the work of Goguryeo monks since the early fifth century. The introduction of Buddhism stimulated the need for artisans to create images for veneration, architects for temples, and the literate for the Buddhist sutras and transformed Korean civilization. Particularly important in the transmission of sophisticated art styles to the Korean kingdoms was the art of the "barbarian" Tuoba, a clan of non-Han Chinese Xianbei people who established the Northern Wei Dynasty in China in 386. The Northern Wei style was particularly influential in the art of the Goguryeo and Baekje. Baekje artisans later transmitted this style along with Southern Dynasty elements and distinct Korean elements to Japan. Korean artisans were highly selective of the styles they incorporated and combined different regional styles together to create a specific Korean Buddhist art style.

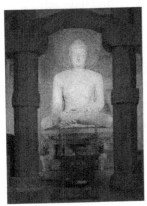

Seokguram Grotto is a World Heritage Site and dates to the Unified Silla era.

While Goguryeo Buddhist art exhibited vitality and mobility akin with Northern Wei prototypes, the Baekje Kingdom was also in close contact with the Southern Dynasties of China and this close diplomatic contact is exemplified in the gentle and proportional sculpture of the Baekje, epitomized by Baekje sculpture exhibiting the fathomless smile known to art historians as the Baekje smile. The Silla Kingdom also developed a distinctive Buddhist art tradition epitomized by the Bangasayusang, a half-seated contemplative maitreya whose Korean-made twin, the Miroku Bosatsu, was sent to Japan as a proselytizing gift and now resides in the Koryu-ji Temple in Japan. Buddhism in the Three Kingdoms period stimulated massive temple-building projects, such as the Mireuksa Temple in the Baekje Kingdom and the Hwangnyongsa Temple in Silla. Baekje architects were famed for their skill and were instrumental in building the massive nine-story pagoda at Hwangnyongsa and early Buddhist temples in Yamato Japan such as Hōkō-ji (Asuka-dera) and Hōryū-ji. Sixth century Korean Buddhist art exhibited the cultural influences of China and India but began to show distinctive indigenous characteristics. These indigenous

characteristics can be seen in early Buddhist art in Japan and some early Japanese Buddhist sculpture is now believed to have originated in Korea, particularly from Baekje, or Korean artisans who immigrated to Yamato Japan. Particularly, the semi-seated Maitreya form was adapted into a highly developed Korean style which was transmitted to Japan as evidenced by the Koryu-ji Miroku Bosatsu and the Chugu-ji Siddhartha statues. Although many historians portray Korea as a mere transmitter of Buddhism, the Three Kingdoms, and particularly Baekje, were instrumental as active agents in the introduction and formation of a Buddhist tradition in Japan in 538 or 552.

Unified Silla

During the Unified Silla period, East Asia was particularly stable with China and Korea both enjoying unified governments. Early Unified Silla art combined Silla styles and Baekje styles. Korean Buddhist art was also influenced by new Tang Dynasty styles as evidenced by a new popular Buddhist motif with full-faced Buddha sculptures. Tang China was the cross roads of East, Central, and South Asia and so the Buddhist art of this time period exhibit the so-called international style. State-sponsored Buddhist art flourished during this period, the epitome of which is the Seokguram Grotto.

Goryeo Dynasty

The fall of the Unified Silla Dynasty and the establishment of the Goryeo Dynasty in 918 indicates a new period of Korean Buddhist art. The Goryeo kings also lavishly sponsored Buddhism

The Goryeo era Gyeongcheonsa Pagoda sits on the first floor of the National Museum of Korea.

and Buddhist art flourished, especially Buddhist paintings and illuminated sutras written in gold and silver ink. [1]. The crowning achievement of this period is the carving of approximately 80,000 woodblocks of the Tripitaka Koreana which was done twice.

Joseon Dynasty

The Joseon Dynasty actively suppressed Buddhism beginning in 1406 and Buddhist temples and art production subsequently decline in quality in quantity although beginning in 1549, Buddhist art does continue to be produced. [2].

Japan

See also: Buddhism in Japan, Japanese art, and Buddhist art in Japan

Before the introduction of Buddhism, Japan had already been the seat of various cultural (and artistic) influences, from the abstract linear decorative art of the indigenous Neolithic Jōmon from around

10500 BC to 300 BC, to the art during the Yayoi and Kofun periods, with developments such as Haniwa art.

The Japanese discovered Buddhism in the 6th century when missionary monks travelled to the islands together with numerous scriptures and works of art. The Buddhist religion was adopted by the state in the following century. Being geographically at the end of the Silk Road, Japan was able to preserve many aspects of Buddhism at the very time it was disappearing in India, and being suppressed in Central Asia and China.

From 711, numerous temples and monasteries were built in the capital city of Nara, including a five-story pagoda, the Golden Hall of the Horyuji, and the Kōfuku-ji temple. Countless paintings and sculptures were made, often under governmental sponsorship. Indian, Hellenistic, Chinese and Korean artistic influences blended into an original style characterized by realism and gracefulness. The creation of Japanese Buddhist art was especially rich between the 8th and 13th centuries during the periods of Nara, Heian and Kamakura. Japan developed an extremely rich figurative art for the pantheon of Buddhist deities, sometimes combined with Hindu and Shinto influences. This art can be very varied, creative and bold.

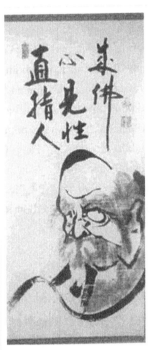

Scroll calligraphy of Bodhidharma "Zen points directly to the human heart, see into your nature and become Buddha", by Hakuin Ekaku (1686 to 1769)

From the 12th and 13th, a further development was Zen art, following the introduction of the faith by Dogen and Eisai upon their return from China. Zen art is mainly characterized by original paintings (such as sumi-e) and poetry (especially haikus), striving to express the true essence of the world through impressionistic and unadorned "non-dualistic" representations. The search for enlightenment "in the moment" also led to the development of other important derivative arts such as the Chanoyu tea ceremony or the Ikebana art of flower arrangement. This evolution went as far as considering almost any human activity as an art with a strong spiritual and aesthetic content, first and foremost in those activities related to combat techniques (martial arts).

Buddhism remains very active in Japan to this day. Still around 80,000 Buddhist temples are preserved. Many of them are in wood and are regularly restored.

Tibet and Bhutan

See also: Bhutanese art and Tibetan art

Tantric Buddhism started as a movement in eastern India around the 5th or the 6th century. Many of the practices of Tantric Buddhism are derived from Brahmanism (the usage of mantras, yoga, or the burning of sacrificial offerings). Tantrism became the dominant form of Buddhism in Tibet from the 8th century. Due to its geographical centrality in Asia, Tibetan Buddhist art received influence from Indian, Nepali, Greco-Buddhist and Chinese art.

One of the most characteristic creations of Tibetan Buddhist art are the mandalas, diagrams of a "divine temple" made of a circle enclosing a square, the purpose of which is to help Buddhist devotees focus their attention through meditation and follow the path to the central image of the Buddha. Artistically, Buddhist Gupta art and Hindu art tend to be the two strongest inspirations of Tibetan art.

Vietnam

Chinese influence was predominant in the north of Vietnam (Tonkin) between the 1st and 9th centuries, and Confucianism and Mahayana Buddhism were prevalent. Overall, the art of Vietnam has been strongly influenced by Chinese Buddhist art.

In the south thrived the former kingdom of Champa (before it was later overtaken by the Vietnamese from the north). Champa had a strongly Indianized art, just as neighboring Cambodia. Many of its statues were characterized by rich body adornments. The capital of the kingdom of Champa was annexed by Vietnam in 1471, and it totally collapsed in the 1720s, while Cham people remain an abundant minority across Southeast Asia.

Southern Buddhist art

During the 1st century AD, the trade on the overland Silk Road tended to be restricted by the rise of the Parthian empire in the Middle East, an unvanquished enemy of Rome, just as Romans were becoming extremely wealthy and their demand for Asian luxury was rising. This demand revived the sea connections between the Mediterranean Sea and China, with India as the intermediary of choice. From that time, through trade connections, commercial settlements, and even political interventions, India started to strongly influence Southeast Asian countries. Trade routes linked India with southern Burma, central and southern Siam, lower Cambodia and southern Vietnam, and numerous urbanized coastal settlements were established there.

For more than a thousand years, Indian influence was therefore the major factor that brought a certain level of cultural unity to the various countries of the region. The Pali and Sanskrit languages and the Indian script, together with Mahayana and Theravada Buddhism, Brahmanism and Hinduism, were transmitted from direct contact and through sacred texts and Indian literature such as the Ramayana and the Mahabharata. This expansion provided the artistic context for the development of Buddhist art in

these countries, which then developed characteristics of their own.

Between the 1st and 8th centuries, several kingdoms competed for influence in the region (particularly the Cambodian Funan then the Burmese Mon kingdoms) contributing various artistic characteristics, mainly derived from the Indian Gupta style. Combined with a pervading Hindu influence, Buddhist images, votive tablets and Sanskrit inscriptions are found throughout the area.

From the 9th to the 13th centuries, Southeast Asia had very powerful empires and became extremely active in Buddhist architectural and artistic creation. The Sri Vijaya Empire to the south and the Khmer Empire to the north competed for influence, but both were adherents of Mahayana Buddhism, and their art expressed the rich Mahayana pantheon of the Bodhisattvas. The Theravada Buddhism of the Pali canon was introduced to the region around the 13th century from Sri Lanka, and was adopted by the newly founded ethnic Thai kingdom of Sukhothai. Since in Theravada Buddhism only monks can reach Nirvana, the construction of **temple complexes** plays a particularly important role in the artistic expression of Southeast Asia from that time.

From the 14th century, the main factor was the spread of Islam to the maritime areas of Southeast Asia, overrunning Malaysia, Indonesia, and most of the islands as far as the Philippines. In the continental areas, Theravada Buddhism continued to expand into Burma, Laos and Cambodia.

Myanmar

A neighbor of India, Myanmar (Burma) was naturally strongly influenced by the eastern part of Indian territory. The Mon of southern Burma are said to have been converted to Buddhism around 200 BC under the proselytizing of the Indian king Ashoka, before the schism between Mahayana and Hinayana Buddhism.

Early Buddhist temples are found, such as Beikthano in central Myanmar, with dates between the 1st and the 5th centuries. The Buddhist art of the Mons was especially influenced by the Indian art of the Gupta and post-Gupta periods, and their mannerist style spread widely in Southeast Asia following the expansion of the Mon Empire between the 5th and 8th centuries.

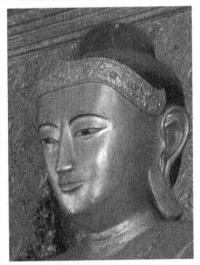

A Mandalay-style statue of Buddha

Later, thousands of Buddhist temples were built at Bagan, the capital, between the 11th and 13th centuries, and around 2,000 of them are still standing. Beautiful jeweled statues of the Buddha are remaining from that period. Creation managed to continue despite the seizure of the city by the Mongols in 1287.

During the Ava period, from the fourteenth to sixteenth centuries, the Ava (Innwa) style of the Buddha image was popular. In this style, the Buddha has large protruding ears, exaggerated eyebrows that curve upward, half-closed eyes, thin lips and a hair bun that is pointed at the top, usually depicted in the bhumisparsa mudra.

During the Konbaung dynasty, at the end of the eighteenth century, the Mandalay style of the Buddha image emerged, a style that remains popular to this day. There was a marked departure from the Innwa style, and the Buddha's face is much more natural, fleshy, with naturally-slanted eyebrows, slightly slanted eyes, thicker lips, and a round hair bun at the top. Buddha images in this style can be found reclining, standing or sitting. Mandalay-style Buddhas wear flowing, draped robes.

Another common style of Buddha images is the Shan style, from the Shan people, who inhabit the highlands of Myanmar. In this style, the Buddha is depicted with angular features, a large and prominently pointed nose, a hair bun tied similar to Thai styles, and a small, thin mouth.

Cambodia

Cambodia was the center of the Funan kingdom, which expanded into Burma and as far south as Malaysia between the 3rd and 6th centuries CE. Its influence seems to have been essentially political, most of the cultural influence coming directly from India.

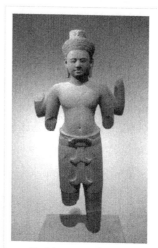

Bodhisattva Lokesvara,
Cambodia 12th century.

Later, from the 9th to 13th centuries, the Mahayana Buddhist and Hindu Khmer Empire dominated vast parts of the Southeast Asian peninsula, and its influence was foremost in the development of Buddhist art in the region. Under the Khmer, more than 900 temples were built in Cambodia and in neighboring Thailand.

Angkor was at the center of this development, with a Buddhist temple complex and urban organization able to support around 1 million urban dwellers. A great deal of Cambodian Buddhist sculpture is preserved at Angkor; however, organized looting has had a heavy impact on many sites around the country.

Often, Khmer art manages to express intense spirituality through divinely beaming expressions, in spite of spare features and slender lines.

See also: Khmer art, Khmer sculpture

Thailand

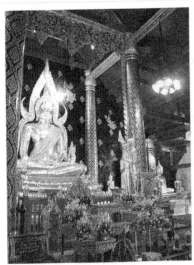

Wat Phra Sri Ratanamahatat. Phitsanulok, Thailand

From the 1st to the 7th centuries, Buddhist art in Thailand was first influenced by direct contact with Indian traders and the expansion of the Mon kingdom, leading to the creation of Hindu and Buddhist art inspired from the Gupta tradition, with numerous monumental statues of great virtuosity.

From the 9th century, the various schools of Thai art then became strongly influenced by Cambodian Khmer art in the north and Sri Vijaya art in the south, both of Mahayana faith. Up to the end of that period, Buddhist art is characterized by a clear fluidness in the expression, and the subject matter is characteristic of the Mahayana pantheon with multiple creations of Bodhisattvas.

From the 13th century, Theravada Buddhism was introduced from Sri Lanka around the same time as the ethnic Thai kingdom of Sukhothai was established. The new faith inspired highly stylized images in Thai Buddhism, with sometimes very geometrical and almost abstract figures.

During the Ayutthaya period (14th-18th centuries), the Buddha came to be represented in a more stylistic manner with sumptuous garments and jeweled ornamentations. Many Thai sculptures or temples tended to be gilded, and on occasion enriched with inlays.

See also: Thai art, Buddha images in Thailand

Indonesia

Like the rest of Southeast Asia, Indonesia seems to have been most strongly influenced by India from the 1st century A.D. The islands of Sumatra and Java in western Indonesia were the seat of the empire of Sri Vijaya (8th-13th century CE), which came to dominate most of the area around the Southeast Asian peninsula through maritime power. The Sri Vijayan Empire had adopted Mahayana and Vajrayana Buddhism, under a line of rulers named the Sailendra. Sri Vijaya spread Mahayana Buddhist art during its expansion into the Southeast Asian peninsula. Numerous statues of Mahayana Bodhisattvas from this period are characterized by a very strong refinement and technical sophistication, and are found throughout the region.

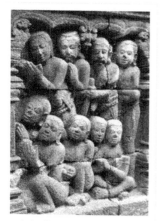

A detailed carved relief stone from Borobudur.

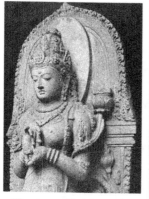

The statue of Prajñāpāramitā from Singhasari, East Java.

Extremely rich and refined architectural remains are found in Java and Sumatra. The most magnificent is the temple of Borobudur (the largest Buddhist structure in the world, built around 780-850 AD). This temple is modelled after the Buddhist concept of universe, the Mandala which counts 505 images of the seated Buddha and unique bell-shaped stupa that contains the statue of Buddha. Borobudur is adorned with long series of bas-reliefs narrated the holy Buddhist scriptures. The oldest Buddhist structure in Indonesia probably is the Batujaya stupas at Karawang, West Java, dated from around 4th century CE. This temple is some plastered brick stupas. However, Buddhist art in Indonesia reach the golden era during the Sailendra dynasty rule in Java. The bas-reliefs and statues of Boddhisatva, Tara, and Kinnara found in Kalasan, Sewu, Sari, and Plaosan temple is very graceful with serene expression, While Mendut temple near Borobudur, houses the giant statue of Vairocana, Avalokitesvara, and Vajrapani.

In Sumatra Sri Vijaya probably built the temple of Muara Takus, and Muaro Jambi. The most beautiful example of classical Javanese Buddhist art is the serene and delicate statue of Prajnaparamita (the collection of National Museum Jakarta) the goddess of transcendental wisdom from Singhasari kingdom. The Indonesian Buddhist Empire of Sri Vijaya declined due to conflicts with the Chola rulers of India, then followed by Majapahit empire, before being destabilized by the Islamic expansion from the 13th century.

Contemporary Buddhist art

Many contemporary artists have made use of Buddhist themes. Notable examples are Bill Viola, in his video installations, John Connell, in sculpture., and Allan Graham in his multi-media "Time is Memory".

In the UK The Network of Buddhist Organisations has interested itself in identifying Buddhist practitioners across all the arts. In 2005 it co-ordinated the UK-wide Buddhist arts festival, "A Lotus in Flower"; in 2009 it helped organise the two-day arts conference, "Buddha Mind, Creative Mind". As a result of the latter an association of Buddhist artists was formed.

See also

- Buddhism
- Buddhist architecture
- Buddhist music
- Buddhist symbolism
- Buddharupa
- Daibutsu
- Borobudur
- Eastern art history

References

- James Huntley Grayson (2002). *Korea: A Religious History*. UK: Routledge. ISBN 0-7007-1605-X.

Further reading

- Foltz, Richard (1999). *Religions of the Silk Road*. New-York: St. Martin's Griffin. ISBN 0-312-23338-8.
- Jarrige, Jean-François (2001). *Arts asiatiques- Guimet* (Éditions de la Réunion des Musées Nationaux ed.). Paris. ISBN 2-7118-3897-8.
- Lee, Sherman (2003). *A History of Far Eastern Art (5th Edition)*. New York: Prentice Hall. ISBN 0-13-183366-9.
- Scarre, Dr. Chris (editor) (1991). *Past Worlds. The Times Atlas of Archeology*. London: Times Books Limited. ISBN 0-7230-0306-8.
- Susan L. Huntington: "Early Buddhist art and the theory of aniconism", Art Journal, Winter 1990.
- D. G. Godse's writings in Marathi.

External links

- Buddhist Art [1] at the Open Directory Project
- The Herbert Offen Research Collection of the Phillips Library at the Peabody Essex Museum [2]

Thangka

A "**Thangka**," also known as "**Tangka**", "**Thanka**" or "**Tanka**" (Nepali pronunciation: Hindustani pronunciation: [ˈtʰaːŋkaː], the 'th' as the aspirated 't' of *top* and the 'a' as in the word *father*) (Tibetan: ⯑⯑⯑⯑⯑, Nepal Bhasa: पौभा) is a Tibetan silk painting with embroidery, usually depicting a Buddhist deity, famous scene, or mandala of some sort. The thankga is not a flat creation like an oil or acrylic painting. However. it consists of a picture panel which is painted or embroidered, over which a textile is mounted, and then over which is laid a cover, usually silk. Generally, thankgas last a very long time and retain much of their lustre, but because of their delicate nature, they have to be kept in dry places where moisture won't affect the quality of the silk. It is sometimes called a scroll-painting.

Originally, thangka painting became popular among traveling monks because the scroll paintings were easily rolled and transported from monastery to monastery. These thangka served as important teaching tools depicting the life of the Buddha, various influential lamas and other deities and bodhisattvas. One popular subject is The Wheel of Life, which is a visual representation of the Abhidharma teachings (Art of Enlightenment).

To Buddhists these Tibetan religious paintings offer a beautiful manifestation of the divine, being both visually and mentally stimulating.

Thangka, when created properly, perform several different functions. Images of deities can be used as teaching tools when depicting the life (or lives) of the Buddha, describing historical events concerning important Lamas, or retelling myths associated with other deities. Devotional images act as the centerpiece during a ritual or ceremony and are often used as mediums through which one can offer prayers or make requests. Overall, and perhaps most importantly, religious art is used as a meditation tool to help bring one further down the path to enlightenment. The Buddhist Vajrayana practitioner uses a thanga image of their yidam, or meditation deity, as a guide, by visualizing "themselves as being that deity, thereby internalizing the Buddha qualities (Lipton, Ragnubs)."

Historian note that Chinese painting had a profound influence on Tibetan painting in general. Starting from the 14th and 15th century, Tibetan painting had incorporated many elements from the Chinese, and during the 18th century, Chinese painting had a deep and far-stretched impact on Tibetan visual art. According to Giuseppe Tucci, by the time of the Qing Dynasty, "a new Tibetan art was then developed, which in a certain sense was a provincial echo of the Chinese 18th century's smooth ornate preciosity."

History

Thangka is a Nepalese art form exported to Tibet after Princess Bhrikuti of Nepal, daughter of King Lichchavi, married Sron Tsan Gampo, the ruler of Tibet imported the images of Aryawalokirteshwar and other Nepalese deities to Tibet .

Types

Based on technique and material, thangkas can be grouped by types. Generally, they are divided into two broad categories: those that are painted (Tib.) bris-tan—and those made of silk, either by appliqué or embroidery.

Thangkas are further divided into these more specific categories:

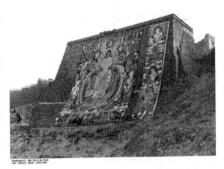

Large thangka hanging on special wall at Gyantse. 1938.

- Painted in colors (Tib.) tson-tang—the most common type
- Appliqué (Tib.) go-tang
- Black Background—meaning gold line on a black background (Tib.) nagtang
- Blockprints—paper or cloth outlined renderings, by woodcut/woodblock printing
- Embroidery (Tib.) tshim-tang
- Gold Background—an auspicious treatment, used judiciously for peaceful, long-life deities and fully enlightened buddhas
- Red Background—literally gold line, but referring to gold line on a vermillion (Tib.) mar-tang

Whereas typical thangkas are fairly small, between about 18 and 30 inches tall or wide, there are also giant festival thangkas, usually Appliqué, and designed to be unrolled against a wall in a monastery for particular religious occasions. These are likely to be wider than they are tall, and may be sixty or more feet across and perhaps twenty or more high.

Process

Thangkas are painted on cotton duct or silk. The most common is a loosely woven cotton produced in widths from 40 to 58 centimeters (16 - 23 inches). While some variations do exist, thangkas wider than 45 centimeters (17 or 18 inches) frequently have seams in the support. The paint consists of pigments in a water soluble medium. Both mineral and organic pigments are used, tempered with a herb and glue solution. In Western terminology, this is a distemper technique.

The composition of a thangka, as with the majority of Buddhist art, is highly geometric. Arms, legs, eyes, nostrils, ears, and various ritual implements are all laid out on a systematic grid of angles and

intersecting lines. A skilled thangka artist will generally select from a variety of predesigned items to include in the composition, ranging from alms bowls and animals, to the shape, size, and angle of a figure's eyes, nose, and lips. The process seems very methodical, but often requires deep understanding of the symbolism involved to capture the spirit of it.

Thangka often overflow with symbolism and allusion. Because the art is explicitly religious, all symbols and allusions must be in accordance with strict guidelines laid out in buddhist scripture. The artist must be properly trained and have sufficient religious understanding, knowledge, and background to create an accurate and appropriate thangka. Lipton and Ragnubs clarify this in *Treasures of Tibetan Art*:

"[Tibetan] art exemplifies the nirmanakaya, the physical body of Buddha, and also the qualities of the Buddha, perhaps in the form of a deity. Art objects, therefore, must follow rules specified in the Buddhist scriptures regarding proportions, shape, color, stance, hand positions, and attributes in order to personify correctly the Buddha or Deities."

Gallery

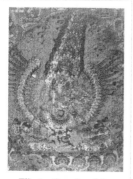

Tibetan thangka of the Hayagriva

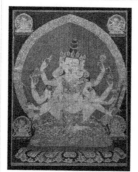

17th century Central Tibetan thanka of Guhyasamaja Akshobhyavajra, Rubin Museum of Art

Bhutanese painted complete
mandala, 19th century, Seula
Gonpa, Punakha, Bhutan

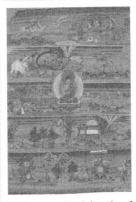

Bhutanese painted thangka of
the Jataka Tales, 18th-19th
century, Phajoding Gonpa,
Thimphu, Bhutan

See also

- Bhavachakra
- Mandala

References

- Lipton, Barbara and Ragnubs, Nima Dorjee. Treasures of Tibetan Art: Collections of the Jacques Marchais Museum of Tibetan Art. Oxford University Press, New York. 1996

- *Art of Enlightenment: A persepective on the Sacred Art of Tibet*, Yeshe De Project. Dharma Publishing, Berkeley, CA 1987.

External links

- More than 4500 pages of sacred Tibetan art from Dharmapala Thangka Centre - Kathmandu | Nepal [1]
- Overview of traditional thangka paintings and courses [2]
- A selection of hi-res downloadable thangkas | Pure View [3]
- Andy Weber - Master Thanka Painter [4]
- 'Thanka blessing in Nepal [5]
- 'Norbulingka thangka's Norbulingka Institute [6]- Tibetan Thangka Paintings from the Tibetan Government's Institute under the Chairmanship of His Holiness the Dalai Lama.
- Video: giant Thangka unfurling ceremony [7]

Bhutanese Art

Bhutanese art

Bhutanese art is similar to the art of Tibet. Both are based upon Vajrayana Buddhism, with its pantheon of divine beings.

The major orders of Buddhism in Bhutan are Drukpa Kagyu and Nyingma. The former is a branch of the Kagyu School and is known for paintings documenting the lineage of Buddhist masters and the 70 Je Khenpo (leaders of the Bhutanese monastic establishment). The Nyingma order is known for images of Padmasambhava, who is credited with introducing Buddhism into Bhutan in the 7th century. According to legend, Padmasambhava hid sacred treasures for future Buddhist masters, especially Pema Lingpa, to find. The treasure finders (*tertön*) are also frequent subjects of Nyingma art.

Each divine being is assigned special shapes, colors, and/or identifying objects, such as lotus, conch-shell, thunderbolt, and begging bowl. All sacred images are made to exact specifications that have remained remarkably unchanged for centuries.

Bhutanese art is particularly rich in bronzes of different kinds that are collectively known by the name *Kham-so* (made in Kham) even though they are made in Bhutan, because the technique of making them was originally imported from the eastern province of Tibet called Kham. Wall paintings and sculptures, in these regions, are formulated on the principal ageless ideals of Buddhist art forms. Even though their emphasis on detail is derived from Tibetan models, their origins can be discerned easily, despite the profusely embroidered garments and glittering ornaments with which these figures are lavishly covered. In the grotesque world of demons, the artists apparently had a greater freedom of action than when modeling images of divine beings.

The arts and crafts of Bhutan that represents the exclusive "spirit and identity of the Himalayan kingdom' is defined as the art of *Zorig Chosum*, which means the "thirteen arts and crafts of Bhutan"; the thirteen crafts are carpentry, painting, paper making, blacksmithery, weaving, sculpting and many other crafts. The Institute of Zorig Chosum in Thimphu is the premier institution of traditional arts and crafts set up by the Government of Bhutan with the sole objective of preserving the rich culture and tradition of Bhutan and training students in all traditional art forms; there is another similar institution in eastern Bhutan known as Trashi Yangtse. Bhutanese rural life is also displayed in the 'Folk Heritage Museum' in Thimphu. There is also a 'Voluntary Artists Studio' in Thimphu to encourage and promote the art forms among the youth of Thimphu. The thirteen arts and crafts of Bhutan and the institutions established in Thimphu to promote these art forms are:

Traditional Bhutanese arts

In Bhutan, the traditional arts are known as *zorig chusum* (*zo* = the ability to make; *rig* = science or craft; *chusum* = thirteen). These practices have been gradually developed through the centuries, often passed down through families with long-standing relations to a particular craft. These traditional crafts represent hundreds of years of knowledge and ability that has been passed down through generations.

The great 15th century treasure finder (*tertön*), Pema Lingpa is traditionally credited with introducing the arts into Bhutan. In 1680, Shabdrung Ngawang Namgyal ordered the establishment of the school for instruction in the 13 traditional arts. Although the skills existed much earlier, it is believed that the *zorig chusum* was first formally categorized during the rule of Tenzin Rabgye (1680-1694), the 4th Druk Desi (secular ruler). The thirteen traditional arts are:

- *Dezo* - Paper Making: Handmade paper made mainly from the Daphne plant and gum from a creeper root.
- *Dozo* - Stonework: Stone arts used in the construction of stone pools and the outer walls of dzongs, *goenpa* (monasteries), stupas, and some other buildings.
- *Garzo* - Blacksmithing: The manufacture of iron goods, such as farm tools, knives, swords, and utensils.
- *Jinzo* - Clay arts: The making of religious statues and ritual objects, pottery and the construction of buildings using mortar, plaster, and rammed earth.
- *Lhazo* - Painting: From the images on thangkas (religious wall hangings), walls paintings, and statues to the decorations on furniture and window-frames.
- *Lugzo* - Bronze casting: Production of bronze roof-crests, statues, bells, and ritual instruments, in addition to jewelry and household items using sand casting and lost-wax casting. Larger statues are made by repoussé.
- *Parzo* - Wood, slate, and stone carving: In wood, slate or stone, for making such items as printing blocks for religious texts, masks, furniture, altars, and the slate images adorning many shrines and altars.
- *Shagzo* - Woodturning: Making a variety of bowls, plates, cups, and other containers.
- *Shingzo* - Woodworking: Employed in the construction of dzongs and *goenpa* (monasteries)
- *Thagzo* - Weaving: The production of some of the most intricately woven fabrics produced in Asia.
- *Trözo* - Silver and Goldsmithing: Working in gold, silver, and copper to make jewelry, ritual objects, and utilitarian household items.
- *Tshazo* - Cane and Bamboo Work: The production of such varied items as bows and arrows, baskets, drinks containers, utensils, musical instruments, fences, and mats.
- *Tshemazo* – Needlework: Working with needle and thread to make clothes, boots, or the most intricate of appliqué thangkas (religious wall hangings).

Characteristics of Bhutanese arts

Articles for everyday use are still fashioned today as they were centuries ago. Traditional artisanship is handed down from generation to generation. Bhutan's artisans are skilled workers in metals, wood and slate carving, and clay sculpture. Artifacts made of wood include bowls and dishes, some lined with silver. Elegant yet strong woven bamboo baskets, mats, hats, and quivers find both functional and decorative usage. Handmade paper is prepared from tree bark by a process passed down the ages.

Each region has its specialties: raw silk comes from eastern Bhutan, brocade from Lhuntshi (Kurtoe), woolen goods from Bumthang, bamboo wares from Kheng, woodwork from Tashi Yangtse, gold and silver work from Thimphu, and yak-hair products from the north or the Black Mountains.

Most Bhutanese art objects are produced for use of the Bhutanese themselves. Except for goldsmiths, silversmiths, and painters, artisans are peasants who produce these articles and fabrics in their spare time, with the surplus production being sold. Most products, particularly fabrics, are relatively expensive. In the highest qualities, every step of production is performed by hand, from dyeing hanks of thread or hacking down bamboo in the forest, to weaving or braiding the final product. The time spent in producing handicrafts is considerable and can involve as much as two years for some woven textiles. At the same time, many modern innovations are also used for less expensive items, especially modern dyes, and yarns - Bhutan must be one of the few places where hand-woven polyester garments can be bought.

Products

Textiles

Bhutanese textiles are a unique art form inspired by nature made in the form of clothing, crafts and different types of pots in eye-catching blend of colour, texture, pattern and composition. This art form is witnessed all over Bhutan and in Thimphu in the daily life of its people. It is also a significant cultural exchange garment that is gifted to mark occasions of birth and death, auspicious functions such as weddings and professional achievements and in greeting dignitaries. Each region has its own special designs of textiles, either made of vegetable dyed wool known as *yathra* or pure silk called *Kishuthara*. It is the women, belonging to a small community, who weave these textiles as a household handicrafts heritage.

Paintings

Most Bhutanese art, including 'Painting in Bhutanese art', known as *lhazo*, is invariably religion centric. These are made by artists without inscribing their names on them. The paintings encompass various types including the traditional thangkas, which are scroll paintings made in "highly stylised and strict geometric proportions" of Buddhist iconography that are made with mineral paints. Most houses in Bhutan have religious and other symbolic motifs painted inside their houses and also on the external walls.

Sculptures

The art of making religious sculptures is unique in Bhutan and hence very popular in the Himalayan region. The basic material used for making the sculptures is clay, which is known as *jinzob*. The clay statues of Buddhist religious icons, made by well known artists of Bhutan, embellish various monasteries in Bhutan. This art form of sculpture is taught to students by professional artists at the Institute of Zorig Chosum in Thimphu.

Paper making

Handmade paper known as *deysho* is in popular usage in Bhutan and it is durable and insect resistant. The basic material used is the bark of the Daphne plant. This paper is used for printing religious texts; traditional books are printed on this paper. It is also used for packaging gifts. Apart from hand made paper, paper factories in Bhutan also produce ornamental art paper with designs of flower petals, and leaves, and other materials. For use on special occasions, vegetable dyed paper is also made.

Wood carving

Wood carving known as *Parzo* is a specialised and ancient art form, which is significantly blended with modern buildings in the resurgent Bhutan. Carved wood blocks are used for printing religious prayer flags that are seen all over Bhutan in front of monasteries, on hill ridges and other religious places. Carving is also done on slate and stone. The wood that is used for carving is seasoned for at least one year prior to carving.

Sword making

The art of sword making falls under the tradition of *garzo* (or blacksmithing), an art form that is used to make all metal implements such as swords, knives, chains, darts and so forth. Ceremonial swords are made and gifted to people who are honoured for their achievements. These swords are to be sported by men on all special occasions. Children, wear a traditional short knife known as the *dudzom*. Terton Pema Lingpa, a religious treasure hunter from central Bhutan, was the most famous sword maker in Bhutan.

Boot Making

It is not uncommon to see Bhutan's traditional boots made of cloth. The cloth is hand stitched, embroidered and appliquéd with Bhutanese motifs. They are worn on ceremonial occasions (mandatory); the colours used on the boot denote the rank and status of the person wearing it. In the pecking order, Ministers wear orange, senior officials wear red and the common people wear white boots. This art form has been revived at the Institute of Zorig Chosum in Thimphu. Women also wear boots but of shorter length reaching just above the ankle.

Bamboo Craft

Bamboo Craft made with cane and bamboo is known as *thazo*. It is made in many rural communities in many regions of Bhutan. Few special items of this art form are the *belo* and the *bangchung*, popularly known as the Bhutanese "Tupperware" basket made in various sizes. Baskets of varying sizes are used

in the homes and for travel on horseback, and as flasks for local drink called the *arra*.

Bow and Arrow Making

To meet the growing demand for bow and arrow used in the national sport of archery, bamboo bows and arrows are made by craftsmen using specific types of bamboo and mountain reeds. The bamboo used are selected during particular seasons, shaped to size and skilfully made into the bow and arrow. Thimphu has the Changlimithang Stadium & Archery Ground where Archery is a special sport.

Jewelry

Intricate jewelry with motif, made of silver and gold, are much sought after by women of Bhutan. The traditional jewelry made in Bhutan are heavy bracelets, *komas* or fasteners attached to the *kira*, the traditional dress of Bhutanse women, loop ear rings set with turquoise and necklaces inlaid with gem stones such as antique turquoise, coral beads and the *zhi* stone. The *zhi* stone is considered a prized possession as it is said to have "protective powers"; this stone has black and white spiral designs called "eyes". The *zhi* is also said to be an agate made into beads.

Institutions

National Institute of Zorig Chusum

The National Institute of Zorig Chusum is the centre for Bhutanese Art education. Painting is the main theme of the institute, which provides 4–6 years of training in Bhutanese traditional art forms. The curricula cover a comprehensive course of drawing, painting, wood carving, embroidery, and carving of statues. Images of Buddha are a popular painting done here.

Handicrafts emporiums

There is a large government run emporium close to the National Institute of Zorig Chusum, which deals with exquisite handicrafts, traditional arts and jewelry; *Gho* and *Kira*, the national dress of Bhutanese men and women, are available in this emporium. The town has many other privately owned emporiums which deal with thangkas, paintings, masks, brassware, antique jewellery, painted lama tables known as *choektse*, drums, Tibetan violins and so forth; Zangma Handicrafts Emporium, in particular, sells handicrafts made in the Institute of Zorig Chusum.

Folk Heritage Museum

Folk Heritage Museum in Kawajangsa, Thimphu is built on the lines of a traditional Bhutanese farm house with more than 100 year old vintage furniture. It is built as a three storied structure with rammed mud walls and wooden doors, windows and roof covered with slates. It reveals much about Bhutanese rural life.

Voluntary Artists Studio

Located in an innocuous building, the Voluntary Artist Studio's objective is to encourage traditional and contemporary art forms among the youth of Thimphu who are keen to imbibe these art forms. The

art works of these young artists is also available on sale in the 'Art Shop Gallery' of the studio.

National Textile Museum

The National Textile Museum in Thimphu displays various Bhutanese textiles that are extensive and rich in traditional culture. It also exhibits colourful and rare kiras and ghos (traditional Bhutanese dress, kira for women and gho for men).

Exhibitions

The Honolulu Academy of Arts spent several years developing and curating *The Dragon's Gift: The Sacred Arts of Bhutan* exhibition. The February - May 2008 exhibition in Honolulu will travel in 2008 and 2009 to locations around the world including the Rubin Museum of Art (New York City), the Asian Art Museum (San Francisco), Guimet Museum (Paris), the Museum of East Asian Art (Cologne, Germany), and the Museum Rietberg Zürich (Switzerland).

Selected examples of Bhutanese art

Contemporary hand woven
Bhutanese fabrics, Bumthang
District

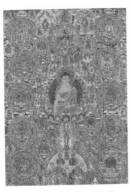

Bhutanese painted complete
mandala, 19th century, Seula
Gonpa, Punakha, Bhutan

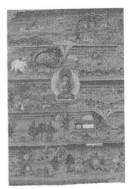

Bhutanese painted thanka
of the Jataka Tales,
18th-19th century,
Phajoding Gonpa,
Thimphu, Bhutan

See also

- Buddhism in Bhutan
- Dzong architecture
- Music of Bhutan
- Vajrayana Buddhism
- Eastern art history

Art and the youth of Bhutan [1]

References

- Bartholomew, Terese Tse, *The Art of Bhutan*, Orientations, Vol. 39, No. 1, Jan./Feb. 2008, 38-44.
- Bartholomew, Terese Tse, John Johnston and Stephen Little, *The Dragon's Gift, the Sacred Arts of Bhutan*, Chicago, Serindia Publications, 2008.
- Johnston, John, "The Buddhist Art of Bhutan", Arts of Asia, Vol. 38, No. 6, Nov./Dec. 2008, 58-68.
- Mehra, Girish N., *Bhutan, Land of the Peaceful Dragon*, Delhi, Vikas Publishing House, 1974.
- Singh, Madanjeet, *Himalayan Art, wall-painting and sculpture in Ladakh, Lahaul and Spiti, the Siwalik Ranges, Nepal, Sikkim, and Bhutan*, New York, Macmillan, 1971.

Cambodian Art

Culture of Cambodia

The **culture of Cambodia** has had a rich and varied history dating back many centuries, and has been heavily influenced by India and China. Throughout Cambodia's long history, a major source of inspiration was from religion. Throughout nearly two millennium, Cambodians developed a unique Khmer belief from the syncreticism of indigenous animistic beliefs and the Indian religions of Buddhism and Hinduism. Indian culture and civilization, including its language and arts reached mainland Southeast Asia around the 1st century A.D.

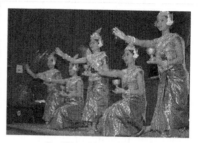

Traditional Khmer dance

It is generally believed that seafaring merchants brought Indian customs and culture to ports along the Gulf of Thailand and the Pacific while trading with China. The first state to benefit from this was Funan.

History

The golden age of Cambodia was between the 9th and 14th century, during the Angkor period, during which it was a powerful and prosperous empire that flourished and dominated almost all of inland south east Asia. However, Angkor would eventually collapse after much in-fighting between royalty and constant warring with its increasingly powerful neighbors, notably Siam and Dai Viet. Many temples from this period however, like Bayon and Angkor Wat still remain today, scattered throughout Thailand, Cambodia, Laos, and Vietnam as a reminder of the grandeur of Khmer arts and culture. Cambodia's unparalleled achievements in art, architectures, music, and dance during this period have had a great influence on many neighboring kingdoms, namely Thailand and Laos. The affect of Angkorian culture can still be seen today in those countries, as they share many close characteristics with current-day Cambodia.

Architecture and housing

Main article: Architecture of Cambodia

The Angkorian architects and sculptors created temples that mapped the cosmic world in stone. Khmer decorations drew inspiration from religion, and mythical creatures from Hinduism and Buddhism were carved on walls. Temples were built in accordance to the rule of ancient Khmer architecture that dictated that a basic temple layout include a central shrine, a courtyard, an enclosing wall, and a moat. Khmer motifs use many creatures from Buddhist and Hindu mythology, like the Royal Palace in Phnom Penh, use motifs

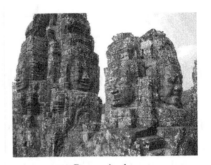

Bayon, Angkor

such as the garuda, a mythical bird in Hinduism. The architecture of Cambodia developed in stages under the Khmer empire from the 9th to the 15th century, preserved in many buildings of the Angkor temple. The remains of secular architecture from this time are rare, as only religious buildings were made of stone. The architecture of the Angkor period used specific structural features and styles, which are one of the main methods used to date the temples, along with inscriptions.

In modern rural Cambodia, the nuclear family typically lives in a rectangular house that may vary in size from four by six meters to six by ten meters. It is constructed of a wooden frame with gabled thatch roof and walls of woven bamboo. Khmer houses are typically raised as much as three meters on stilts for protection from annual floods. Two ladders or wooden staircases provide access to the house. The steep thatch roof overhanging the house walls protects the interior from rain. Typically a house contains three rooms separated by partitions of woven bamboo. The front room serves as a living room used to

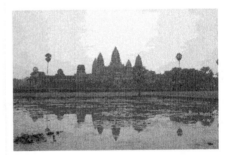

Angkor Wat, The most Cambodian famous heritage.

receive visitors, the next room is the parents' bedroom, and the third is for unmarried daughters. Sons sleep anywhere they can find space. Family members and neighbors work together to build the house, and a house-raising ceremony is held upon its completion. The houses of poorer persons may contain only a single large room. Food is prepared in a separate kitchen located near the house but usually behind it. Toilet facilities consist of simple pits in the ground, located away from the house, that are covered up when filled. Any livestock is kept below the house. Chinese and Vietnamese houses in Cambodian towns and villages are typically built directly on the ground and have earthen, cement, or tile floors, depending upon the economic status of the owner. Urban housing and commercial buildings may be of brick, masonry, or wood.

Religion

Main article: Religion in Cambodia

Cambodia is predominantly Buddhist with 90% of the population being Theravada Buddhist, 1% Christian and the majority of the remaining population follow Islam, atheism, or animism.

Buddhism has existed in Cambodia since at least the 5th century CE. Theravada Buddhism has been the Cambodian state religion since the 13th century CE (excepting the Khmer Rouge period), and is currently estimated to be the faith of 90% of the population.

Buddhist nun at Angkor Wat, Siem Reap, Cambodia (January 2005).

Islam is the religion of a majority of the Cham (also called Khmer Islam) and Malay minorities in Cambodia. According to Po Dharma, there were 150,000 to 200,000 Muslims in Cambodia as late as 1975. Persecution under the Khmer Rouge eroded their numbers, however, and by the late 1980s they probably had not regained their former strength. All of the Cham Muslims are Sunnis of the Shafi'i school. Po Dharma divides the Muslim Cham in Cambodia into a traditionalist branch and an orthodox branch.

Christianity was introduced into Cambodia by Roman Catholic missionaries in 1660. However, it made little headway at first, particularly among Buddhists. In 1972 there were probably about 20,000 Christians in Cambodia, most of whom were Roman Catholics. According to Vatican statistics, in 1953, members of the Roman Catholic Church in Cambodia numbered 120,000, making it, at that time, the second largest religion in the country. In April 1970, just before repatriation, estimates indicate that about 50,000 Catholics were Vietnamese. Many of the Catholics remaining in Cambodia in 1972 were Europeans—chiefly French. American Protestant missionary activity increased in Cambodia, especially among some of the hill tribes and among the Cham, after the establishment of the Khmer Republic. The 1962 census, which reported 2,000 Protestants in Cambodia, remains the most recent statistic for the group. Observers reported that in 1980 there were more registered Khmer Christians among the refugees in camps in Thailand than in all of Cambodia before 1970. Kiernan notes that, until June 1980, five weekly Protestant services were held in Phnom Penh by a Khmer pastor, but that they had been reduced to a single weekly service after police harassment. There are around 20,000 Catholics in Cambodia which represents only 0.15% of the total population. There are no dioceses, but there are three territorial jurisdictions - one Apostolic Vicariate and two Apostolic Prefectures.

Highland tribal groups, most with their own local religious systems, probably number fewer than 100,000 persons. The Khmer Loeu have been loosely described as animists, but most tribal groups have their own pantheon of local spirits. In general they see their world filled with various invisible spirits (often called yang), some benevolent, others malevolent. They associate spirits with rice, soil, water, fire, stones, paths, and so forth. Sorcerers or specialists in each village contact these spirits and

prescribe ways to appease them. In times of crisis or change, animal sacrifices may be made to placate the anger of the spirits. Illness is often believed to be caused by evil spirits or sorcerers. Some tribes have special medicine men or shamans who treat the sick. In addition to belief in spirits, villagers believe in taboos on many objects or practices. Among the Khmer Loeu, the Rhade and Jarai groups have a well developed hierarchy of spirits with a supreme ruler at its head.

Ways of life

Birth and death rituals

The birth of a child is a happy event for the family. According to traditional beliefs, however, confinement and childbirth expose the family, and especially the mother and the child to harm from the spirit world. A woman who dies in childbirth—crosses the river (chhlong tonle) in Khmer is believed to become an evil spirit. In traditional Khmer society, a pregnant woman respects a number of food taboos and avoids certain situations. These traditions remain in practice in rural Cambodia, but they have become weakened in urban areas.

Death is not viewed with the great outpouring of grief common to Western society; it is viewed as the end of one life and as the beginning of another life that one hopes will be better. Buddhist Khmer usually are cremated, and their ashes are deposited in a stupa in the temple compound. A corpse is washed, dressed, and placed in a coffin, which may be decorated with flowers and with a photograph of the deceased. White pennant-shaped flags, called "white crocodile flags," outside a house indicate that someone in that household has died. A funeral procession consisting of an achar, Buddhist monks, members of the family, and other mourners accompanies the coffin to the crematorium. The spouse and the children show mourning by shaving their heads and by wearing white clothing. Relics such as teeth or pieces of bone are prized by the survivors, and they are often worn on gold chains as amulets. If the child is always ill, his or her parents can go and change the name of child

Childhood and adolescence

Main article: Childhood and adolescence in Cambodia

A Cambodian child may be nursed until he or she is between two and four years of age. Up to the age of three or four, the child is given considerable physical affection and freedom. Children around five years of age also may be expected to help look after younger siblings. Children's games emphasize socialization or skill rather than winning and losing.

Cambodian girls on a bicycle

Most children begin school when they are seven or eight. By the time they reach this age, they are familiar with the society's norms of politeness, obedience, and respect toward their elders and toward Buddhist monks. The father at this time begins his permanent retreat into a relatively remote, authoritarian role. By age ten, a girl is expected to help her mother in basic household tasks; a boy knows how to care for the family's livestock and can do farm work under the supervision of older males. Adolescent children usually play with members of the same sex. During his teens, a boy may become a temple servant and go on to serve a time as a novice monk, which is a great honor for the parents.

In precommunist days, parents exerted complete authority over their children until the children were married, and the parents continued to maintain some control well into the marriage. Age difference is strictly recognized with polite vocabulary and special generational terms for "you".

It is acceptable for a mother or caretaker in Cambodia, especially those from rural areas, to kiss the penis of an infant or put it in her mouth as a sign of respect or love. The child is usually 1 year old or younger, "but no more than 2 years old," he said. The act has nothing to do with sexual feelings, he said, noting that it can be viewed as a sign of high respect by a caretaker for a future "master." The act is not part of the general culture, it is an exception.

Courtship, marriage, and divorce

Main article: Courtship, marriage, and divorce in Cambodia

In Cambodia, premarital sex is deplored. The choice of a spouse is a complex one for the young male, and it may involve not only his parents and his friends, as well as those of the young woman, but also a matchmaker. In theory, a girl may veto the spouse her parents have chosen. Courtship patterns differ between rural and urban Khmer; romantic love is a notion that exists to a much greater extent in larger cities. A man usually marries between the ages of nineteen and twenty-five, a girl between the ages of sixteen and twenty-two. After a spouse has been selected, each family investigates the other to make sure its child is marrying into a good family. In rural areas, there is a form of bride-service; that is, the young man may take a vow to serve his prospective father-in-law for a period of time.

The traditional wedding is a long and colorful affair. Formerly it lasted three days, but in the 1980s it more commonly lasted a day and a half. Buddhist priests offer a short sermon and recite prayers of blessing. Parts of the ceremony involve ritual hair cutting, tying cotton threads soaked in holy water around the bride's and groom's wrists, and passing a candle around a circle of happily married and respected couples to bless the union. After the wedding, a banquet is held. Newlyweds traditionally move in with the wife's parents and may live with them up to a year, until they can build a new house nearby.

Divorce is legal and relatively easy to obtain, but not common. Divorced persons are viewed with some disapproval. Each spouse retains whatever property he or she brought into the marriage, and jointly-acquired property is divided equally. Divorced persons may remarry, but the woman must wait ten months. Custody of minor children is usually given to the mother, and both parents continue to have an obligation to contribute financially toward the rearing and education of the child.

Social organization

Main article: Social organization in Cambodia

Khmer culture is very hierarchical. The greater a person's age, the greater the level of respect that must be granted to them. Cambodians are addressed with a hierarchical title corresponding to their seniority before the name. When a married couple becomes too old to support themselves, they may invite the youngest child's family to move in and to take over running the household. At this stage in their lives, they enjoy a position of high status.

The individual Khmer is surrounded by a small inner circle of family and friends who constitute his or her closest associates, those he would approach first for help. The nuclear family, consisting of a husband and a wife and their unmarried children, is the most important kin group. Within this unit are the strongest emotional ties, the assurance of aid in the event of trouble, economic cooperation in labor, sharing of produce and income, and contribution as a unit to ceremonial obligations. In rural communities, neighbors—who are often also kin—may be important, too. Fictive child-parent, sibling, and close friend relationships Cambodia transcend kinship boundaries and serve to strengthen interpersonal and interfamily ties. Beyond this close circle are more distant relatives and casual friends. In rural Cambodia, the strongest ties a Khmer may develop—besides those to the nuclear family and to close friends—are those to other members of the local community. A strong feeling of pride—for the village, for the district, and province—usually characterizes Cambodian community life.

Legally, the husband is the head of the Khmer family, but the wife has considerable authority, especially in family economics. The husband is responsible for providing shelter and food for his family; the wife is generally in charge of the family budget, and she serves as the major ethical and religious model for the children, especially the daughters. Both husbands and wives are responsible for domestic economic tasks.

Customs

In Khmer culture a person's head is believed to contain the persons soul--therefore making it taboo to touch or point your feet at it. It is also considered to be extremely disrespectful to point or sleep with your feet pointing at a person, as the feet are the lowest part of the body and are considered to be impure.

When greeting people or to show respect in Cambodia people do the "sampeah" gesture, identical to the Indian namaste and Thai wai

Sampeah (Cambodian greeting)

Customary Cambodian teachings include: that if a person does not wake up before sunrise he is lazy; you have to tell your parents or elders where you are going and what time you are coming back home; close doors gently, otherwise you have a bad temper; sit with your legs straight down and not crossed (crossing your legs shows that you are an impolite person); and always let other people talk more than you.

Clothing

Main article: Cambodian clothing

Clothing in Cambodia is one of the most important aspects of the culture. Cambodian fashion is divided by the people's differing castes and social classes. Cambodians traditionally wear a checkered scarf called a "Krama". The "krama" is what distinctly separates the Khmer (Cambodians) from their neighbors the Thai, the Vietnamese, and the Laotians. The scarf is used for many purposes including for style, protection from the sun, an aid (for your feet) when climbing trees, a hammock for infants, a towel, or as a "sarong". A "krama" can also be easily shaped into a small child's doll for play. Under the Khmer Rouge, krama of various patterns were part of standard clothing.

The long-popular traditional costume known as the *Sampot*, a Chinese-influenced costume which Cambodians wore since the Funan era, has lost popularity. However, Khmer People's clothing also changed depending on the time period and religion. From the Funan era back to the Angkor Era, there was a strong invasion of Hinduism which influenced Cambodian fashion to have upper naked, wear Sampot and wear their jewelry like bracelets and especially, collars like *Sarong Kor*, a symbol of Hinduism.

After the decrease in popularity of Hinduism, leading to Buddhism, Khmer people started wearing the blouse, shirt and trousers of Khmer style. Most important of all, Khmer people, both common and royal, stopped wearing the Hindu-style collars and began to adopt shawls like *Sbai* with beautiful decoration instead. This new clothing style was popular from the Chatomok region to Oudok period.

A Khmer lady habitually chooses the right colour for her Sampot or blouse, both to please herself and to follow the costume of good luck.

Some Cambodians still wear a religious style of clothing. Some Khmer men and women wear a Buddha pendant in a necklace fashion. There are different pendants for different uses; some are meant for protection from evil spirits, some are meant to bring good luck.

Otherwise, in the notable class people in Cambodia, especially the royal caste, have adapted a well known dress as well as expensive fashion style.*Sampot* is still well recognized among the royalty. Most royalty prefer *Sampot Phamung*, a new version of sampot adapted by Thai people in the 17th century. Since the Oudok period, most royalty have retained their dressing habits. Female royalty created the most attractive fashion. The lady always wears a traditional cape called *sbai* or *rabai kanorng*, which is draped over the left shoulder, leaving the right shoulder bare. Rarely was the cape worn over the right shoulder. The sbai or rabai kanorng would have been sumptuously fashioned in the old days in threads of genuine gold or silver. The cape in the old days would have hung down to the hem of the Sampot.

Dancers wear a collar known as *Sarong Kor* around their necks. Importantly, they wear a unique skirt called *Sampot sara-bhap* (lamé), made from silk inter-woven with gold or silver threads, forming elaborate and intricate designs that shimmer as the dancers move. This is held in place with a bejewelled belt. A multitude of jewellery is also worn by the female dancers. These include earrings, several pairs of bangles, a garland of flowers in the form of a bracelet, bracelets, anklets and an armlet that is worn on the right. Several body chains cross over the body like a sash. A circular or diamond shaped pendant is worn around the neck.

There are several different types of mokot worn by female royalty. The typical mokots that are worn are much similar to those of male royalty. Some crowns are just like tiaras where at the back of the mokot hair is let loose, cascading down the back. Other mokots have a few accessories such as ear pieces that would sit above the ear and help hold the mokot in place while a comb at the back is just an added accessory. Flowers are also worn on the mokot in the same style, but the hanging garlands of flowers are worn on the left and the bouquet is worn on the right. The best example of these royal clothes is illustrated by Khmer classical dance costumes, which are an adaptation of the beautiful royalty costume.

Cuisine

Main article: Cuisine of Cambodia

Khmer cuisine is similar to that of its Southeast Asian neighbors. It shares many similarities with Thai cuisine, Vietnamese cuisine and Teochew cuisine. Cambodian cuisine also uses fish sauce widely in soups, stir-fried cuisine, and as dippings. The Chinese legacy of Stir frying can be noted in the use of many variations of rice noodles; while Curry dishes known as *kari* (in Khmer, រប) that employ dried spices such as star anise, cardamom, cinnamon, nutmeg and fennel were borrowed from the Indians and

given a distinctive Cambodian twist with the addition of local ingredients like lemongrass, garlic, kaffir lime leaves, shallots and galangal. Pork broth rice noodle soup known simply as ka tieu (កុយទាវ) is one of Cambodia's popular dish. Also, *Banh Chiao* is the Khmer version of the Vietnamese *Bánh xèo*.

Khmer cuisine is noted for the use of prahok (ប្រហុក), a type of fermented fish paste, in many dishes as a distinctive flavoring. When prahok is not used, it is likely to be *kapĭ* (កាពិ) instead, a kind of fermented shrimp paste. Coconut milk is the main ingredient of many Khmer curries and desserts. In Cambodia there is regular aromatic rice and glutinous or sticky rice. The latter is used more in dessert dishes with fruits such as durian. Almost every meal is eaten with a bowl of rice. Typically, Cambodians eat their meals with at least three or four separate dishes. Each individual dish will usually be one of either sweet, sour, salty or bitter. Chili is usually left up to the individual to add themselves. In this way Cambodians ensure that they get a bit of every flavor to satisfy their palates.

Otherwise,Cuisine of Cambodians also become unique depend on some area of different ethnics.In Kampot and Kep, famous for its cuisine known Kampot Pepper Crab or *Kdab Cha Mrin Kyai* (ក្ដាមឆាម្រេចក្ដៅ) in khmer. With its name Kampot Pepper crab, this cuisine is mostly cooking with kampot famous crap fried with the pepper from pepper field in the area. While in Pailin, *Mee Kola* is was born in that place, create by Kula people who is one of ethnic groups in Cambodia.In southern Cambodia, most of Vietnamese cuisine had been found especially Bánh tráng which is so famous dish in southern Cambodia but just few people from Central, had ever eat this meals.Look forward to The area between Siem Reap to Kampong Thom, a village with full of Chinese Cambodian. A lot of delicious dishes from China in Khmer version explored for the guest in family as well as its urban restaurants.

Arts and literature

Visual art

Main articles: Visual arts of Cambodia and Khmer sculpture

The history of visual arts in Cambodia stretches back centuries to ancient crafts; Khmer art reached its peak during the Angkor period. Traditional Cambodian arts and crafts include textiles, non-textile weaving, silversmithing, stone carving, lacquerware, ceramics, wat murals, and kite-making. Beginning in the mid-20th century, a tradition of modern art began in Cambodia, though in the later 20th century both traditional and modern arts declined for several reasons, including the killing of artists by the Khmer Rouge. The country has experienced a recent artistic revival due to increased support from governments, NGOs, and foreign tourists.

Music

Main article: Music of Cambodia

Especially in the 60s and 70s, the 'big two' duet of Sinn Sisamouth and Ros Sereysothea had been a large hit in the country. However after their deaths, new music stars have tried to bring back the music. Cambodian music has undergone heavy Westernization.

The Cambodian pinpeat ensemble is traditionally heard on feast days in the pagodas. It is also a court ensemble used to accompany classical dance for ritual occasions or theatrical events. The pinpeat is primarily made up of percussion instruments: the roneat ek (lead xylophone), roneat thung (low bamboo xylophone), kong vong touch and kong vong thom (small and large sets of tuned gongs), sampho (two-sided drum), skor thom (two large drums), and sralai (quadruple-reed instrument).

Dance

Main article: Dance of Cambodia

Cambodian Dance can be divided into three main categories: classical dance, folk dances, and vernacular dances.

Khmer classical dance is a form of Cambodian dance originally performed only for royalty. The dances have many elements in common with Thai classical dance. During the mid-20th century, it was introduced to the public where it now remains a celebrated icon of Khmer culture, often being performed during public events, holidays, and for tourists visiting Cambodia.this classical Dance is famous for its using of hands and feet to express emotion which known as there are 4,000 different gestures in this type of dance. Provided as repeating a golden age in 1960s, Khmer Classical Dance which know as *The Royal Ballet of Cambodia* after select as UNESCO's Masterpieces of the Oral and Intangible Heritage of Humanity, has lead one of its dance to be a outstanding dance of all for culture and society. Reamker, a khmer version of Indian, Ramayana had influced strongly to Khmer classical dance. It involved in khmer gesture, movement and story line.The dance that divided from *Reamker Dance* known as *robam sovann macha* and *robam moni mekala*. In Facts, all of Dance reminded the audience of celestial dance which is an angel or Apsara in sansrit mythology in goal of bring the good luck and success to the viewer. The Classical dance is create by the heart of high art as the performer is decorated with themselves with a branches of jewellry.

Apsara Dance, a khmer dance that has survived since the Angkor Era, has been singled out to attract foreign tourists and to make the richness of khmer culture known to the world. Apsara Dance was promoted by Princess Norodom Bopha Devi before the Khmer Rouge times and recently has received an award as one of the main symbols of Cambodia.

Khmer folk dances, which are performed for audiences, are fast-paced. The movements and gestures are not as stylized as Khmer classical dance. Folk dancers wear clothes of the people they are portraying such as Chams, hill tribes, farmers, and peasants. The folk dance music is played by a

mahori orchestra.

Cambodian vernacular dances (or social dances) are those danced at social gatherings. Such dances include *ram vong, ram kbach, ram saravan,* and *lam leav.* Some of these dances have much influence from the traditional dances of Laos. But *rom kbach,* for example, take heavily from the classical dance of the royal court. Other social dances from around the world have had an impact on Cambodian social culture include the Cha-cha, Bolero, and the Madison.

Literature

Main article: Literature of Cambodia

A testimony of the antiquity of the Khmer language are the multitude of epigraphic inscriptions on stone. The first written proof that has allowed the history of the Khmer Kingdom to be reconstructed are those inscriptions. These writings on columns, stelae and walls throw light on the royal lineages, religious edicts, territorial conquests and internal organization of the kingdom.

Following the stone inscriptions, some of the oldest Khmer documents are translations and commentaries of the Pali Buddhist texts of the Tripitaka. They were written by the monks on palmyra palm leaves and kept in various monasteries throughout the country.

The **Ram Ker** (Rama's fame) is the Cambodian version of the Ramayana, the famous Indian epic. The Ram Ker comes in rhymed verses and is staged in sections that are adapted to dance movements interpreted by local artists. The Ram Ker is the oldest form of Cambodian theatre.

Cambodia had a rich and varied traditional oral literature. There are many legends, tales and songs of very ancient origin that were not put into writing until the arrival of the Europeans. One of the most representative of these tales was the story of Vorvong and Sorvong (Vorvong and Saurivong), a long story about two Khmer princes that was first put into writing by Auguste Pavie. This French civil servant claimed that he had obtained the story from old Uncle Nip in Somrontong District. This story was put into writing in Battambang. In 2006 the Vorvong and Sorvong story was enacted in dance form by the Royal Ballet of Cambodia.

Tum Teav which has been compared to a local version of Shakespeare's Romeo and Juliet, is a khmer famous literature,originally based on a poem written by a Khmer Monk named Sam. The story is took place during Lovek era, about tragic love story that has been told throughout Cambodia since at least the middle of the 19th century.The story has been portrayed in many forms including oral, historical, literary, theatre, and film adaptions. The story also have a role in Cambodia's education in the 12th grade as a topic for Khmer language examination for several times. Although its first translation in French had been made by Étienne Aymonier already in 1880, Tum Teav was popularized abroad when writer George Chigas translated the 1915 literary version by the venerable Buddhist monk Preah Botumthera Som or Padumatthera Som, known also as **Som**, one of the best writers in the Khmer language.

The notable people especially in royalty caste which in attraction and talented in khmer literature known as King Ang Duong (1841-1860) and King Thommaracha II (1629-1634). King Thomaracha had reserved for Khmer young generation with a well loved poem and a educated poem while King Ang Duong famous for his novel called *Kakey*, an inspiration from Jataka tales about an unfaithful woman and a female law which now become a notable law, used to teach the young khmer girl in some notable famil today.

Shadow Theatre

Nang sbek (shadow theatre) (or *Lkhaon Nang Sbek*; Khmer: ល្ខោនស្បែកធំ) is closely related to the Nang Yai of Thailand, Wayang of Malaysia and Indonesia like the Islands of Java and Bali, thus implying that nang sbek may have came from an Indonesian or Malaysian origin from many centuries ago. Nang sbek is also a dying art form and may disappear because of the decline in popularity over the years with the introduction of modern entertainment. Before the spread of modern technology such as movies, videos and television the Khmers enjoyed and watch shadow theatre apart from the other sources of entertainment available around during that time. There are three kinds of shadow theatre in Cambodia:

- **Nang sbek thom** is an art that involves mime, song, music and having to dance as well as narration to the accompaniment of the Pinpeat orchestra.It is mainly features the Reamker.
- **Nang sbek toch** also called *nang kalun* and sometimes called *ayang* (small shadow theatre) uses smaller puppets and a wide range of stories.
- **Sbek paor** (coloured puppet theatre) uses colored leather puppets.

Film

Main article: Cinema in Cambodia

Cinema in Cambodia began in the 1950s; King Norodom Sihanouk himself was an avid film enthusiast. Many films were being screened in theaters throughout the country by the 1960s, which are regarded as the "golden age". After a decline during the Khmer Rouge regime, competition from video and television has meant that the Cambodian film industry is relatively weak today.

Sports

Main article: Sport in Cambodia

Cambodia has increasingly become involved in sports over the last 30 years. Football is popular as are martial arts, including Bokator, Pradal Serey (Khmer kick boxing) and Khmer traditional wrestling.

Bokator is an ancient Khmer martial art said to be the predecessor of all Southeast Asian kickboxing styles. Depicted in bas reliefs at Angkor Wat, Bokator was the close quarter combat system used by the ancient Angkor army. Unlike kick boxing, which is a sport fighting art, Boxkator was a soldier's art, designed to be used on the battlefield. When fighting, Bokator practitioners still wear the uniforms of ancient Khmer armies. A kroma (scarf) is folded around their waist and blue and red silk cords are tied around the combatant's head and biceps.

Pradal Serey, or traditional Khmer boxing, is a popular sport in Cambodia. Victory is by knockout or by judge's decision. Styles of boxing have been practiced in Southeast Asia since ancient times. In the Angkor era, both armed and unarmed martial arts were practiced by the Khmers. Evidence shows that a style resembling Pradal Serey existed around the 9th century. There have been heated debates between nations about the true origins of South East Asian kickboxing.

Khmer traditional wrestling is yet another popular Cambodian sport. Wrestling match consists of three rounds, which may be won by forcing an opponent to his back. Traditional matches are held during the Khmer New Year and other Cambodian holidays.

The Cambodian Football Federation is the governing body of football in Cambodia, controlling the Cambodian national team. It was founded in 1933, and has been a member of FIFA since 1953 and the Asian Football Confederation since 1957.

Phnom Pehn National Olympic Stadium is the national stadium with a capacity of 50,000 in Phnom Pehn.

See also

* Ministry of Culture and Fine Arts, Cambodia

External links

* Cambodia Cultural Profile (Ministry of Culture and Fine Arts/Visiting Arts) [1]
* Center For Khmer Studies [2]
* Khmer Renaissance [3]
* Culture Kampot pepper [4]

1. REDIRECT Template:Navboxes

Visual arts of Cambodia

The history of **visual arts in Cambodia** stretches back centuries to ancient crafts. Traditional Cambodian arts and crafts include textiles, non-textile weaving, silversmithing, stone carving, lacquerware, ceramics, wat murals, and kite-making. Beginning in the mid-20th century, a tradition of modern art began in Cambodia, though in the later 20th century both traditional and modern arts declined for several reasons, including the killing of artists by the Khmer Rouge. The country has experienced a recent artistic revival due to increased support from governments, NGOs, and foreign tourists.

History

The history of Cambodian art stretches back centuries to ancient pottery, silk weaving, and stone carving. The height of Khmer art occurred during the Angkor period; much of the era's stone carving and architecture survives to the present. In pre-colonial Cambodia, art and crafts were generally produced either by rural non-specialists for practical use or by skilled artists producing works for the Royal Palace. In modern Cambodia, many artistic traditions entered a period of decline or even ceased to be practiced, but the country has experienced a recent artistic revival as the tourist market has increased and governments and NGOs have contributed to the preservation of Cambodian culture.

Further information: http:/ / www. culturalprofiles. net/ cambodia/ Directories/ Cambodia_Cultural_Profile/-1820.html

Traditional visual arts

Textiles

Silk weaving in Cambodia has a long history. The practice dates to as early as the first century, and textiles were used in trade during Angkorian times. Even modern textile production evidences these historic antecedents: motifs found on silk today often echo clothing details on ancient stone sculptures.

There are two main types of Cambodian weaving. The ikat technique (Khmer: *chong kiet*), which produces patterned fabric, is quite complex. To create patterns, weavers tie and dye portions of weft yarn before weaving begins. Patterns are diverse and vary by region; common motifs include lattice, stars, and spots. The second weaving technique, unique to Cambodia, is called "uneven twill". It yields single or two-color fabrics, which are produced by weaving three threads so that the "color of one thread dominates on one side of the fabric, while the two others determine the colour on the reverse side." Traditionally, Cambodian textiles have employed natural dyes. Red dye comes from lac insect nests, blue dye from indigo, yellow and green dye from prohut bark, and black dye from ebony bark.

Cambodia's modern silk-weaving centers are Takeo, Battambang, Beanteay Meanchey, Siem Reap and Kampot provinces. Silk-weaving has seen a major revival recently, with production doubling over the past ten years. This has provided employment for many rural women. Cambodian silk is generally sold domestically, where it is used in *sampot* (wrap skirts), furnishings, and *pidan* (pictoral tapestries), but interest in international trade is increasing.

Cotton textiles have also played a significant role in Cambodian culture. Though today Cambodia imports most of its cotton, traditionally woven cotton remains popular. Rural women often weave homemade cotton fabric, which is used in garments and for household purposes. Krama, the traditional check scarves worn almost universally by Cambodians, are made of cotton.

Non-textile weaving

Many Cambodian farmers weave baskets (Khmer: tbanh kantrak) for household use or as a supplemental source of income. Most baskets are many of thinly cut bamboo. Regions known for basketry include Siem Reap and Kampong Cham. Mat weaving (tbanh kantuel) is a common seasonal occupation. They are most commonly made from reeds, either left a natural tan color or dyed in deep jewel tones. The region of Cambodia best-known for mat weaving is the Mekong floodplain, especially around Lvea Em district. Mats are commonly laid out for guests and are important building materials for homes. Wicker and rattan crafts (tbanh kanchoeu) made from dryandra trees are also significant. Common wicker and rattan products include walls, mats, furniture, and other household items.

Stone carving

See also: Khmer sculpture

Cambodia's best-known stone carving adorns the temples of Angkor, which are "renowned for the scale, richness and detail of their sculpture". In modern times, however, the art of stone carving became rare, largely because older sculptures survived undamaged for centuries (eliminating the need for replacements) and because of the use of cement molds for modern temple architecture. By the 1970s and 1980s, the craft of stone carving was nearly lost.

During the late 20th century, however, efforts to restore Angkor resulted in a new demand for skilled stone carvers to replace missing or damaged pieces, and a new tradition of stone carving is arising to meet this need. Most modern carving is traditional-style, but some carvers are experimenting with contemporary designs. Interest is also renewing for using stone carving in modern wats. Modern carvings are typically made from Banteay Meanchey sandstone, though stone from Pursat and Kompong Thom is also used.

Lacquerware

The height of Cambodian traditional lacquerware was between the 12th and 16th centuries; some examples of work from this era, including gilded Buddha images and betel boxes, have survived to the present day. Lacquerware was traditionally colored black using burnt wood, representing the underworld; red using mercury, representing the earth; and yellow using arsenic, representing the heavens. Lacquer on Angkorian stone dates to the 15th or 16 century.

In modern Cambodia, the art of lacquerwork nearly faded into oblivion: few lacquer trees survived, and lacquer was unavailable in local markets. Today's revival is still in its infancy, but 100 lacquer artists have been trained by a French expert under the guidance of Artisans d'Angkor, a company that produces traditional crafts in village workshops. Some artists are "beginning to experiment with different techniques and styles...to produce modern and striking effects."

Silversmithing

Silversmithing in Cambodia dates back centuries. The Royal Palace traditionally patronized silversmiths' workshops, and silversmiths remain concentrated at Kompong Luong, near the former royal capital Oudong. Silver was made into a variety of items, including weaponry, coins, ceremonial objects used in funerary and religious rituals, and betel boxes. During Cambodia's colonial period, artisans at the School of Fine Art produced celebrated silverwork, and by the late 1930s there were more than 600 silversmiths. Today, silverwork is popular for boxes, jewellery, and souvenir items; these are often adorned with fruit, fire, and Angkor-inspired motifs. Men produce most of the forms for such work, but women often complete the intricate filigree.

Ceramics

Cambodian pottery traditions date to 5000 BCE. Ceramics were mostly used for domestic purposes such as holding food and water. There is no evidence that Khmer ceramics were ever exported, though ceramics were imported from elsewhere in Asia beginning in the 10th century. Ceramics in the shape of birds, elephants, rabbits, and other animals were popular between the 11th and 13th centuries.

Potting traditionally was done either on a pottery wheel or using shaping tools such as paddles and anvils. Firing was done in clay kilns, which could reach temperatures of 1,000–1,200 °C, or in the open air, at temperatures of around 700 °C. Primarily green and brown glazes were used. In rural Cambodia, traditional pottery methods remained. Many pieces are hand-turned and fired on an open fire without glaze. The country's major center for pottery is Kompong Chhnang Province.

In modern Cambodia, the art of glazed ceramics faded into oblivion: the technique of stoneware stop to be used around 14th century, at the end of Angkor era. Today this technique begin a slow revival through a Belgian ceramist who founded the Khmer Ceramics Revival Center, in Siem Reap, the organization lead vocational training and researches about this lost skill.

Wat murals

Because of destruction during recent war, few historic wat murals remain in Cambodia. In the 1960s, art historians Guy and Jacqueline Nafilyan photographed 19th-century murals, providing a record of this lost cultural heritage. The best known surviving murals are at the Silver Pagoda in Phnom Penh, Wat Rajabo in Siem Reap province, and Wat Kompong Tralach Leu in Kompong Chhnang Province. In the last decade, wat murals have seen a resurgence, but Cambodia's surviving older murals are generally more refined and detailed.

Also, a Stegosaurus is depicted in a little picture on the Angkor Wat. There has been speculation about Stegosaurus being known in Cambodian mythology. According to one story, Vishnu actually fought a creature that is said to have a spiked tail, plates on its back, an elephant shaped body, and a little head when it was attacking a little village. Stegosaurus seems to fit this description, but dinosaurs went extinct millions of years ago, suggesting that Vishnu actually fought a surviving Stegosaurus from the Jurassic period. Most people discount this information as a fake, as some people believe that Vishnu may have actually fought a weird-looking serpent.

Masks

See http:/ / www. culturalprofiles. net/ cambodia/ Directories/ Cambodia_Cultural_Profile/ -1831.html

Kites

Cambodia's kite-making and kite-flying tradition, which dates back many centuries, was revived in the early 1990s and is now extremely popular throughout the country. Kites (Khmer: khleng ek) are generally flown at night during the northeast monsoon season. A bow attached to the kites resonates in the wind, producing a musical sound.

Modern and contemporary visual arts

Cambodia's tradition of modern (representational) drawing, painting, and sculpture was established in the late 1940s at the School of Cambodian Arts (later called the University of Fine Arts), where it occupied occupied much of the school's curriculum a decade later. These developments were supported by the government, which encouraged new areas of specialization (e.g. design and modern painting) at the school and purchased modern art for the Prime Minister's residences and for government buildings. Galleries opened in Phnom Penh during the 1960s, and cultural centers hosted exhibitions of modern paintings and provided art libraries. One important painter of the 1960s was Nhek Dim; he has become the painter of reference for modern painters. During the subsequent Khmer Rouge era, many artists were killed and art production nearly ceased.

After the fall of the Khmer Rouge, artists and professors returned the University of Fine Arts to rebuild arts training. Socialist Bloc governments sponsored the education of young art students in Poland, Bulgaria, the former Soviet Union, and Hungary during the late 1980s and early 1990s. Other local efforts aimed to re-establish workshops, collect documents, and preserve traditional knowledge.

Though several galleries present changing exhibitions in Phnom Penh, the vast majority of artists cannot support themselves through exhibitions and sales of modern work. Artists generally earn income from Angkor-inspired art for tourists or from painting commercial signs and large reproductions that in the West would be mechanically produced.

Several broad schools of art exist among modern Cambodian artists. Some artists, including Som Samai (a silversmith), An Sok (a mask-maker), and Chet Chan (a painter) follow colonial traditions to produce traditional Khmer art. Chhim Sothy's work is also derived from these traditions. Many young artists who studied abroad in the 1980s, including Phy Chan Than, Soeung Vannara, Long Sophea, and Prom Sam An, have presented a modern Khmer art forms combining subjects from Khmer art with Western modernism. Other notable Cambodian artists include Leang Seckon, Pich Sopheap, Svay Ken, Asasax, Chhan Dina, Lam Soeung, and Chhorn Bun Son. During the 1990s, Cambodia saw the return of many members of the Khmer diaspora, including several internationally recognized artists. Among these are Marine Ky and Chath Piersath.

Works cited

- Visiting Arts [1] & the Ministry of Culture and Fine Arts of Cambodia. (September 18, 2005). "Cambodia Cultural Profile" [2]. Culturalprofiles.net. Retrieved 2008-02-21.

Khmer sculpture

Khmer sculpture refers to the stone sculpture of the Khmer Empire, which ruled a territory based on modern Cambodia, but rather larger, from the 9th to the 13th century. The most celebrated examples are found in Angkor, which served as the seat of the empire.

Movement away from Indian models

By the 7th century, Khmer sculpture begins to drift away from its Hindu influences – pre-Gupta for the Buddhist figures, Pallava for the Hindu figures – and through constant stylistic evolution, it comes to develop its own originality, which by the 10th century can be considered complete and absolute. Khmer sculpture soon goes beyond religious representation, which becomes almost a pretext in order to portray court figures in the guise of gods and goddesses. But furthermore, it also comes to constitute a means and end in itself for the execution of stylistic refinement, like a kind of testing ground. We have already seen how the social context of the Khmer kingdom provides a second key to understanding this art. But we can also imagine that on a more exclusive level, small groups of intellectuals and artists were at work, competing among themselves in mastery and refinement as they pursued a hypothetical perfection of style.

The gods we find in Khmer sculpture are those of the two great religions of India, Buddhism and Hinduism. And they are always represented with great iconographic precision, clearly indicating that learned priests supervised the execution of the works. Nonetheless, unlike those Hindu images which repeat an idealized stereotype, these images are treated with great realism and originality because they depict living models: the king and his court. The true social function of Khmer art was, in fact, the glorification of the aristocracy through these images of the gods embodied in the princes. In fact, the cult of the "deva-raja" required the development of an eminently aristocratic art in which the people were supposed to see the tangible proof of the sovereign's divinity, while the aristocracy took pleasure in seeing itself – if, it's true, in idealized form – immortalized in the splendour of intricate adornments, elegant dresses and extravagant jewelry.

The sculptures are admirable images of a gods, royal and imposing presences, though not without feminine sensuality, makes us think of important persons at the courts, persons of considerable power. The artists who sculpted the stones doubtless satisfied the primary objectives and requisites demanded by the persons who commissioned them. The sculptures represent the chosen divinity in the orthodox manner and succeeds in portraying, with great skill and expertise, high figures of the courts in all of their splendour, in the attire, adornments and jewelry of a sophisticated beauty.

But if we go beyond this initial impression, we can pause to observe some of the details of the sculptures, such as the double arc drawn by the eyebrows on the foreheads, evoked below by the wisely sketched curve of the noses and further down, by the double arc which masterfully outlines the lips and

the double chin. Following a hypothetical vertical line down still further, we find another double arc outlining the breasts, and then, continuing down from the waist all along the skirts and ending in the ankles, we find almost at the bottom, a twisted double arc intended to represent the other side of the skirts. This detail serves, above all, to eliminate a certain hieratic fixedness, which was relatively common in the Khmer statues of lesser quality.

Archeological exploration

Ever since 1864, when France established a Protectorate in Cambodia, Western travellers have been amazed by the impressive ruins of Angkor. Not long after, once the École française d'Extrême-Orient began to study and catalogue the findings made at the excavations, the growing number of scholars from all around the world, art lovers and admirers of this sculpture, became fervent proponents of Khmer Art.

"Khmer Art, captivating in its civility, refinement and delight, open to all forms of life, is made in the image of the country and its inhabitants. Nevertheless, among the arts of the Far East, few are as accessible to the Western temperament. Its profound beauty impresses itself upon the spirit and sensibility without requiring prior study. Its sobriety, its horror of excess and its sense of balance and harmony allow it to attain universal value." Thus wrote Madeleine Giteau, the distinguished member of the École française d'Extrême-Orient, in the introduction to her book Les Khmers in 1965.

Currently, the largest museums of the West dedicate entire halls to Khmer sculpture, not to mention the enormous exhibition which took place first at the Galeries Nationales du Grand Palais in Paris and later at the National Gallery of Art in Washington in 1997.

See also

- Architecture of Cambodia
- Angkor Wat
- Khmer Empire
- Angkor
- Sculpture
- Eastern art history
- Culture of Cambodia
- Visual arts of Cambodia

References

Published references:

La espiritualidad del vacio, Khmer sculpture exhibition catalogue, Professor Matthias Barmann, Obrasocial Bancaja, Valencia, Spain.

- Lord Umagangapatisvara [1] Annette L. Heitmann, Published: November 21, 2005. Asian Art.
- A Cambodian Masterpiece restored [2] Jennifer Casler, September 2007. Apollo Magazine.
- Khmer Art [3] Doctor Heiner Hachmeister, Hachmeister Galerie, Munich, Germany.
- Les Khmers, Sculptures Khmeres, reflets de la civilisation d'Angkor, Fribourg, Office du Livre. Madeleine Giteau, 1965.

External links

- Khmer Sculpture of Angkor and Ancient Cambodia [4] Millennium of Glory, National Gallery of Art, Washington DC.
- Sacred Angkor [5] Sushama Londhe, Hindu Wisdom, A tribute to Hinduism.
- Asia Society [6] Museum, Southeast Asia, John D. Rockefeller 3rd Collection, New York.
- Angkor [7] A Khmer Empire, Angkor Empire.

Chinese Art

Chinese art

Chinese art (Chinese: 中國藝術/中国艺术) has varied throughout its ancient history, divided into periods by the ruling dynasties of China and changing technology. Different forms of art have been influenced by great philosophers, teachers, religious figures and even political leaders. Chinese art encompasses fine arts, folk arts and performance arts.

Chinese Jade ornament with flower design, Jin Dynasty (1115-1234 AD), Shanghai Museum.

History of the Art

Main article: History of Chinese art

Early forms of art in China were made from pottery and jade in the Neolithic period, to which was added bronze in the Shang Dynasty. The Shang are most remembered for their blue casting, noted for its clarity of detail. Early Chinese music and poetry was influenced by the *Book of Songs*, Confucius and the Chinese poet and statesman Qu Yuan.

In early imperial China, porcelain was introduced and was refined to the point that in English the word *china* has become synonymous with high-quality porcelain. Around the 1st century AD, Buddhism arrived in China, though it did not become popular until the 4th century. At this point, Chinese Buddhist art began to flourish, a process which continued through the 20th century. It was during the period of Imperial China that calligraphy and painting became highly appreciated arts in court circles, with a great deal of work done on silk until well after the invention of paper.

A statue of a Bodhisattva from the Song Dynasty (960-1279 AD).

Buddhist architecture and sculpture thrived in the Sui and Tang dynasty. Of which, the Tang Dynasty was particularly open to foreign influence. Buddhist sculpture returned to a classical form, inspired by Indian art of the Gupta period. Towards the late Tang dynasty, all foreign religions were outlawed to support Taoism.

In the Song Dynasty, poetry was marked by a lyric poetry known as Ci (詞) which expressed feelings of desire, often in an adopted persona. Also in the Song dynasty, paintings of

Chinese variety art, also known in the west as "Chinese circus"

more subtle expression of landscapes appeared, with blurred outlines and mountain contours which conveyed distance through an impressionistic treatment of natural phenomena. It was during this period that in painting, emphasis was placed on spiritual rather than emotional elements, as in the previous period. Kunqu, one of the oldest extant forms of Chinese opera developed during the Song Dynasty in Kunshan, near present-day Shanghai. In the Yuan dynasty, painting by the Chinese painter Zhao Mengfu (趙孟頫) greatly influenced later Chinese landscape painting, and the Yuan dynasty opera became a variant of Chinese opera which continues today in examples such as Cantonese opera.

Late imperial China was marked by two specific dynasties: Ming and Qing. Of Ming Dynasty poetry, Gao Qi was acknowledged as the most popular poet of the era. Artwork in the Ming dynasty perfected

color painting and color printing, with a wider color range and busier compositions than Song paintings. In the Qing dynasty, Beijing opera was introduced; it is considered the one of the best-known forms of Chinese opera. Qing poetry was marked by a poet named Yuan Mei whose poetry has been described as having "unusually clear and elegant language" and who stressed the importance of personal feeling and technical perfection. Under efforts of masters from the Shanghai School during the late Qing Dynasty, traditional Chinese art reached another climax and continued to the present in forms of the "Chinese painting" (*guohua*, 國畫). The Shanghai School challenged and broke the literati tradition of Chinese art, while also paying technical homage to the ancient masters and improving on existing traditional techniques.

Contemporary

New forms of Chinese art were heavily influenced by the New Culture Movement, which adopted Western techniques and employed socialist realism. The Cultural Revolution would shape Chinese art in the 20th century like no other event in history with the Four Olds destruction campaign. Contemporary Chinese artists continue to produce a wide range of experimental works, multimedia installations, and performance "happenings" which have become very popular in the international art market.

Art market

Today, the market of Chinese art is widely reported to be among the hottest and fastest-growing in the world, attracting buyers all over the world. The *Voice of America* reported in 2006 that Modern Chinese art is raking in record prices both internationally and in domestic markets, some experts even fearing the market might be overheating. *The Economist* reported that Chinese art has become the latest darling in the world market according to the record sales from Sotheby's and Christie's, the biggest fine-art auction houses. The *International Herald Tribune* reported that Chinese porcelains were fought over in the art market as "if there was no tomorrow". A 14th century porcelain vase was easily sold by the Christie's with a staggering £15.68 million. In terms of buying-market, China recently overtook France becoming the world's third-largest art market, after the United States and the United Kingdom, due to the growing middle-class in the country. Sotheby's noted that Contemporary Chinese art has rapidly changed the Contemporary Asian art world into one of the most dynamic sectors on the international art market. Recently, because of the global economic crisis, the Contemporary Asian art market and the Contemporary Chinese art market, is experiencing a slow down. The market for Contemporary Chinese and Asian art saw a major revival in late 2009 with record level sales at Christie's. For centuries largely made-up of European and American buyers, the international buying market for Chinese art has also began to be dominated by Chinese dealers and collectors in recent years.

Types

hese dragon sculpture

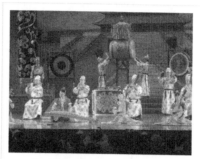

Traditional style Chinese concert
performance in China

Art type	Main art	Major category	Start era
Chinese folk art	Paper cutting	Chinese paper cutting	Eastern Han Dynasty
		Chinese paper folding	Eastern Han Dynasty
	Puppetry	Glove puppetry	
		Chinese shadow theatre	Han Dynasty
	Handicraft	Chinese knot	Tang Dynasty
Literature	Chinese literature	Chinese classic texts	Spring and Autumn Period
		Chinese poetry	Spring and Autumn Period
		Chinese historiography	Spring and Autumn Period
		Chinese dictionary	Zhou Dynasty

Visual art	Pottery	Chinese ceramics	Palaeolithic
	Embroidery	Chinese embroidery	Neolithic
	Chinese painting	Ming Dynasty painting	Ming Dynasty
		Tang Dynasty painting	Tang Dynasty
		Ink and wash painting	Tang Dynasty
		Shan Shui painting	Song Dynasty
	Photography		
	East Asian calligraphy	Oracle bone script	Shang Dynasty
		Cursive script	Han Dynasty
		Drawing Daoist Talismans	Tang Dynasty
	Comics	Lianhuanhua	1880s
		Manhua	1880s, termed in 1920s
Film	Cinema of China		1890s
	Chinese animation		1920s
Chinese music	Traditional	Instrumental	Zhou Dynasty
		Yayue	Western Zhou Dynasty
	Modern	National music	1910s
		C-pop	1920s
		Chinese rock	1980s
Performing arts	Variety art	Chinese variety art	Han Dynasty
	Chinese opera	Beijing opera	
		Kunqu	
		Cantonese opera	
	Theatre	Xiangsheng	Ming Dynasty
	Shuochang narrative	Quyi	Dynastic times, termed in 1940s
	Dances	Dragon Dance	
		Lion Dance	
Architecture	Landscape architecture	Chinese architecture	
Gardening	Chinese Garden	Scholar's Garden	Zhou Dynasty
	Bonsai	Penjing	

See also

- Culture of China
- Culture of Hong Kong
- Longmen Grottoes
- Four Olds
- Eastern art history

Further reading

- Lee Yuan-Yuan and Shen, Sinyan. *Chinese Musical Instruments (Chinese Music Monograph Series)*. 1999. Chinese Music Society of North America Press. ISBN 1-880464039
- Shen, Sinyan. *China: A Journey into Its Musical Art (Chinese Music Monograph Series)*. 2001. Chinese Music Society of North America Press. ISBN 1-880464071
- Shen, Sinyan. *Chinese Music in the 20th Century (Chinese Music Monograph Series)*. 2001. Chinese Music Society of North America Press. ISBN 1-880464047
- Watson, W., *The Arts of China to AD 1900* (Yale University Press, 1995).

External links

- Chinese Art and Galleries [1] at China Online Museum
- Famous Chinese Painters and their Galleries [1] at China Online Museum
- Chinese Sumi-e by Artist Sheng Kuan Chung [2]
- 88 mocca - The Museum of Chinese Contemporary Art on the web [3]
- ShangART Gallery Shanghai [4]
- The Saatchi Gallery [5]
- Yan Gallery - Modern and Chinese Contemporary Art [6]
- Chinese Contemporary Art [7]
- Portraits paintings - Picture [8]
- Chinese Calligraphy, Visual Art [9]
- News on contemporary Chinese art, artists, market, etc. (via China Digital Times) [10]
- "Looking Back on the History of Chinese Contemporary Art" in *Fillip* [11]
- The Herbert Offen Research Collection of the Phillips Library at the Peabody Essex Museum [2]
- Exclusive. Chinese. Art. [12]
- 20th Century Chinese Paintings - Canadian Museum of civilization [13]

Chinese painting

Chinese painting is one of the oldest continuous artistic traditions in the world. The earliest paintings were not representational but ornamental; they consisted of patterns or designs rather than pictures. Stone Age pottery was painted with spirals, zigzags, dots, or animals. It was only during the Warring States Period (403-221 B.C.) that artists began to represent the world around them.

Painting in the traditional style is known today in Chinese as *guó huà* 国画, meaning 'national' or 'native painting', as opposed to Western styles of art which became popular in China in the 20th century. Traditional painting involves essentially the same techniques as calligraphy and is done with a brush dipped in black or colored ink; oils are not used. As with calligraphy, the most popular materials on which paintings are made of are paper and silk. The finished work is then mounted on scrolls, which can be hung or rolled up. Traditional painting also is done in albums and on walls, lacquerwork, and other media.

The two main techniques in Chinese painting are:

- Meticulous - Gong-bi (工筆) often referred to as "court-style" painting
- Freehand - Shui-mo (水墨) loosely termed watercolour or brush painting. The Chinese character "mo" means ink and "shui" means water. This style is also referred to as "xie yi" (寫意) or freehand style.

Artists from the Han (202 BC) to the Tang (618–906) dynasties mainly painted the human figure. Much of what we know of early Chinese figure painting comes from burial sites, where paintings were preserved on silk banners, lacquered objects, and tomb walls. Many early tomb paintings were meant to protect the dead or help their souls get to paradise. Others illustrated the teachings of the Chinese philosopher Confucius, or showed scenes of daily life.

Many critics consider landscape to be the highest form of Chinese painting. The time from the Five Dynasties period to the Northern Song period (907–1127) is known as the "Great age of Chinese landscape". In the north, artists such as Jing Hao, Fan Kuan, and Guo Xi painted pictures of towering mountains, using strong black lines, ink wash, and sharp, dotted brushstrokes to suggest rough stone. In the south, Dong Yuan, Juran, and other artists painted the rolling hills and rivers of their native countryside in peaceful scenes done with softer, rubbed brushwork. These two kinds of scenes and techniques became the classical styles of Chinese landscape painting.

Early Imperial China (221 BC–AD 220)

In imperial times (beginning with the Eastern Jin Dynasty), painting and calligraphy in China were the most highly appreciated arts in court circles and were produced almost exclusively by amateurs—aristocrats and scholar-officials—who had the leisure time necessary to perfect the technique and sensibility necessary for great brushwork. Calligraphy was thought to be the highest and

purest form of painting. The implements were the brush pen, made of animal hair, and black inks made from pine soot and animal glue. In ancient times, writing, as well as painting, was done on silk. However, after the invention of paper in the 1st century CE, silk was gradually replaced by the new and cheaper material. Original writings by famous calligraphers have been greatly valued throughout China's history and are mounted on scrolls and hung on walls in the same way that paintings are.

Period of division (220–581)

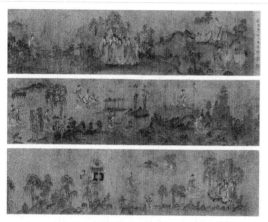

Luoshenfu by Gu Kaizhi (344-406 AD)

During the Six Dynasties period (220–589), people began to appreciate painting for its own beauty and to write about art. From this time we begin to know about individual artists, such as Gu Kaizhi. Even when these artists illustrated Confucian moral themes – such as the proper behavior of a wife to her husband or of children to their parents – they tried to make the figures graceful.

Six principles

The "Six principles of Chinese painting" were established by Xie He, a writer, art historian and critic in 5th century China. He is most famous for his "Six points to consider when judging a painting" (绘画六法, Pinyin:Huìhuà Liùfǎ), taken from the preface to his book "The Record of the Classification of Old Painters" (古画品录; Pinyin: Gǔhuà Pǐnlù). Keep in mind that this was written circa 550 A.D. and refers to "old" and "ancient" practices. The six elements that define a painting are:

1. "Spirit Resonance", or vitality, and seems to translate to the nervous energy transmitted from the artist into the work. The overall energy of a work of art. Xie He said that without Spirit Resonance, there was no need to look further.
2. "Bone Method", or the way of using the brush. This refers not only to texture and brush stroke, but to the close link between handwriting and personality. In his day, the art of calligraphy was inseparable from painting.
3. "Correspondence to the Object", or the depicting of form, which would include shape and line.

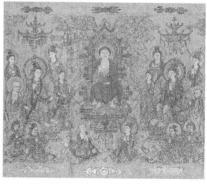

The Sakyamuni Buddha, by Zhang Shengwen, 1173-1176 AD, Song Dynasty.

4. "Suitability to Type", or the application of color, including layers, value and tone.

5. "Division and Planning", or placing and arrangement, corresponding to composition, space and depth.

6. "Transmission by Copying", or the copying of models, not only from life but also the works of antiquity.

Sui and Tang dynasties (581–960)

Further information: Tang Dynasty painting

During the Tang Dynasty, figure painting flourished at the royal court. Artists such as Zhou Fang showed the splendor of court life in paintings of emperors, palace ladies, and imperial horses. Figure painting reached the height of elegant realism in the art of the court of Southern Tang (937-975).

Most of the Tang artists outlined figures with fine black lines and used brilliant color and elaborate detail. However, one Tang artist, the master Wu Daozi, used only black ink and freely painted brushstrokes to create ink paintings that were so exciting that crowds gathered to watch him work. From his time on, ink paintings were no longer thought to be preliminary sketches or outlines to be filled in with color. Instead they were valued as finished works of art.

Beginning in the Tang Dynasty, many paintings were landscapes, often *shanshui* (山水, "mountain water") paintings. In these landscapes, monochromatic and sparse (a style that is collectively called *shuimohua*), the purpose was not to reproduce exactly the appearance of nature (realism) but rather to grasp an emotion or atmosphere so as to catch the "rhythm" of nature.

Song and Yuan dynasties (960–1368)

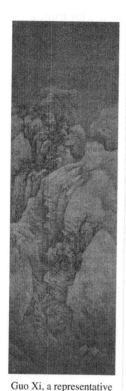

Guo Xi, a representative painter of landscape painting in the Northern Song dynasty, has been well known for depicting mountains, rivers and forests in winter. This piece shows a scene of deep and serene mountain valley covered with snow and several old trees struggling to survive on precipitous cliffs. It is a masterpiece of Guo Xi by using light ink and magnificent composition to express his open and high artistic conception.

In the Song Dynasty period (960–1279), landscapes of more subtle expression appeared; immeasurable distances were conveyed through the use of blurred outlines, mountain contours disappearing into the mist, and impressionistic treatment of natural phenomena. Emphasis was placed on the spiritual qualities of the painting and on the ability of the artist to reveal the inner harmony of man and nature, as perceived according to Taoist and Buddhist concepts. One of the most famous artists of the period was Zhang Zeduan, painter of Along the River During the Qingming Festival. Yi Yuanji achieved a high degree of realism painting animals, in particular monkeys and gibbons.

During the Southern Song period (1127–1279), court painters such as Ma Yuan and Xia Gui used strong black brushstrokes to sketch trees and rocks and pale washes to suggest misty space.

While many Chinese artists were attempting to represent three-dimensional objects and to master the illusion of space, another group of painters pursued very different goals. At the end of Northern Song period, the poet Su Shi and the scholar-officials in his circle became serious amateur painters. They created a new kind of art in which they used their skills in calligraphy (the art of beautiful writing) to make ink paintings. From their time onward, many painters strove to freely express their feelings and to capture the inner spirit of their subject instead of describing its outward appearance.

During the Mongolian Yuan Dynasty (1279–1368), painters joined the arts of painting, poetry, and calligraphy by inscribing poems on their paintings. These three arts worked together to express the artist's feelings more completely than one art could do alone. Even so, Mongol Khagan Tugh Temur (r.1328,1329–1332) was very fond of this culture.

Late imperial China (1368–1895)

Beginning in the 13th century, the tradition of painting simple subjects—a branch with fruit, a few flowers, or one or two horses—developed. Narrative painting, with a wider color range and a much busier composition than Song paintings, was immensely popular during the Ming period (1368–1644).

The first books illustrated with colored woodcuts appeared around this time; as color-printing techniques were perfected, illustrated manuals on the art of painting began to be published. *Jieziyuan Huazhuan (Manual of the Mustard Seed Garden)*, a five-volume work first published in 1679, has been in use as a technical textbook for artists and students ever since.

Some painters of the Ming dynasty (1368–1644) continued the traditions of the Yuan scholar-painters. This group of painters, known as the Wu School, was led by the artist Shen Zhou. Another group of painters, known as the Zhe School, revived and transformed the styles of the Song court.

During the early Qing Dynasty (1644–1911), painters known as Individualists rebelled against many of the traditional rules of painting and found ways to express themselves more directly through free brushwork. In the 18th and 19th centuries, great commercial cities such as Yangzhou and Shanghai became art centers where wealthy merchant-patrons encouraged artists to produce bold new works.

In the late 19th and 20th centuries, Chinese painters were increasingly exposed to Western art. Some artists who studied in Europe rejected Chinese painting; others tried to combine the best of both traditions. Perhaps the most beloved modern painter was Qi Baishi, who began life as a poor peasant and became a great master. His best known works depict flowers and small animals.

Modern painting

Beginning with the New Culture Movement, Chinese artists started to adopt using Western techniques.

In the early years of the People's Republic of China, artists were encouraged to employ socialist realism. Some Soviet Union socialist realism was imported without modification, and painters were assigned subjects and expected to mass-produce paintings. This regimen was considerably relaxed in 1953, and after the Hundred Flowers Campaign of 1956-57, traditional Chinese painting experienced a significant revival. Along with these developments in professional art circles, there was a proliferation of peasant art depicting everyday life in the rural areas on wall murals and in open-air painting exhibitions.

During the Cultural Revolution, art schools were closed, and publication of art journals and major art exhibitions ceased. Major destruction was also carried out as part of the elimination of Four Olds campaign.

Since 1978

Following the Cultural Revolution, art schools and professional organizations were reinstated. Exchanges were set up with groups of foreign artists, and Chinese artists began to experiment with new subjects and techniques. One particular case of freehand style (xieyi hua) may be noted in the work of the child prodigy Wang Yani -born 1975- who started painting at age 3 and has since considerably contributed to the exercise of the style in contemporary artwork.

See also

- Bird-and-flower painting
- Chinese art
- Chinese Piling paintings
- Eastern art history
- History of Chinese art
- History of painting
- Ink and wash painting
- Lin Tinggui
- List of Chinese painters
- Ming Dynasty painting
- Qiu Ying
- Shan Shui painting
- Mu Qi

Further reading

- Siren, O., *A History of Later Chinese Painting* - 2 vols. (Medici Society, London, 1937).

External links

- Chinese Painting and Galleries [1] at China Online Museum
- Famous Chinese Painters and their Galleries [1] at China Online Museum
- Chinese Paintings and Arts Gallery with Classifieds and Auction features [2]
- Gallery featuring ancient Chinese paintings and calligraphy from Eastern Chin dynasty (AD 317) to the 20th Century [3]
- A Gallery of Classical Chinese Paintings [4]
- Chinese Painting Articles [5]
- Famous Chinese Painting Reproductions [6], famous Chinese gongbi paintings reproduced by Chinese artist Cao Xiaohui.
- Traditional Chinese Paintings [7]

- Chinese paintings with cats throughout the centuries at the National Palace Museum, Taipei, Taiwan [8]
- Gallery of China Traditional Chinese Art [9]

Chinese ceramics

Chinese ceramic ware is an artform that has been developing since the dynastic periods. China is richly endowed with the raw materials needed for making ceramics. The first types of ceramics were made about 11,000 years ago, during the Palaeolithic era. Chinese Ceramics range from construction materials such as bricks and tiles, to hand-built pottery vessels fired in bonfires or kilns, to the sophisticated porcelain wares made for the imperial court.

Introduction

Terminology and categories

Porcelain "it is a collective term comprising all ceramic ware that is white and translucent, no matter what ingredients are used to make it or to what use it is put." The Chinese tradition recognizes two primary categories

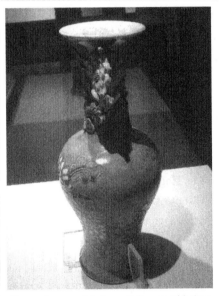

Chrysanthemum styled porcelain vase with three colors from the Ming Dynasty (1368-1644 AD) at the National Museum of China

of ceramics, high-firedWikipedia:Please clarify [cí 瓷] and low-firedWikipedia:Please clarify [táo 陶]. The oldest Chinese dictionaries define porcelain [cí 瓷] as "fine, compact pottery" [táo 陶]. Chinese ceramic wares can also classified as being either *northern* or *southern*. Present-day China comprises two separate and geologically different land masses, brought together by the action of continental drift and forming a junction that lies between the Yellow river and the Yangtze river. The contrasting geology of the north and south led to differences in the raw materials available for making ceramics.

Materials

Chinese porcelain is mainly made by a combination of the following materials:

- *Kaolin* - composed largely of the clay mineral kaolinite.
- *Pottery stone* - are decomposed micaceous or feldspar rocks, historically also known as petunse.
- *Feldspar*
- *Quartz*

Technical Developments

In the context of Chinese ceramics the term *porcelain* lacks a universally accepted definition. This in turn has led to confusion about when the first Chinese porcelain was made. Claims have been made for the late Eastern Han period (100 to 200 AD), the Three Kingdoms period (220 to 280 AD), the Six Dynasties period (220 to 589 AD), and the Tang Dynasty (618 to 906 AD).

Early wares

The *Proceedings of the National Academy of Sciences* in 2009 reports that pottery that dates back to 18,000 years ago in the Yuchanyan Cave in southern China has also been found, making it among the earliest pottery yet found. Fragments of pottery vessels dating from around the year 9000 BC found at the Xianrendong (Spirit Cave) site, Wannian County, in the province of Jiangxi represent some of the earliest known Chinese ceramics. The wares were hand-made by coiling and fired in bonfires. Decorations include impressed cord marks, and features produced by stamping and by piercing.

The Xianrendong site was occupied from about 9000 BC to about 4000 BC. During this period two types of pottery were made. The first consisted of coarse-bodied wares possibly intended for everyday use. The second being finer, thinner-bodied wares possibly intended for ritual use or special occasions. There is archaeological evidence suggesting that both types of wares were produced at the same time at some point.

Han dynasty, 202 BC-220 AD

Some experts believe the first true porcelain was made in the province of Zhejiang during the Eastern Han period. Chinese experts emphasize the presence of a significant proportion of porcelain-building minerals (china clay, porcelain stone or a combination of both) as an important factor in defining *porcelain*.Wikipedia:Disputed statement Shards recovered from archaeological Eastern Han kiln sites estimated firing temperature ranged from 1260 to 1300°C. As far back as 1000 BC, the so-called *"Porcelaneous wares"* or *"proto-porcelain wares"* were made using at least some kaolin fired at high temperatures. The dividing the line between the two and *true porcelain wares* is not a clear one.

The late Han years saw the early development of the peculiar art form of *hunping*, or "soul jar": a funerary jar whose top was decorated by a sculptural composition. This type vessels became

widespread during the following Jin Dynasty (265–420) and the Six Dynasties.

Sui and Tang dynasties, 581-907

During the Sui and Tang periods (581 to 907) a wide range of ceramics, low-fired and high-fired, were produced. These included the well-known Tang lead-glazed *sancai* (three-colour) wares, the high-firing, lime-glazed *Yue* celadon wares and low-fired wares from *Changsha*. In northern China, high-fired, translucent porcelains were made at kilns in the provinces of Henan and Hebei.

One of the first mentions of porcelain by a foreigner was made by an Arabian traveler during the Tang Dynasty who recorded that:

> *"They have in China a very fine clay with which they make vases which are as transparent as glass; water is seen through them. The vases are made of clay"* .

The Arabs were aware of the materials necessary to create glass ware, and he was certain it was not the usual glass material.

Song and Yuan dynasties, 960-1368

The city of Jingdezhen (also Jingde Zhen) has been a central place of production since the early Han Dynasty. In 1004 Jingde established the city as the main production hub for Imperial porcelain. During the Song and Yuan dynasties, porcelain made in the city and other southern China kiln sites used crushed and refined pottery stones alone.

Ming dynasty, 1368-1644

The Ming Dynasty saw an extraordinary period of innovation in ceramic manufacture. Kilns investigated new techniques in design and shapes, showing a predilection for color and painted design, and an openness to foreign forms. The Yongle Emperor (1402-24) was especially curious about other countries (as evidenced by his support of the eunuch Zheng He's extended exploration of the Indian Ocean), and enjoyed unusual shapes, many inspired by Islamic metalwork, (*see for example two vessels from the Asian Art Museum, a Buddhist Ablution Basin*, [1], *and Handled Ewer* [2]). During the Xuande reign (1425–35), a technical refinement was introduced in the preparation of the cobalt used for underglaze blue decoration. Prior to this the cobalt had been brilliant in color, but with a tendency to bleed in firing; by adding a manganese the color was duller, but the line crisper. Xuande porcelain is now considered among the finest of all Ming output. Enameled decoration (*such as the one at left*) was perfected under the Chenghua Emperor (1464-1487), and greatly prized by later collectors. Indeed by the late sixteenth century, Chenghua and Xuande era works (*especially wine cups, such as this one in the Met* [3]) had grown so much in popularity, that their prices nearly matched genuine antique wares of Song or even older. This esteem for relatively recent ceramics excited much scorn on the part of

literati scholars (such as Wen Zhenheng, Tu Long, and Gao Lian, who is cited below); these men fancied themselves arbiters of taste and found the painted aesthetic 'vulgar.'

In addition to these decorative innovations, the late Ming period underwent a dramatic shift towards a market economy, exporting porcelain around the world on an unprecedented scale. Thus aside from supplying porcelain for domestic use, the kilns at Jingdezhen became the main production centre for large-scale porcelain exports to Europe starting with the reign of the Wanli Emperor (1572-1620). By this time kaolin and pottery stone were mixed in about equal proportions. Kaolin produced wares of great strength when added to the paste; it also enhanced the whiteness of the body - a trait that became a much sought after property, especially when form blue-and-white wares grew in popularity. Pottery stone could be fired at a lower temperature (1250°C) than paste mixed with kaolin, which required 1350°C. These sorts of variations were important to keep in mind because the large southern egg-shaped kiln varied greatly in temperature. Near the firebox it was hottest; near the chimney, at the opposite end of the kiln, it was cooler.

Qing dynasty, 1644-1911

Primary source material on Qing Dynasty porcelain is available from both foreign residents and domestic authors. Two letters written by Père Francois Xavier d'Entrecolles, a Jesuit missionary and industrial spy who lived and worked in Jingdezhen in the early eighteenth century, described in detail manufacturing of porcelain in the city. In his first letter dating 1712, d'Entrecolles described the way in which pottery stones were crushed, refined and formed into little white bricks, known in Chinese as *petuntse*. He then went on to describe the refining of china clay *kaolin* along with the developmental stages of glazing and firing. He explained his motives:

Yellow-glazed brush-holder, "Chen Guo Zhi" mark; Jingdezhen Daoguang reign, (1821-50); Shanghai Museum

❝ Nothing but my curiosity could ever have prompted me to such researches, but it appears to me that a minute description of ❞ all that concerns this kind of work might, be useful in Europe.

In 1743, during the reign of the Qianlong Emperor, Tang Ying, the imperial supervisor in the city produced a memoir entitled *"Twenty illustrations of the manufacture of porcelain."* Unfortunately, the original illustrations have been lost, but the text of the memoir is still accessible.

Types of Chinese porcelain wares

Tang *Sancai* burial wares

Main article: Sancai

Sancai means *three-colours*. However, the colours of the glazes used to decorate the wares of the Tang dynasty were not limited to three in number. In the West, Tang sancai wares were sometimes referred to as *egg-and-spinach* by dealers for the use of green, yellow and white. Though the latter of the two colours might be more properly described as *amber* and *off-white / cream*.

Sancai wares were northern wares made using white and buff-firing secondary kaolins and fire clays . At kiln sites located at Tongchuan, Neiqui county in Hebei and Gongxian in Henan , the clays used for burial wares were similar to those used by Tang potters. The burial wares were fired at a lower temperature than contemporaneous whitewares. Burial wares, such as the well-known representations of camels and horses, were cast in sections, in moulds with the parts luted together using clay slip. In some cases, a degree of individuality was imparted to the assembled figurines by hand-carving.

Jian tea wares

Jian blackwares, mainly comprising tea wares, were made at kilns located in Jianyang of Fujian province. They reached the peak of their popularity during the Song dynasty. The wares were made using locally-won, iron-rich clays and fired in an oxidising atmosphere at temperatures in the region of 1300°C. The glaze was made using clay similar to that used for forming the body, except fluxed with wood-ash. At high temperatures the molten glaze separate to produce a pattern called *hare's fur*. When Jian wares were set tilted for firing, drips run down the side, creating evidence of liquid glaze pooling.

The *hare's fur* Jian tea bowl illustrated in the Metropolitan Museum of Art in New York was made during the Song dynasty (960 to 1279 AD) and exhibits the typical pooling, or thickening, of the glaze near the bottom. The *hare's fur* patterning in the glaze of this bowl resulted from the random effect of phase separation during early cooling in the kiln and is unique to this bowl. This phase separation in the iron-rich glazes of Chinese blackwares was also used to produce the well-known *oil-spot*, *teadust* and *partridge-feather* glaze effects. No two bowls have identical patterning. The bowl also has a dark brown *iron-foot* which is typical of this style. It would have been fired, probably with several thousand other pieces, each in its own stackable saggar, in a single-firing in a large dragon kiln. One such kiln, built on the side of a steep hill, was almost 150 metres in length, though most Jian dragon kilns were fewer than 100 metres in length.

An 11th century resident of Fujian wrote:

> " Tea is of light colour and looks best in black cups. The cups made at Jianyang are bluish-black in colour, marked like the fur of a hare. Being of rather thick fabric they retain the heat, so that when once warmed through they cool very slowly, and they are additionally valued on this account. None of the cups produced at other places can rival these. Blue and white cups are not used by those who give tea-tasting parties. "

At the time, tea was prepared by whisking powdered leaves that had been pressed into dried cakes together with hot water, (somewhat akin to matcha in Japanese Tea Ceremony). The water added to this powder produced a white froth that would stand out better against a dark bowl. Tastes in preparation changed during the Ming dynasty; the Hongwu Emperor himself preferred leaves to powdered cakes, and would accept only leaf tea as tribute from tea-producing regions. Leaf tea, in contrast to powdered tea, was prepared by steeping whole leaves in boiling water - a process that led to the invention of the teapot and subsequent popularity of Yixing wares over the dark tea bowls.

Jian tea wares of the Song dynasty were also greatly appreciated and copied in Japan, where they were known as tenmoku wares.

Ding ware

Main article: Ding ware

Ding (Wade-Giles: *Ting*) ware was produced in Ding Xian (modern Chu-yang), Hebei Province, slightly south-west of Beijing. Already in production when the Song emperors came to power in 940, *Ding* ware was the finest porcelain produced in northern China at the time, and was the first to enter the palace for official imperial use. Its paste is white, generally covered with an almost transparent glaze that dripped and collected in "tears," (though some *Ding* ware was glazed a monochrome black or brown, white was the much more common type). Overall, the *Ding* aesthetic relied more on its elegant shape than ostentatious decoration; designs were understated, either incised or stamped into the clay prior to glazing. Due to the way the dishes were stacked in the kiln, the edged remained unglazed, and had to be rimmed in metal such as gold or silver when used as tableware. Some hundred years later, a Southern Song era writer commented that it was this defect that led to its demise as favored imperial ware. Since the Song court lost access to these northern kilns when they fled south, it has been argued that Qingbai ware (*see below*) was viewed as a replacement for *Ding*.

Although not as highly ranked as *Ru* ware, the late Ming connoisseur Gao Lian awards Ding ware a brief mention in his volume *Eight Discourses on the Art of Living*. Classified under his sixth discourse, the section on "pure enjoyment of cultured idleness," Master Gao says:

> " "The best sort has marks on it like tear-stains… Great skill and ingenuity is displayed in selecting the forms of the vessels…" "

Ru ware

Like Ding ware, **Ru** (Wade-Giles: *ju*) was produced in North China for imperial use. The Ru kilns were near the Northern Song capital at Kaifeng. In similar fashion to Longquan celadons, Ru pieces have small amounts of iron in their glaze that oxidize and turn greenish when fired in a reducing atmosphere. Ru wares range in color—from nearly white to a deep robin's egg—and often are covered with reddish-brown crackles. The crackles, or "crazing," are caused when the glaze cools and contracts faster than the body, thus having to stretch and ultimately to split, (*as seen in the detail at right; see also* [4]). The art historian James Watt comments that the Song dynasty was the first period that viewed crazing as a merit rather than a defect. Moreover, as time went on, the bodies got thinner and thinner, while glazes got thicker, until by the end of the Southern Song the 'green-glaze' was thicker than the body, making it extremely 'fleshy' rather than 'bony,' to use the traditional analogy (*see section on* Guan *ware, below*). Too, the glaze tends to drip and pool slightly, leaving it thinner at the top, where the clay peeps through.

Ru Ware Bowl Stand, detail of crazing; V&A
FE.1-1970 [5]

As with Ding ware, the Song imperial court lost access to the Ru kilns after it fled Kaifeng when the Jin invaded, and settled at Lin'an in Hangzhou, towards the south. There the Emperor Gaozong founded the *Guan yao* ('official kilns') right outside the new capital in order to produce imitations of Ru ware. However, posterity has remembered Ru ware as something unmatched by later attempts; Master Gao says, "Compared with Guan yao, the above were of finer substance and more brilliant luster."

Jun ware

Main article: Jun ware

Jun (Wade-Giles: *chün*) ware was a third style of porcelain used at the Northern Song court. Characterized by a thicker body than Ding or Ru ware, Jun is covered with a turquoise and purple glaze, so thick and viscous looking that it almost seems to be melting off its substantial golden-brown body. Not only are Jun vessels more thickly potted, their shape is much more robust than the fine Jun pieces, yet both types were appreciated at court of Emperor Huizong. Jun production was centered at Jun-tai in Yüxian county, Hunan Province.

Guan ware

Guan (Wade-Giles: *kuan*) ware, literally means "official" ware; so certain Ru, Jun, and even Ding could be considered *Guan* in the broad sense of being produced for the court. Strictly speaking, however, the term only applies to that produced by an official, imperially-run kiln, which didn't start until the Southern Song fled the advancing Jin and settled at Lin'an. It was during this period that walls become so thin and glaze so thick that the latter superseded the former in breadth. As the clay in the foothills around Lin'an, was a brownish color, and the glaze so viscus, "Guan" ware became known for its "brown mouth" (sometimes translated as "purple"), indicating the top rim or a vessel where the glaze is thinner and the body shows through.[6] Guan ceramics have been much admired over the years, and very subject to copy. Indeed Gao Lain spends the greatest part of his commentary on describing Guan and its partner *Ge ware* (See below: though similar to *Ge* ware, Guan tends to have a bluer finish and a more translucent glaze), as though that were the most troublesome, least easily identified type of pottery.

Ge ware

Ge (Wade-Giles: *ko*), literally means 'big-brother' ware, because legend has it that of two brothers working in Longquan, one made the typical celadon style ceramics, but the elder made *ge* ware, produced in his private kiln. Ming commentator, Gao Lian claims that the *ge* kiln took its clay from the same site as *Guan* ware, which is what accounts for the difficulty in distinguishing one from the other (though Gao thinks "*Ge* is distinctly inferior" to Guan). Overall, Ge remains somewhat elusive, but basically comprises two types—one with a 'warm rice-yellow glaze and two sets of crackles, a more prominent set of darker color interspersed with a finer set of reddish lines (called *chin-ssu t'ieh-hsien* or 'golden floss and iron threads', which can just faintly be detected on this bowl: [7]). The other Ge ware is much like Guan ware, with grayish glaze and one set of crackles. Once thought to have only been manufactured alongside Longquan celadon, per its legendary founding, Ge is now believed to have also been produced at Jingdezhen.

While similar to Guan ware, Ge typically has a grayish-blue glaze that is fully opaque with an almost matte finish (*as seen on this bottle in the Asian Art Museum* [8]). Its crackle pattern is exaggerated, often standing out in bold black. Though still shrouded in mystery, many specialists believe that Ge ware did not develop until the very late Southern Song or even the Yuan. In any case, enthusiasm for it persisted throughout the Ming; Wen Zhenheng preferred it to all other types of porcelain, in particular for brush washers and water droppers (although he preferred jade brush washers to porcelain, Guan and Ge were the best ceramic ones, especially if they have scalloped rims). Differences between later Ming imitations of Song/Yuan Ge include: Ming versions substitute a white porcelain body; they tend to be produced in a range of new shapes, for example those for the scholar's studio; glazes tend to be thinner and more lustrous; and slip is applied to the rim and base to simulate the "brown mouth and iron foot" of Guan ware.

Qingbai wares

Qingbai wares (also called 'yingqing') were made at Jingdezhen and at many other southern kilns from the time of the Northern Song Dynasty until they were eclipsed in the 14th century by underglaze-decorated blue and white wares. Qingbai in Chinese literally means "clear blue-white". The qingbai glaze is a *porcelain glaze*, so-called because it was made using pottery stone. The qingbai glaze is clear, but contains iron in small amounts. When applied over a white porcelain body the glaze produces a greenish-blue colour that gives the glaze its name. Some have incised or moulded decorations.

The Song dynasty qingbai bowl illustrated was likely made at the Jingdezhen village of Hutian, which was also the site of the Imperial kilns established in the year 1004. The bowl has incised decoration, possibly representing clouds or the reflection of clouds in the water. The body is white, translucent and has the texture of very-fine sugar, indicating that it was made using crushed and refined pottery stone instead of pottery stone and kaolin. The glaze and the body of the bowl would have been fired together, in a saggar, possibly in a large wood-burning dragon-kiln or climbing-kiln, typical of southern kilns in the period.

Though many Song and Yuan qingbai bowls were fired upside down in special segmented saggars, a technique first developed at the Ding kilns in Hebei province. The rims of such wares were left unglazed but were often bound with bands of silver, copper or lead.

One remarkable example of *qingbai* porcelain is the so-called *Fonthill Vase*, described in a guide for Fonthill Abbey published in 1823

"...an oriental china bottle, superbly mounted, said to be the earliest known specimen of porcelain introduced into Europe"

The vase was made at Jingdezhen, probably around the year 1300 and was sent as a present to Pope Benedict XII by one of the last Yuan emperors of China, in 1338. The mounts referred to in the 1823 description were of enamelled silver-gilt and were added to the vase in Europe in 1381. An 18th century water colour of the vase complete with its mounts exists, but the mounts themselves were removed and lost in the 19th century. The vase is now in the National Museum of Ireland. It is often held that *qingbai* wares were not subject to the higher standards and regulations of the other porcelain wares, since they were made for everyday use. They were mass-produced, and received little attention from scholars and antiquarians. The Fonthill Vase, given by a Chinese emperor to a pope, might appear to cast at least some doubt on this view.

Blue and white wares

Main article: Blue and white porcelain

Following in the tradition of earlier *qingbai* porcelains, blue and white wares are glazed using a transparent *porcelain glaze*. The blue decoration is painted onto the body of the porcelain before glazing, using very finely ground cobalt oxide mixed with water. After the decoration has been applied the pieces are glazed and fired.

It is believed that underglaze blue and white porcelain was first made in the Tang Dynasty. Only three complete pieces of Tang blue and white porcelain are known to exist (in Singapore from Indonesian Belitung shipwreck), but shards dating to the 8th or 9th century have been unearthed at Yangzhou in the Jiangsu province. It has been suggested that the shards originated from a kiln in the province of Henan. In 1957 excavations at the site of a pagoda in the province Zhejiang uncovered a Northern Song bowl decorated with underglaze blue and further fragments have since been discovered at the same site. In 1970 a small fragment of a blue and white bowl, again dated to the 11th century, was also excavated in the province of Zhejiang.

In 1975 shards decorated with underglaze blue were excavated at a kiln site in Jiangxi and, in the same year, an underglaze blue and white urn was excavated from a tomb dated to the year 1319, in the province of Jiangsu. It is of interest to note that a Yuan funerary urn decorated with underglaze blue and underglaze red and dated 1338 is still in the Chinese taste, even though by this time the large-scale production of blue and white porcelain in the Yuan, Mongol taste had started its influence at Jingdezhen.

Starting early in the 14th century, blue and white porcelain rapidly became the main product of Jingdezhen, reaching the height of its technical excellence during the later years of the reign of the Kangxi Emperor and continuing in present times to be an important product of the city.

The tea caddy illustrated shows many of the characteristics of blue and white porcelain produced during the Kangxi period. The translucent body showing through the clear glaze is of great whiteness and the cobalt decoration, applied in many layers, has a fine blue hue. The decoration, a sage in a landscape of lakes and mountains with *blazed* rocks is typical of the period. The piece would have been fired in a saggar (a lidded ceramic box intended to protect the piece from kiln debris, smoke and cinders during firing) in a reducing atmosphere in a wood-burning *egg-shaped* kiln, at a temperature approaching 1350°C.

Distinctive blue-and-white porcelain was exported to Japan where it is known as Tenkei blue-and-white ware or *ko sometsukei*. This ware is thought to have been especially ordered by tea masters for Japanese ceremony.

Blanc de Chine

Main article: Blanc de Chine

Blanc de Chine is a type of white porcelain made at Dehua in the Fujian province. It has been produced from the Ming Dynasty (1368-1644) to the present day. Large quantities arrived in Europe as Chinese Export Porcelain in the early 18th century and it was copied at Meissen and elsewhere.

The area along the Fujian coast was traditionally one of the main ceramic exporting centers. Over one-hundred and eighty kiln sites have been identified extending in historical range from the Song period to present.

From the Ming period porcelain objects were manufactured that achieved a fusion of glaze and body traditionally referred to as "ivory white" and "milk white." The special characteristic of Dehua porcelain is the very small amount of

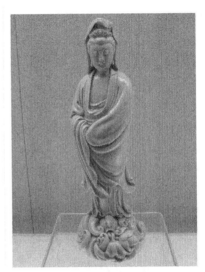

Statue of Guan Yin, Ming Dynasty
(Shanghai Museum)

iron oxide in it, allowing it to be fired in an oxidising atmosphere to a warm white or pale ivory color. (Wood, 2007)

The porcelain body is not very plastic but vessel forms have been made from it. Donnelly, (1969, pp.xi-xii) lists the following types of product: figures, boxes, vases and jars, cups and bowls, fishes, lamps, cup-stands, censers and flowerpots, animals, brush holders, wine and teapots, Buddhist and Taoist figures, secular figures and puppets. There was a large output of figures, especially religious figures, e.g. Guanyin, Maitreya, Lohan and Ta-mo figures.

The numerous Dehua porcelain factories today make figures and tableware in modern styles. During the Cultural Revolution "Dehua artisans applied their very best skills to produce immaculate statuettes of the Great Leader and the heroes of the revolution. Portraits of the stars of the new proletarian opera in their most famous roles were produced on a truly massive scale." Mao figures later fell out of favor but have been revived for foreign collectors.

Notable artists in *blanc de Chine*, such as the late Ming period He Chaozong, signed their creations with their seals. Wares include crisply modeled figures, cups, bowls and joss stick-holders.

Many of the best examples of *blanc de Chine* are found in Japan where the white variety was termed *hakugorai* or "Korean white", a term often found in tea ceremony circles. The British Museum in London has a large number of *blanc de Chine* pieces, having received as a gift in 1980 the entire collection of P.J.Donnelly.

Fakes and reproductions

Chinese potters have a long tradition of borrowing design and decorative features from earlier wares. Whilst ceramics with features thus borrowed might sometimes pose problems of provenance, they would not generally be regarded as either reproductions or fakes. However, fakes and reproductions have also been made at many times during the long history of Chinese ceramics and continue to be made today in ever-increasing numbers.

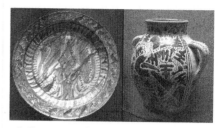

Italian pottery of the mid-15th century shows heavy influences from Chinese ceramics. A Sancai ("Three colors") plate (left), and a Ming-type blue-and-white vase (right), made in Northern Italy, mid-15th century. Musée du Louvre.

- Reproductions of Song dynasty Longquan celadon wares were made at Jingdezhen in the early 18th century, but outright fakes were also made using special clay that were artificially aged by boiling in meat broth, refiring and storage in sewers. Père d'Entrecolles records that by this means the wares could be passed off as being hundreds of years old.

- At Jingdezhen the two remaining wood fired, egg-shaped kilns produce convincing reproductions of earlier wares. At Zhejiang province good reproductions of Song Longquan celedon wares continue to be made in large, side-stoked dragon kilns.[citation needed]

- Before World War II, the English potter Bernard Leach found what he took to be genuine Song dynasty *cizhou* rice-bowls being sold for very little money on the dock of a Chinese port and was surprised to learn that they were in fact newly made.[citation needed]

- In modern times the market for Song dynasty *Jian* tea-bowls has been severely depressed by the appearance in large numbers of modern fakes good enough to deceive even expert collectors. It is reported that some of these fakes show evidence of having had genuine Song dynasty *iron-foot* bases grafted onto newly made bodies.[citation needed]

- In the late 19th century fakes of Kangxi period *famille noire* wares were made that were convincing enough to deceive the experts of the day. Many such pieces may still be seen in museums today, as may pieces of genuine Kangxi porcelain decorated in the late nineteenth century with *famille noire* enamels. A body of modern expert opinion holds that porcelain decorated with *famille noire* enamels was not made at all during the Kangxi period, though this view is disputed .

- A fashion for Kangxi period (1662 to 1722) blue and white wares grew to large proportions in Europe during the later years of the 19th century and triggered the production at Jingdezhen of large quantities of porcelain wares that strike a resemblance to ceramics of earlier periods. Such blue and white wares were not fakes or even convincing reproductions, even though some pieces carried four-character Kangxi reign-marks that continue to cause confusion to this day. Kangxi reign-marks in the form shown in the illustration occur only on wares made towards the end of the 19th century or later, without exception.

Authentication

The most widely-known test is the thermoluminescence test, or TL test, which is used on some types of ceramic to estimate, roughly, the date of last firing. The TL test is carried out on small samples of porcelain drilled or cut from the body of a piece, which can be risky and disfiguring. For this reason, the test is rarely used for dating finely-potted, high-fired ceramics. TL testing cannot be used at all on some types of porcelain items, particularly high-fired porcelain.[citation needed]

Discussions on authenticating porcelain can be found at UnderglazedBlue.com [9].

Gallery

Early wares

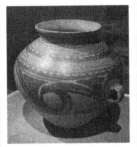

Painted jar of the Majiayao culture, Late Neolithic period (3300 - 2200 BC)

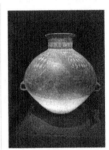

Painted pot of Majiayao culture (2200 - 2000 BC)

Black pottery goblet of the Late Neolithic period from the Longshan culture, dated (ca. 2500 - 2000 BC)

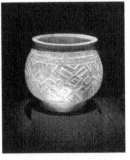

White pottery pot with geometric design, Shang dynasty (1600-1100 BC)

Han (202 BC to 220 AD)

Ceramic sculptures with polychrome, from the 2nd century BC, Han Dynasty.

A painted earthenware tripod, Western Han Dynasty, late 3rd century BC to early 1st century AD

A Han celadon pot with mountain-shaped lid and animal designs

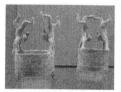

Two Western Han Dynasty terracotta vases with acrobats

Ceramic tomb statuette of a cavalryman and horse, Western Han Dynasty

A Han Dynasty pottery tomb model of residential towers joined by a bridge

A Han pottery face of a laughing woman

A Western Han glazed pottery *ding* with *taotie*-faced door knocker designs

An Eastern Han ceramic candle-holder with animal figurines

Three Kingdoms, Jin, Southern and Northern Dynasties, Sui (220 to 618)

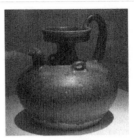

A black-glazed wine or water jug with a rooster-headed spout, Jin Dynasty (265-420)

A footed earthenware lamp with lions, from either the Northern dynasties or Sui Dynasty, 6th century

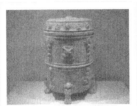

Covered footed earthenware vessel from the Northern Qi (550–577)

A white-glazed figurine of a woman holding a jar, Sui Dynasty (581–618)

Northern Dynasties
lotus vessel

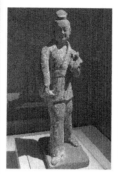

A Western Wei
(536–556) ceramic
figurine of a military
officer

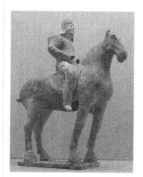

A ceramic cavalryman with a
horn, Northern Wei
(386–534)

Tang (618 to 906 AD)

Sancai-horse and
figurine, Tang
Dynasty

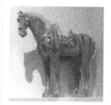

A sancai glazed
pottery horse from the
7th-8th century

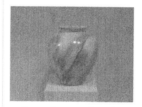

An earthenware jar with
green and yellow glaze, first
half of 8th century

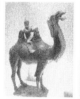

A Western on a
Bactrian Camel,
a sancai glazed
figurine from
the Tang
Dynasty

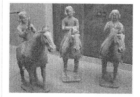

Tang female musicians on
horseback

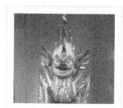

A Tang sancai-glazed
tomb guardian, 8th
century

Song (960 to 1279 AD)

Chinese tea bowls made of
stoneware, Song Dynasty,
12th to 13th century

Longquan celadon wares,
13th century

*Ding Ware
Bottle* with
iron pigment
over
transparent
colorless
glaze, 11th
century; Freer
Gallery,
F1959.6.

Northern Song Dynasty
white-glazed baby boy
pillow

A
Song-era
amphora
with
dragon
handles

Yuan (1279 to 1368 AD)

Qingbai porcelain vase, 14th century

Longquan celadon, 13th-14th century

Celadon dish with a flower design

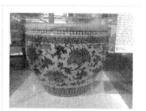

A covered jar made of Longquan celadon, 14th century

Ming (1368 to 1644 AD)

A Ming Dynasty blue-and-white porcelain dish with depiction of a dragon

Guanyin (Goddess of Mercy) with children, statuette made of Dehua porcelain ware

A Ming Dynasty porcelain bowl with flower designs

A Ming glazed earthenware
statue of a seated Buddha

Yongle reign red plate

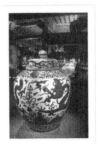

Jiajing covered jar
with green dragon
and cloud design

Qing (1644 to 1912 AD)

Porcelain plate from
the reign of the
Kangxi Emperor
(1661–1722)

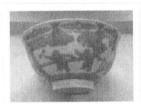

A porcelain bowl with a
scene of two boys playing in
a courtyard, from the reign of
the Yongzheng Emperor
(1722–1735)

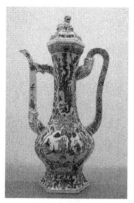

Porcelain vase from the reign
of the Kangxi Emperor
(1661–1722)

Four ritual porcelain water
vessels with elephant-trunk
spouts, from the reign of the
Qianlong Emperor
(1735–1796)

White
porcelain
from the
reign of the
Qianlong
Emperor
(1735–1796)

Republic and People's Republic (1912, to date)

See also

- Chinese art
- Blanc-de-Chine (the white wares of Dehua).
- Canton porcelain (Jingdezhen porcelain decorated at Canton for export to the West).
- Chinese export porcelain (Chinese porcelain made for export to the West).
- Dehua porcelain factories (the factories at Dehua).
- Famille jaune, noire, rose, verte (enamelled wares of the eighteenth and nineteenth centuries).
- Kraak porcelain (blue and white export wares in the Dutch taste).

- Longquan Celadon (the celadon wares of Longquan county).
- Swatow ware (wares exported through the port of Swatow).
- Yixing clay (the red stonewares of Yixing).
- Tiger Cave Kiln (site of much of Southern Song official celadon ware)
- Shiwan Ware

Bibliography

- Ayers, J. and Bingling, Y., (2002) *Blanc de Chine: Divine Images in Porcelain*, China Institute, New York
- Ayers, J and Kerr, R., (2000), *Blanc de Chine Porcelain from Dehua*, Art Media Resources Ltd.
- Brook, Timothy. *The Confusions of Pleasure: Commerce and Culture in Ming China*. Berkeley and Los Angeles: University of California Press, 1998. ISBN 0-520-22154-0.
- Clunas, Craig. *Superfluous Things: Material Culture and Social Status in Early Modern China*. Urbana: University of Illinois Press, 1991 and Honolulu: University of Hawai'i Press, 2004.
- Donnelly, P.J. (1969), *Blanc de Chine*, Faber and Faber, London
- Fong, Wen C, and James C.Y. Watt. *Possessing the Past: Treasures from the National Palace Museum Taipei*. New York: The Metropolitan Museum of Art, 1996.
- Gao, Lian. "The *Tsun Sheng Pa Chien*, AD 1591, by Kao Lien." Translated by Arthur Waley. *Yearbook of Oriental Art and Culture*, 1, (1924-25).
- Harrison-Hall, J. (2001), *Ming Ceramics in the British Museum*, British Museum, London
- Kerr, Rose and Wood, Nigel (2004). *Science and Civilisation in China,* Volume 5, Part XII: Ceramic Technology. Cambridge University Press. ISBN 0-521-83833-9.
- Kotz, Suzanne (ed.) (1989) *Imperial Taste. Chinese Ceramics from the Percival David Foundation.* Chronicle Books, San Francisco. ISBN 0-87701-612-7.
- Li, Chu-tsing and James C.Y. Watt, eds. *The Chinese scholar's studio: artistic life in the late Ming period*. New York: Thames and Hudson, 1987.
- Li, He, (1996). *Chinese Ceramics. The New Standard Guide*. Thames and Hudson, London. ISBN 0-500-23727-1.
- Li, He and Michael Knight. *Power and Glory: Court Art of China's Ming Dynasty*. San Francisco: Asian Art Museum, 2008.
- Lion-Goldschmidt, Daisy. *Ming Porcelain*. Translated by Katherine Watson. New York: Rizzoli, 1978.
- Moujian, S., (1986) *An Encyclopedia of Chinese Art*, p. 292.
- Pierson, Stacey, (1996). *Earth, Fire and Water: Chinese Ceramic Technology*. Percival David Foundation of Chinese Art, University of London. ISBN 0-7286-0265-2.
- Wood, N. (2007), *Chinese Glazes: Their Chemistry, Origins and Re-creation*, A & C Black, London, and University of Pennsylvania Press, USA

Chinese jade

Chinese jade is any of the carved-jade objects produced in China from the Neolithic Period (c. 3000–1500 BC) onward. The Chinese regarded carved-jade objects as intrinsically valuable. They metaphorically equated jade with human virtues because of its hardness, durability, and (moral) beauty.

The Chinese used jade for tools, but also for carved insignias and talismans probably related to ceremonial ritual. Jade was prized by the Chinese for its durability, its musical qualities, its subtle, translucent colors, and its alleged protective powers - it was thought to prevent fatigue and delay the decomposition of the body.

Names

In almost all dictionaries, the Chinese character 'yù' (玉 is translated into English as 'jade'. However, this frequently leads to misunderstanding. The cultural concept of 'jade' is considerably broader in China and Korea than in the West. A more semantically inclusive rendering of this character on its own would be 'precious/ornamental stone'. It is seldom, if ever, used on its own to denote 'true' jade in modern Mandarin Chinese; for example, one would normally refer to 'ying yu' (硬玉, 'hard jade') for jadeite, or 'ruan yu' (軟玉, 'soft jade') for nephrite. (Though it is used with these meanings in Classical Chinese texts e.g. in poetry.) The Chinese names for many ornamental non-jade rocks also incorporate this character as a radical, and it is widely understood by native speakers that such stones are not, in fact, true precious nephrite or jadeite. Even so, for commercial reasons, the names of such stones may well still be translated into English as 'jade'.

History

Jade ornament with flower design, Jin Dynasty (1115-1234 AD), Shanghai Museum.

Jade has been used in virtually all periods of Chinese history and generally accords with the style of decorative art characteristic of each period. Thus, the earliest jades, of the Neolithic Period, are quite simple and unornamented; those of the Shang (18th–12th century BC), Zhou (1111–255 BC), and Han (206 BC–AD 220) dynasties are increasingly embellished with animal and other decorative motifs characteristic of those times; in later periods ancient jade shapes, shapes derived from bronze vessels, and motifs of painting were used, essentially to demonstrate the craftsman's extraordinary technical facility.

During Neolithic times, the key known sources of nephrite jade in China for utilitarian and ceremonial jade items were the now depleted deposits in the Ningshao area in the Yangtze River Delta (Liangzhu culture 3400–2250 BC) and in an area of the Liaoning province in Inner Mongolia (Hongshan culture 4700–2200 BC). As early as 6000 B.C. Dushan Jade has been mined. In the Yin Ruins of Shang Dynasty (1,600 B.C. to 1,050 B.C.) in Anyang, Dushan Jade ornaments was unearthed in the tomb of the Shang kings. Jade was used to create many utilitarian and ceremonial objects, ranging from indoor decorative items to jade burial suits. Jade was considered the "imperial gem". From about the earliest Chinese dynasties until present, the jade deposits in most use were not only from the region of Khotan in the Western Chinese province of Xinjiang but also from other parts of China, like Lantian, Shaanxi. There, white and greenish nephrite jade is found in small quarries and as pebbles and boulders in the rivers flowing from the Kuen-Lun mountain range northward into the Takla-Makan desert area. River jade collection was concentrated in the Yarkand, the White Jade (Yurungkash) and Black Jade (Karakash) Rivers. From the Kingdom of Khotan, on the southern leg of the Silk Road, yearly tribute payments consisting of the most precious white jade were made to the Chinese Imperial court and there transformed into *objets d'art* by skilled artisans as jade was considered more valuable than gold or silver. Jade became a favorite material for the crafting of Chinese scholars objects, such as rests for calligraphy brushes, as well as the mouthpieces of some opium pipes, due to the belief that breathing through jade would bestow longevity upon smokers who used such a pipe.

Jadeite, with its bright emerald-green, pink, lavender, orange and brown colours was imported from Burma to China only after about 1800. The vivid green variety became known as Feicui (翡翠) or Kingfisher (feathers) Jade. It quickly replaced nephrite as the imperial variety of jade.

Categories

Jade objects of early ages (Neolithic through Zhou) fall into five categories: small decorative and functional ornaments such as beads, pendants, and belt hooks; weapons and related equipment; independent sculptural, especially of real and mythological animals; small objects of probably emblematic value, including the han (ornaments, often carved in the shape of a cicada, to be placed in the mouth of the dead), and many examples of larger objects — such as the *cong* (a hollow cylinder or truncated cone)

The Six Ritual and Six Ceremonial Jades

The "Six Ritual Jades" originating in pre-history were the *bi* (a flat disk with a hole in its center), the *cong*, the *huang* (a flat, half-ring pendant), the hu and the flat, bladelike *gui* and *zhang*. The original names, value and functions of these objects have invited much speculation. The Zhou Li, itself probably compiled in the Han Dynasty, ascribes the circular *bi* as representing the heavens, the *cong* as representing the earth, the *gui* the east, the *zhang* the south, the *hu* the west and the *huang* the north. Although over two millennia old these names and symbolism were given to these objects by much later

writers, who interpreted the objects in a way that reflected their own understanding of the cosmos.

The original use of the "Six Ritual Jades" became lost, with such jades becoming status symbols, with utility and religious significance forgotten. The objects came to represent the status of the holder due to the expense and authority needed to command the resources and labour in creating the object. Thus it was as the "Ceremonial Jades" that the forms of some of these jades were perpetuated. The "Zhou Li" states that a king (wang) was entitled to *gui* of the *zhen* type, dukes (gong) to the huang, marquis to *gui* of the *xin* type, earls (bo) to *gui* of the *gong* type, viscounts (zi) to a *bi* of the *gu* type and barons (nan) to a *bi* of the *pu* type.

See also

* Jade
* Jade use in Mesoamerica

References

* Scott-Clark, Cathy and Levy, Adrian. (2002) The Stone of Heaven: Unearthing the Secret History of Imperial Green Jade. ISBN 0316525960 [1]

Further reading

* Laufer, Berthold, 1912, *Jade: A Study in Chinese Archeology & Religion*, Reprint: Dover Publications, New York. 1974.
* Rawson, Jessica, 1975, *Chinese Jade Throughout the Ages*, London: Albert Saifer, ISBN 0-87556-754-1
* Between hell and the Stone of Heaven: Observer article on Jade Mining in Burma [2]
* Old Chinese Jades: Real or Fake? [3]
* BOOK REVIEW, The Stone of Heaven: The Secret History of Imperial Green Jade by Adrian Levy and Cathy Scott-Clark [4]

East Asian calligraphy

East Asian calligraphy	
Chinese name	
Traditional Chinese	書法
Simplified Chinese	书法

Transliterations	
Hakka	
- Romanization	su^{24} fab^2
Mandarin	
- Hanyu Pinyin	Shūfǎ
Min	
- Hokkien POJ	su-hoat
Wu	
- Romanization	sy平 fah入
Cantonese	
- Jyutping	syu^1 faat3

Japanese name	
Kanji	書道
Hiragana	しょどう (modern) しよだう (historical)

Transliterations	
- Revised Hepburn	Shodō

Korean name	
Hangul	서예
Hanja	書藝

Transliterations	
- Revised Romanization	Seoye
- McCune-Reischauer	Sŏye

Vietnamese name	
Quốc ngữ	Thư Pháp
Hán tự	書法

East Asian calligraphy is a form of **calligraphy** widely practised and revered in the Sinosphere. This most often includes China, Japan, Korea, and Vietnam. The East Asian calligraphic tradition originated and developed from China. There is a general standardization of the various styles of calligraphy in this tradition. Calligraphy has influenced ink and wash painting, which is accomplished using similar tools and techniques. Calligraphy has also led to the development of many forms of art in East Asia, including seal carving, ornate paperweights, and inkstones.

Definition and classification

Names

The local name for calligraphy is *Shūfǎ* 書法 in China, literally "the way/method/law of writing" ; *Shodō* 書道 in Japan, literally "the way/principle of writing"; and *Seoye (서예)* 書藝 in Korea, literally "the skill/criterion of writing". The calligraphy of East Asian characters is an important and appreciated aspect of East Asian culture. East Asian calligraphy is normally regarded as one of the "arts" (Chinese 藝術 pinyin: *yìshù*, Japanese 芸術 geijutsu) in the countries where it is practiced. But there is actually a debate as to whether East Asian calligraphy is a discipline or an art. Indeed, both may be true.

As a practice

As a discipline calligraphy is, at the basic level, a pursuit 一書法 Chinese: shūfǎ, "the rules of writing Han characters" 一 focused on writing well. Students aim to obtain the characteristics of the writing of famous calligraphic masters. Elementary school students practice calligraphy in this way, as do elders practicing temporary calligraphy, without aspiring to artistic creation.

As an art

Calligraphy is also considered an art 一 艺术 Chinese: yìshù, a relatively recent word meaning "art", where works are appreciated more or only for their aesthetic qualities.

The English word "Calligraphy" refers to that which is "beautiful writing", thus including both aspects.

Evolution and Styles

Main article: East Asian script styles

| Jiǎgǔwén |
| Jīnwén |
| Dàzhuàn |
| Xiǎozhuàn |
| Lìshū |
| Cǎoshū |
| Xíngshū |
| Kǎishū (trad) |
| Kǎishū (simp) |
| Source [1] |

Ancient China

The oldest extant Chinese characters from ancient China are Jiǎgǔwén characters carved on ox scapulas and tortoise plastrons. Brush-written examples decay over time and have not survived. During the divination ceremony, after the cracks were made, characters were written with a brush on the shell or bone to be later carved.(Keightley, 1978). With the development of *Jīnwén* (Bronzeware script) and *Dàzhuàn* (Large Seal Script) "cursive" signs continued. Moreover, each archaic kingdom of current China had its own set of characters.

Imperial China

In Imperial China, the graphs on old steles — some dating from 200 BC, and in Xiaozhuan style — are still accessible.

In about 220 BC, the emperor Qin Shi Huang, the first to conquer the entire Chinese basin, imposed several reforms, among them Li Si's character unification, which created a set of 3300 standardized *Xiǎozhuàn* characters. Despite the fact that the main writing implement of the time was already the

brush, little paper survives from this period, and the main examples of this style are on steles.

The Lìshū style (clerical script) which is more regularized, and in some ways similar to modern text, were also authorised under Qin Shi Huangdi.

Kǎishū style (traditional regular script) — still in use today — and attributed to Wang Xizhi (王義之, 303-361) and his followers, is even more regularized. Its spread was encouraged by Emperor Mingzong of Later Tang (926-933), who ordered the printing of the classics using new wooden blocks in Kaishu. Printing technologies here allowed shapes to stabilize. The Kaishu shape of characters 1000 years ago was mostly similar to that at the end of Imperial China. But small changes have been made, for example in the shape of 厂 which is not absolutely the same in the Kangxi Dictionary of 1716 as in modern books. The Kangxi and current shapes have tiny differences, while stroke order is still the same, according to old style.

Styles which did not survive include Bāfēnshū, a mix of 80% Xiaozhuan style and 20% Lishu. Some Variant Chinese characters were unorthodox or locally used for centuries. They were generally understood but always rejected in official texts. Some of these unorthodox variants, in addition to some newly created characters, were incorporated in the Simplified Chinese character set.

Cursive styles and hand-written styles

Cursive styles such as *Xíngshū* (semi-cursive or running script) and *Cǎoshū* (cursive or grass script) are less constrained and faster, where more movements made by the writing implement are visible. These styles' stroke orders vary more, sometimes creating radically different forms. They are descended from Clerical script, in the same time as Regular script (Han Dynasty), but Xíngshū and Cǎoshū were use for personal notes only, and were never used as standard. Caoshu style was highly appreciated during Emperor Wu of Han reign (140-87).

Printed and computer styles

Examples of modern printed styles are Song from the Song Dynasty's printing press, and sans-serif. These are not considered traditional styles, and are normally not written.

Tools : The Four Treasures of the Study

The **ink brush**, **ink**, **paper**, and **inkstone** are essential implements of East Asian calligraphy: they are known together as the **Four Treasures of the Study** (T: 文房四寶 / S: 文房四宝) in China, and as the **Four Friends of the Study** (HG: 문방사우 / HJ: 文房四友) in Korea. In addition to these four tools, desk pads and paperweights are also used by calligraphers.

Brush

Main article: Ink brush

The brush is the traditional writing implement in East Asian calligraphy. The body of the brush can be made from either bamboo, or rarer materials such as red sandalwood, glass, ivory, silver, and gold. The head of the brush can be made from the hair (or feathers) of a wide variety of animals, including the weasel, rabbit, deer, chicken, duck, goat, pig, tiger, etc. There is also a tradition in both China and Japan of making a brush using the hair of a newborn, as a once-in-a-lifetime souvenir for the child. This practice is associated with the legend of an ancient Chinese scholar who scored first in the Imperial examinations by using such a personalized brush. Calligraphy brushes are widely considered an extension of the calligrapher's arm.

Today, calligraphy may also be done using a pen, but pen calligraphy does not enjoy the same prestige as traditional brush calligraphy.

Paper

Paper nowadays is frequently sold together with a paperweight and desk pad.

Paper

Special types of paper are used in East Asian calligraphy.

In China, *Xuanzhi* (宣纸), traditionally made in Anhui province, is the preferred type of paper. It is made from the Tartar wingceltis (*Pteroceltis tartarianovii*), as well as other materials including rice, the paper mulberry (*Broussonetia papyrifera*), bamboo, hemp, etc. In Japan, *washi* is made from the *kozo* (paper mulberry), *ganpi* (*Wikstroemia sikokiana*), and *mitsumata* (*Edgeworthia papyrifera*), as well as other materials such as bamboo, hemp, rice, and wheat.

Paperweights

Paperweights are used to hold down paper. A paperweight is often placed at the top of all but the largest pages to prevent slipping; for smaller pieces the left hand is also placed at the bottom of the page for support. Paperweights come in several types: some are oblong wooden blocks carved with calligraphic or pictorial designs; others are essentially small sculptures of people or animals. Like inkstones, paperweights are collectible works of art on their own right.

Desk pads

The desk pad (Chinese T: 畫氈, S: 画毡, Pinyin: huàzhān; Japanese: 下敷 shitajiki) is a pad made of felt. Some are printed with grids on both sides, so that when it is placed under the translucent paper, it can be used as a guide to ensure correct placement and size of characters. However, these printed pads are used only by students. Both desk pads and the printed grids come in a variety of sizes.

Ink and Inkstick

The ink is made from lampblack (soot) and binders, and comes in inksticks which must be rubbed with water on an inkstone until the right consistency is achieved. Much cheaper, pre-mixed bottled inks are now available, but these are used primarily for practice as stick inks are considered higher quality and chemical inks are more prone to bleeding over time, making them less suitable for use in hanging scrolls. Learning to rub the ink is an essential part of calligraphy study. Traditionally, East Asian calligraphy is written only in black ink, but modern calligraphers sometimes use other colours. Calligraphy teachers use a bright orange or red ink with which they write practice characters on which students trace, or to correct students' work.

Inkstone

A stone or ceramic inkstone is used to grind the solid inkstick into liquid ink and to contain the ink once it is liquid. Chinese inkstones are highly prized as art objects and an extensive bibliography is dedicated to their history and appreciation, especially in China.

Seal and Seal paste

Main article: Chinese seal

Calligraphic works are usually completed by the calligrapher putting his or her seal at the very end, in red ink. The seal serves the function of a signature.

Technique: principles

The shape, size, stretch and hairs type of the ink brush, the color, color density and water density of the ink, as well as the paper water absorptive speed and surface texture are the main physical parameters influencing the final result. The calligrapher also influence the result by the quantity of ink/water he let the brush takes first, then by the pressure, inclination, and direction he give to the brush, producing thiner or bolder strokes, and smooth or toothed borders. Eventually, the speed, accelerations, decelerations of the writer's moves, turns, and crochets, and the stroke order give the "spirit" to the characters, by influencing greatly their final shapes.

Study

The bulk of the study of calligraphy is composed of copying exemplary works of reputed calligraphers. Competency in a particular style often requires many years of practice. Correct strokes, stroke order, character structure, balance, and rhythm are essential in calligraphy. A student would also develop their skills in traditional Chinese arts, as familiarity and ability in the arts contributes to their calligraphy.

Since the development of regular script, nearly all calligraphers have started their study by imitating exemplary models of regular script. A beginning student may practice writing the character 永

(Chinese: yǒng, *eternal*) for its abundance of different kinds of strokes and difficulty in construction. The Eight Principles of Yong refers to the eight different strokes in the character, which some argue summarizes the different strokes in regular script.

How the brush is held depends on the calligrapher and which calligraphic genre is practiced. Commonly, the brush is held vertically straight gripped between the thumb and middle finger. The index finger lightly touches the upper part of the shaft of the brush (stabilizing it) while the ring and little fingers tuck under the bottom of the shaft, leaving a space inside the palm. Alternatively, the brush is held in the right hand between the thumb and the index finger, very much like a Western pen. A calligrapher may change his or her grip depending on the style and script. For example, a calligrapher may grip higher for cursive and lower for regular script.

In Japan, smaller pieces of Japanese calligraphy are traditionally written while in seiza. In modern times, however, writers frequently practice calligraphy seated on a chair at a table. Larger pieces may be written while standing; in this case the paper is usually placed directly on the floor, but some calligraphers use an easel.

Basic calligraphy instruction is part of the regular school curriculum in both China and Japan and specialized programs of study exist at the higher education level in China, Korea, and Japan.

Evaluation and appreciation

What is considered good calligraphy often varies depending on individual preferences. However, there are established traditional rules which cannot be violated. Violation of these rules will render a calligraphic work unable to be considered good calligraphy. Those who repeatedly violate these rules are not considered legitimate calligraphers. Among these rules are:

- **The characters must be written correctly.** A correctly written character is composed in a way that is accepted as correct by legitimate calligraphers. Calligraphic works often use variant Chinese characters, which are deemed correct or incorrect on a case-by-case basis, but in general, more popular variants are more likely to be correct. Correct characters are written in the traditional stroke order and not a modern standard (See Stroke Order per Polity).
- **The characters must be legible.** As calligraphy is the method of writing well, a calligraphic work must be recognizable as script, and furthermore be easily legible to those familiar with the script style, although it may be illegible to those unfamiliar with the script style. For example, many people cannot read cursive, but a calligraphic work in cursive can still be considered good if those familiar with cursive can read it.
- **The characters must be concise.** This is in contrast to Western calligraphy where flourishes are acceptable and often desirable. Good Chinese calligraphy must be unadorned script. It must also be in black ink unless there is a reason to write in other ink.
- **The characters must fit their context.** All reputable calligraphers in China were well educated and well read. In addition to calligraphy, they were skilled in other areas, most likely painting, poetry,

music, opera, martial arts, and chess. Therefore, their abundant education contributed to their calligraphy. A calligrapher practicing another calligrapher's characters would always know what the text means, when it was created, and in what circumstances. When they write, their characters' shape and weight agrees with the rhythm of the phrases, especially in less constrained styles such as semi-cursive and cursive. One who does not know the meaning of the characters they write, but vary their shape and weight on a whim, does not produce good calligraphy.

- **The characters must be aesthetically pleasing.** Generally, characters that are written correctly, legibly, concisely, and in the correct context are also aesthetically pleasing to some degree. Characters the violate the above rules are often less aesthetically pleasing.

Influences

Japanese and Korean calligraphies

East Asian Calligraphy usually refers to Chinese character calligraphy. Japanese and Korean people developed specific sensibilities and styles of calligraphies, as well as applying to specific scripts.

Japanese calligraphy extends beyond Han characters to also include local scripts such as hiragana and katakana.

In the case of Korean calligraphy, the Hangeul and the existence of the circle required the creation of a new technique.

The existence of temporary calligraphy is also to be noted. This is the practice of water-only calligraphy on the floor which dries out within minutes. This practice is especially appreciated by the new generation of retired Chinese in public parks of China.

Other arts

Calligraphy has influenced ink and wash painting, which is accomplished using similar tools and techniques. Calligraphy has influenced most major art styles in East Asia, including Ink and wash painting, a style of Chinese, Korean, Japanese painting, and Vietnamese painting based entirely on calligraphy.

Notable calligraphers

China

- Wei Shuo 衛鑠 (272–349)
- Wang Xizhi 王羲之 (303–361)
- Wang Xianzhi 王獻之 (344–386)
- Ouyang Xun 歐陽詢 (557–641)
- Yu Shinan 虞世南 (558–638)
- Chu Suiliang 褚遂良 (597–658)
- Emperor Taizong of Tang 唐太宗 李世民 (599–649)
- Zhang Xu 張旭 (658–747)
- Yan Zhenqing 顏真卿 (709–785)
- Huai Su 懷素 (737–799)
- Liu Gongquan 柳公權 (778–865)
- Emperor Gaozong of Song 宋高宗 趙構 (1107–1187)
- Cai Xiang 蔡襄 (1012–1067)
- Su Shi 蘇軾 (1037–1101)
- Huang Tingjian 黃庭堅 (1045–1105)
- Mi Fu 米黻 (1051–1107)
- Emperor Huizong of Song 宋徽宗 趙佶 (1082–1135)
- Zhao Mengfu 趙孟頫 (1254–1322)
- Ni Zan 倪瓚 (1301–1374)
- Tang Yin 唐寅 (1470–1524)
- Wen Zhengming (1470–1559)
- Dong Qichang 董其昌 (1555–1636)
- Huang Ruheng 黃汝亨 (1558–1626)
- Wang Duo 王鐸 (1592–1652)
- Zheng Xie 鄭燮 (1693–1765)
- Yu Youren 于右任 (1879-1964)

Japan

- Kūkai 空海
- Emperor Saga 嵯峨天皇
- Tachibana no Hayanari 橘逸勢
- Ono Michikaze 小野道風
- Fujiwara no Sukemasa 藤原佐理
- Fujiwara no Yukinari 藤原行成
- Ichikawa Beian 市河米庵
- Iwaya Ichiroku 巌谷一六
- Konoe Nobutada 近衛信尹
- Kusakabe Meikaku 日下部鳴鶴
- Maki Ryōko 巻菱湖
- Nakabayashi Gochiku 中林梧竹
- Nukina Sūō 貫名菘翁
- Shōkadō Shōjō 松花堂昭乗
- Sugawara no Michizane 菅原道真
- Ryōkan 良寬
- Yamaoka Tesshu 山岡鉄舟

Korea

- Choi Chiwon 崔致遠(최치원)
- Kim Saeng 金生(김생)
- Tan Yeon 坦然(탄연)
- Yi Aam 李嵒(이암)
- Yi Yong 李瑢(이용)
- Pak Jega 朴齊家(박제가)
- Kim Jeonghee 金正喜(김정희)
- Kim Myeong-hui 金命喜(김명희)
- Han Ho 韓石峰(한석봉)
- Sejong the Great 世宗大王(세종대왕)
- Grand Prince Anpyeong 安平大君(안평대군)
- Kang Sehwang 姜世晃(강세황)
- Yun Sun 尹淳(윤순)
- Yi I 李珥(이이)
- Yi Hwang 李滉(이황)
- Yi Sun-sin 李舜臣(이순신)
- Shin Saimdang 申師任堂(신사임당)

- Jeong Yak-yong 丁若鏞(정약용)
- Kim Okgyun 金玉均(김옥균)
- An Jung-geun 安重根(안중근)

Gallery

A copy of 上虞帖 by Wang Xizhi

Part of a stone rubbing of 九成宮醴泉銘 [2] by Ouyang Xun

Cry for noble Saichō by Emperor Saga

A work of semi-cursive and cursive by Mi Fu

A work by Emperor Huizong of Song

See also

- Calligraphy
- East asian script styles
- Chinese art
- Japanese art
 - Japanese calligraphy
- Korean art
- Ink and wash painting
- Songti
- Stroke order
- Chinese character
- Eight Principles of Yong
- Wonton font

References

Internal

Books

- Daniels O, *Dictionary of Japanese (Sōsho) Writing Forms*, Lunde Humphries, 1944 (reprinted 1947)
- Deng Sanmu 鄧散木, *Shufa Xuexi Bidu* 書法學習必讀. Hong Kong Taiping Book Department Publishing 香港太平書局出版: Hong Kong, 1978.
- Qiú Xīguī (裘錫圭), *Chinese Writing*, Early China Special Monograph Series No. 4. Berkeley: The Society for the Study of Early China and the Institute of East Asian Studies, University of California, Berkeley, 2000. ISBN 1-55729-071-7.
- Ouyang, Zhongshi & Fong, Wen C., Eds, *Chinese Calligraphy*, Yale University Press, New Haven, 2008. ISBN 9780300121070
- Burckhardt, O. "The Rhythm of the Brush" [1] *Quadrant*, Vol 53, No 6, (June 2009) pp. 124–126. A review-essay that explores the motion of the brush as the hallmark of Chinese calligraphy.

External links

- List of Chinese Calligraphers [2] at China Online Museum
- list of calligraphers [3] at chinapage.com
- History of Chinese Calligraphy [4]
- Introduction to Chinese Calligraphy [5], at Skyren-art.com
- History of Calligraphy in Vietnam [6]
- Basic Calligraphy Styles From Taoism [7] contains introductory comparisons of different calligraphy styles of basic characters.

Indian Art

Indian art

Indian Art is the art produced on the Indian subcontinent from about the 3rd millennium BC to modern times. To viewers schooled in the Western tradition, Indian art may seem overly ornate and sensuous; appreciation of its refinement comes only gradually, as a rule. Voluptuous feeling is given unusually free expression in Indian culture. A strong sense of design is also characteristic of Indian art and can be observed in its modern as well as in its traditional forms.

The vast scope of the art of India intertwines with the cultural history, religions and philosophies which place art production and patronage in social and cultural contexts.

Indian art can be classified into specific periods each reflecting particular religious, political and cultural developments.

- Ancient period (3500 BCE-1200 CE)
- Islamic ascendancy (1192-1757)
- Colonial period (1757–1947)
- Independence and the postcolonial period (Post-1947)

Rock-art

Main article: Indian rock-cut architecture

The earliest Indian religion to inspire major artistic monuments was Buddhism. Though there may have been earlier structures in wood that have been transformed into stone structures, there are no physical evidences for these except textual references. Obscurity shrouds the period between the decline of the Harappans and the definite historic period starting with the Mauryas. Soon after the Buddhists initiated the rock-cut caves, Hindus and Jains started to imitate them at Badami, Aihole, Ellora, Salsette, Elephanta, Aurangabad and Mamallapuram.

Indian rock art has continuously evolved, since the first rock cut caves, to suit different purposes, social and religious contexts, and regional differences.

Indian fresco

The tradition and methods of Indian cliff painting gradually evolved throughout many thousands of years - there are found multiple locations with prehistoric art. The oldest frescoes of historical period have been preserved in Ajanta Caves from 2nd century BC. In total there are known more than 20 locations in India with paintings and traces of former paintings of ancient and early medieval times (up to 8th - 10th century AD). The most significant frescoes of ancient and early medieval period are located in Ajanta Caves, Bagh Caves, Ellora Caves, Sittanavasal.

Chola Fresco of Dancing girls. Brihadisvara Temple c. 1100 C.E.

The Chola fresco paintings were discovered in 1931 within the circumambulatory passage of the Brihadisvara Temple in India and are the first Chola specimens discovered.

Researchers have discovered the technique used in these frescoes. A smooth batter of limestone mixture is applied over the stones, which took two to three days to set. Within that short span, such large paintings were painted with natural organic pigments.

During the Nayak period the chola paintings were painted over. The Chola frescoes lying underneath have an ardent spirit of saivism is expressed in them. They probably synchronised with the completion of the temple by Rajaraja Cholan the Great.

Kerala has well preserved fresco or mural or wall painting in temple walls in Pundarikapuram, Ettumanoor and Aymanam.

Folk and tribal art

Folk and tribal art in India takes on different manifestations through varied medium such as pottery, painting, metalwork, paper-art, weaving and designing of objects such as jewelry and toys.

Often puranic gods and legends are transformed into contemporary forms and familiar images. Fairs, festivals, and local deities play a vital role in these arts.

It is in art where life and creativity are inseparable. The tribal arts have a unique sensitivity, as the tribal people possess an intense awareness very different from the settled and urbanized people. Their minds are supple and intense with myth, legends, snippets from epic, multitudinous gods born out of dream and fantasy. Their art is an expression of their life and holds their passion and mystery.

Folk art also includes the visual expressions of the wandering nomads. This is the art of people who are exposed to changing landscapes as they travel over the valleys and highlands of India. They carry with them the experiences and memories of different spaces and their art consists of the transient and dynamic pattern of life. The rural, tribal and arts of the nomads constitute the matrix of folk expression.

The folk spirit has a tremendous role to play in the development of art and in the overall consciousness of indigenous cultures. The Taj Mahal, the Ajanta and Ellora caves have become world famous. The Taj Mahal is one of the New Seven Wonders of the World.

- Gajavidala
- Warli tribe
- Dhokra Craft

The Taj Mahal built by the Mughals.

Visual art

Main article: Indian painting

British colonial rule had a great impact on Indian art. The old patrons of art became less wealthy and influential, and Western art more ubiquitous. Abanindranath Tagore (1871-1951), referred to as the father of Modern Indian art introduced reworked Asian styles, in alignment with a developing Indian nationalism and pan_Asianism to create a new school of art, which is today known as the Bengal School of art. Other artists of the Tagore family, such as Rabindranath Tagore (1861-1941) and Gaganendranath Tagore (1867-1938) as well as new artists of the early 20th c such as Amrita Sher-Gil (1913-1941) were responsible for introducing Avant garde western styles into Indian Art. Many other artists like Jamini Roy and later S.H. Raza took inspiration from folk traditions.

In 1947 India became independent of British rule. A group of six artists - K. H. Ara, S. K. Bakre, H. A. Gade, M.F. Husain, S.H. Raza and Francis Newton Souza - founded the Progressive Artist's Group, to establish new ways of expressing India in the post-colonial era. Though the group was dissolved in 1956, it was profoundly influential in changing the idiom of Indian art. Almost all India's major artists in the 1950s were associated with the group. Some of those who are well-known today are Bal Chabda, V. S. Gaitonde, Krishen Khanna, Ram Kumar, Tyeb Mehta, Devender Singh, Akbar Padamsee, John Wilkins, Himmat Shah and Manjit Bawa. Present-day Indian art is varied as it had been never before. Among the best-known artists of the newer generation include Sanjay Bhattacharya, Bose Krishnamachari, Narayanan Ramachandran, Geeta Vadhera, Devajyoti Ray, Satish Gupta, and Bikash Bhattacharya. Another prominent Pakistani modernist was Ismail Gulgee, who after about 1960 adopted an abstract idiom that combines aspects of Islamic calligraphy with an abstract expressionist (or gestural abstractionist) sensibility.

Contemporary art

From the 1990s onwards, Indian artists began to increase the forms they used in their work. Painting and sculpture remained important, though in the work of leading artists such as Subodh Gupta,Narayanan Ramachandran, Vivan Sundaram, Jitish Kallat, Jagannath Panda, Atul and Anju Dodiya, T.V.Santosh, Bharti Kher and Thukral and Tagra, they often found radical new directions.

Crucially, however, in a complex time when the number of currents affecting Indian society seemed to multiply, many artists sought out new, more polyvocal and immersive forms of expression. Ranbir Kaleka, Raqs Media Collective[1] have produced compelling contemporary works using such assortments of media forms including video and

Sneha-village belle, Oil on canvas by John Wilkins(Indian artist)

internet.Narayanan Ramachandran [2] created a new style of painting called Third Eye Series. This development coincided with the emergence of new galleries interested in promoting a wider range of art forms, such as Nature Morte in Delhi and its partner gallery Bose Pacia Gallery (New York and Kolkata) and Sakshi Gallery, Chatterjee and Lal, and Project 88 (http://www.project88.in)and kalpa:vraksha (http://www.kalpavraksha.in) in Mumbai. In addition, Talwar Gallery in New Delhi, India and New York, NY, represents a roster of diverse, internationally recognized artists from India and the Diaspora maintaining that the artist is geographically located and not the art (www.talwargallery.com). In the UK, in April 2006, The Noble Sage Art Gallery www.thenoblesage.com [3] opened to specialise exclusively in Indian, Sri Lankan and Pakistani contemporary art. The Noble Sage, rather than looking to the Mumbai, Delhi and Baroda schools, saw their gallery as an opportunity to platform the South Indian contemporary art scene, particularly the work arising from the Madras School. Artists highlighted by The Noble Sage collection include the late K.M. Adimoolam, A.P. Santhanaraj and S. Dhanapal, senior artists Achuthan Kudallur, Alphonso Doss and R.B. Bhaskaran, through to new talent such as Benitha Perciyal, S. Ravi Shankar, P. Jayakani and T. Athiveerapandian.

At the same, ironically, the absence of gallery or white cube support for newer ventures, produced a lot of artists who were connected to the Bangalore art scene(like Surekha's "Communing With Urban Heroins" (2008) and "Un-Claimed and Other Urban F(r)ictions", 2010) and those who produced a sense of art-community or art-activism in a certain sense.

Contemporary Indian art takes influence from all over the world. With many Indian artists immigrating to the west, art for some artists has been a form of expression merging their past with their current in

western culture.

Also, the increase in the discourse about Indian art, in English as well as vernacular Indian languages, appropriated the way art was perceived in the art schools. Critical approach became rigorous, critics like Geeta Kapur, Shivaji K. Panikkar, Parul Dave Mukherji, R. Siva Kumar, Gayathri Sinha, Anil Kumar H.A and Suresh Jayaram, amongst others, contributed to re-thinking contemporary art practice in India. The last decade or so has also witnessed an increase in Art magazines like Art India (from Bombay), Art & Deal (New Delhi, edited and published by Siddharth Tagore), 'Art Etc.' (from Emami Chisel, edited by Amit Mukhopadhyay) complementing the catalogues produced by the respective galleries.

Music

Main article: Music of India

The music of India includes multiple varieties of folk, popular, pop, and classical music. India's classical music tradition, including Carnatic and Hindustani music, has a history spanning millennia and, developed over several eras, remains fundamental to the lives of Indians today as sources of religious inspiration, cultural expression and pure entertainment. India is made up of several dozen ethnic groups, speaking their own languages and dialects. Alongside distinctly subcontinental forms there are major influences from Persian, Arabic and British music.Indian genres like filmi and bhangra have become popular throughout the United Kingdom, South and East Asia,

See also

- The Arts Trust - Institute of Contemporary Indian Art
- Culture of India
- *The Dictionary of Indian Art and Artists* (book)
- Rasa (art)
- Bengal school of art
- Pseudorealism
- Indian painting
- Indian architecture

 - Indian vernacular architecture
- Patna School of Painting or Patna Qalaam
- Raqs Media Collective
- Bose Pacia Gallery
- Art Alive Gallery, New Delhi
- Talwar Gallery
- [kalpa:vraksha [4]]

External links

- Twentieth Century Indian Art in Mukul Dey Archives [5]
- India Art Architecture Heritage Online Exhibition [6]
- Central Indian pictures, Garhwal painting, Kangra painting, Mughal painting [7]
- Which Way Indian Art? by Mukul Dey [8]
- Twentieth Century Indian Art [9]
- Gond Tribal Art [10]
- Punjabi Paintings - Inspired Indian Art [11]
- India: The Living Arts - The Canadian Museum of Civilization [12]

References

- Harsha V. Dehejia, *The Advaita of Art* (Delhi: Motilal Banarsidass, 2000, ISBN 81-208-1389-8), p. 97
- Kapila Vatsyayan, *Classical Indian Dance in Literature and the Arts* (New Delhi: Sangeet Natak Akademi, 1977), p. 8
- Mitter, Partha. *Indian Art* (Oxford: Oxford University Press, 2001, ISBN 0-19-284221-8)

Indian painting

Indian painting is a form of Indian art. The earliest **Indian paintings** were the rock paintings of pre-historic times, the petroglyphs as found in places like Bhimbetka, and some of them are older than 5500 BC. Such works continued and after several millennia, in the 7th century, carved pillars of Ellora, Maharashtra state present a fine example of Indian paintings, and the colors, mostly various shades of red and orange, were derived from minerals. Thereafter, frescoes of Ajanta and Ellora Caves appeared. India's Buddhist literature is replete with examples of texts which describe that palaces of kings and aristocratic class were embellished with paintings, but they have largely not survived. But, it is believed that some form of art painting was practiced during that time.

Raja Ravi Varma's Shakuntala

Indian paintings provide an aesthetic continuum that extends from the early civilization to the present day. From being essentially religious in purpose in the beginning, Indian painting has evolved over the years to become a fusion of various cultures and traditions. The Indian painting was exposed to Greco-Roman as well as Iranian and Chinese influences. Cave paintings in different parts of India bear testimony to these influences and a continuous evolution of new idioms is evident.

Sadanga of Indian painting

Around 1st century BC the *Sadanga* or Six Limbs of Indian Painting, were evolved, a series of canons laying down the main principles of the art. Vatsyayana, who lived during the third century A.D., enumerates these in his Kamasutra having extracted them from still more ancient works.

These 'Six Limbs' have been translated as follows:

1. *Rupabheda* The knowledge of appearances.
2. *Pramanam* Correct perception, measure and structure.
3. *Bhava* Action of feelings on forms.
4. *Lavanya Yojanam* Infusion of grace, artistic representation.
5. *Sadrisyam* Similitude.
6. *Varnikabhanga* Artistic manner of using the brush and colours. (Tagore.)

The subsequent development of painting by the Buddhists indicates that these ' Six Limbs ' were put into practice by Indian artists, and are the basic principles on which their art was founded.

Genres of Indian painting

Indian Paintings can be broadly classified as the murals and miniatures. Murals are huge works executed on the walls of solid structures, as in the Ajanta Caves and the Kailashnath temple. Miniature paintings are executed on a very small scale on perishable material such as paper and cloth. The Palas of Bengal were the pioneers of miniature painting in India. The art of miniature painting reached its glory during the Mughal period. The tradition of miniature paintings was carried forward by the painters of different Rajasthani schools of painting like the Bundi, Kishangarh, Jaipur, Marwar and Mewar. The Ragamala paintings also belong to this school.

The modern Indian art has seen the rise of the Bengal School of art in 1930s followed by many forms of experimentations in European and Indian styles. In the aftermath of India's independence, many new genres of art developed by important artists like Jamini Roy, MF Husain, FN Souza, and Gaitonde. With the progress of the economy the forms and styles of art also underwent many changes. In the 1990s, Indian economy was liberalized and integrated to the world economy leading to the free flow oif cultural information within and without. This period saw the emergence of Pseudorealism as a new genre in contemporary Indian art. Alongside this the country saw the rise of mahny young Turks in the field of art like Subodh Gupta, Atul Dodiya, Devajyoti Ray, Bose Krishnamachari and Jitish Kahllat

whose works went for auction in international markets.

Murals

The history of Indian murals starts in ancient and early medieval times, from 2nd century BC to 8th - 10th century AD. There are known more than 20 locations around India containing murals from this period, mainly natural caves and rock-cut chambers. The highest achievements of this time are the caves of Ajanta, Bagh, Sittanavasal, Armamalai Cave (Tamil Nadu), Ravan Chhaya rock shelter, Kailasanatha temple in Ellora Caves.

Murals from this period depict mainly religious themes of Buddhist, Jain and Hindu religions. There are though also locations where paintings were made to adorn mundane premises, like the ancient theatre room in Jogimara Cave and possible royal hunting lodge circa 7th century AD - Ravan Chhaya rock shelter.

Miniature painting

The pattern of large scale wall painting which had dominated the scene, witnessed the advent of miniature paintings during the 11th & 12th centuries. This new style figured first in the form of illustrations etched on palm-leaf manuscripts. The contents of these manuscripts included literature on Buddhism & Jainism. In eastern India, the principal centres of artistic and intellectual activities of the Buddhist religion were Nalanda, Odantapuri, Vikramshila and Somarpura situated in the Pala kingdom (Bengal & Bihar).

Eastern Indian painting

In eastern India miniature painting developed in 10th century. These miniatures, depicting Buddhist divinities and scenes from the life of Buddha were painted on the leaves (about 2.25 by 3 inches) of the palm-leaf manuscripts as well as their wooden covers. Most common Buddhist illustrated manuscripts include the texts *Astasahasrika Prajnaparamita*, *Pancharaksa*, *Karandavyuha* and *Kalachakrayanatantra*. The earliest extant miniatures are found in a manuscript of the *Astasahasrika Prajnaparamita* dated in the sixth regnal year of Mahipala (c. 993), presently in the possession of The Asiatic Society, Kolkata. This style disappeared from India in the late 12th century.

Western Indian painting

In western India between the 10th to 12th century miniature painting developed. These small paintings were part of manuscripts written at the time and illustrate the subjects of the manuscripts. These miniatures are found in some Jaina manuscripts and are of 2 to 4 inches in size.

Earliest Jaina illustrated palm-leaf manuscripts include the texts *Ogha-niryukti* and *Dasavaikalika-tika*. Another surviving example of early illustrated Jaina palm-leaf manuscript is the *Savaga-padikkamana-sutta-cunni* written by Pandit Ramachandra (13th century).

It was in the 14th century, that paper replaced the palm leaf. Most common Jaina illustrated paper manuscripts include the Kalpasutra of Bhadrabahu and the *Kalakacharyakatha*. The Jaina style of paintings attained a high degree of development by the late 15th and 16th century.

In the 16th century, a number of Hindu illustrated manuscripts appeared in western India, which include the texts, the Gitagovinda of Jayadeva and the Bhagavata Purana.

Malwa, Deccan and Jaunpur schools of painting

A new trend in manuscript illustration was set by a manuscript of the *Nimatnama* painted at Mandu, during the reign of Nasir Shah (1500–1510). This represent a synthesis of the indigenous and the Persion style, though it was the latter which dominated the Mandu manuscripts. There was another style of painting known as Lodi Khuladar that flourished in the Sultanate's dominion of North India extending from Delhi to Jaunpur.

The miniature painting style, which flourished initially in the Bahmani court and later in the courts of Ahmadnagar, Bijapur and Golkonda is popularly known as the Deccan school of Painting. One of the earliest surviving paintings are found as the illustrations of a manuscript *Tarif-i-Hussain Shahi* (c.1565), which is now in Bharata Itihasa Samshodhaka Mandala, Pune. About 400 miniature paintings are found in the manuscript of Nujum-ul-Ulum (Stars of Science) (1570), kept in Chester Beatty Library, Dublin.

Mughal painting

Main article: Mughal painting

Mughal painting is a particular style of Indian painting, generally confined to illustrations on the book and done in miniatures, and which emerged, developed and took shape during the period of the Mughal Empire 16th -19th centuries).

Mughal paintings were a unique blend of Indian, Persian and Islamic styles. Because the Mughal kings wanted visual records of their deeds as hunters and conquerors, their artists accompanied them on military expeditions or missions of state, or recorded their prowess as animal slayers, or depicted them in the great dynastic ceremonies of marriages.

Akbar's reign (1556–1605) ushered a new era in Indian miniature painting. After he had consolidated his political power, he built a new capital at Fatehpur Sikri where he collected artists from India and Persia. He was the first morarch who established in India an atelier under the supervision of two Persian master artists, Mir Sayyed Ali and Abdus Samad. Earlier, both of them had served under the patronage of Humayun in Kabul and accompanied him to India when he regained his throne in 1555. More than a hundred painters were employed, most of whom were Hindus from Gujarat, Gwalior and Kashmir, who gave a birth to a new school of painting, popularly known as the Mughal School of miniature Paintings.

One of the first productions of that school of miniature painting was the Hamzanama series, which according to the court historian, Badayuni, was started in 1567 and completed in 1582. The Hamzanama, stories of Amir Hamza, an uncle of the Prophet, were illustrated by Mir Sayyid Ali. The paintings of the Hamzanama are of large size, 20 x 27" and were painted on cloth. They are in the Persian safavi style. Brilliant red, blue and green colours predominate; the pink, eroded rocks and the vegetation, planes and blossoming plum and peach trees are reminiscent of Persia. However, Indian tones appear in later work, when Indian artists were employed.

After him, Jahangir encouraged artists to paint portraits and durbar scenes. His most talented portrait painters were Ustad Mansur, Abul Hasan and Bishandas.

Shah Jahan (1627–1658) continued the patronage of painting. Some of the famous artists of the period were Mohammad Faqirullah Khan, Mir Hashim, Muhammad Nadir, Bichitr, Chitarman, Anupchhatar, Manohar and Honhar.

Aurangzeb had no taste for fine arts. Due to lack of patronage artists migrated to Hyderabad in the Deccan and to the Hindu states of Rajasthan in search of new patrons.

Rajput painting

Main article: Rajput painting

Rajput painting, a style of Indian painting, evolved and flourished, during the 18th century, in the royal courts of Rajputana, India. Each Rajput kingdom evolved a distinct style, but with certain common features. Rajput paintings depict a number of themes, events of epics like the Ramayana and the Mahabharata, Krishna's life, beautiful landscapes, and humans. Miniatures were the preferred medium of Rajput painting, but several manuscripts also contain Rajput paintings, and paintings were even done on the walls of palaces, inner chambers of the forts, havelies, particularly, the havelis of Shekhawati.

The colours extracted from certain minerals, plant sources, conch shells, and were even derived by processing precious stones, gold and silver were used. The preparation of desired colours was a lengthy process, sometimes taking weeks. Brushes used were very fine.

Mysore painting

Main article: Mysore painting

Mysore painting is an important form of classical South Indian painting that originated in the town of Mysore in Karnataka. These paintings are known for their elegance, muted colours, and attention to detail. The themes for most of these paintings are Hindu Gods and Goddesses and scenes from Hindu mythology. In modern times, these paintings have become a much sought after souvenir during festive occasions in South India.

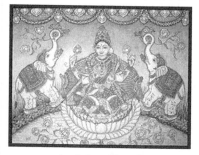

A painting of Laxmi

The process of making a Mysore painting involves many stages. The first stage involves the making of the preliminary sketch of the image on the base. The base consists of cartridge paper pasted on a wooden base. A paste made of Zinc oxide and Arabic gum is made called "gesso paste". With the help of a thin brush all the jewellery and parts of throne or the arch which have some relief are painted over to give a slightly raised effect of carving. This is allowed to dry. On this thin gold foil is pasted. The rest of the drawing is then painted using watercolours. Only muted colours are used.

Tanjore painting

Main article: Tanjore painting

Tanjore painting is an important form of classical South Indian painting native to the town of Tanjore in Tamil Nadu. The art form dates back to the early 9th century, a period dominated by the Chola rulers, who encouraged art and literature. These paintings are known for their elegance, rich colours, and attention to detail. The themes for most of these paintings are Hindu Gods and Goddesses and scenes from Hindu mythology. In modern times, these paintings have become a much sought after souvenir during festive occasions in South India.

The process of making a Tanjore painting involves many stages. The first stage involves the making of the preliminary sketch of the image on the base. The base consists of a cloth pasted over a wooden base. Then chalk powder or zinc oxide is mixed with water-soluble adhesive and applied on the base. To make the base smoother, a mild abrasive is sometimes used. After the drawing is made, decoration of the jewellery and the apparels in the image is done with semi-precious stones. Laces or threads are also used to decorate the jewellery. On top of this, the gold foils are pasted. Finally, dyes are used to add colours to the figures in the paintings.

Madhubani painting

Main article: Madhubani painting

Madhubani painting is a style of uttradi mutt painting, practiced in the Mithila region of Bihar state, India. The origins of Madhubani painting are shrouded in antiquity, and a tradition states that this style of painting originated at the time of the Ramayana, when King Janak commissioned artists to do paintings at the time of marriage of his daughter, Sita, with Sri Rama who is considered to be an incarnation of the Hindu god lord Vishnu.

Pattachitra

Main article: Pattachitra

Pattachitra refers to the folk painting of the state of Orissa, in the eastern region of India.'Patta' in Sanskrit means 'Vastra' or 'clothings' and 'chitra' means paintings.The tradition of Pattachitra is closely linked with the worship of Lord Jagannath. Apart from the fragmentary evidence of paintings on the caves of Khandagiri and Udayagiri and Sitabhinji murals of the Sixth century A.D., the earliest indigenous paintings from Odisha are the Pattachitra done by the Chitrakars (the painters are called Chitrakars). The theme of

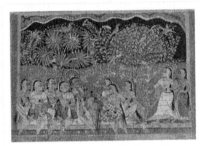

Gita Govinda depicted in Pattachitra

Odishan painting centres round the Vaishnava cult. Since beginning of Pattachitra culture Lord Jagannath who was an incarnation of Lord Krishna was the major source of inspiration. The subject matter of Patta Chitra is mostly mythological, religious stories and folk lore. Themes are chiefly on Lord Jagannath and Radha-Krishna, different "Vesas" of Jagannath, Balabhadra and Subhadra, temple activities, the ten incarnations of Vishnu basing on the 'Gita Govinda' of Jayadev, Kama Kujara Naba Gunjara, Ramayana, Mahabharata. The individual paintings of gods and goddesses are also being painted.The painters use vegetable and mineral colours without going for factory made poster colours. They prepare their own colours. White colour is made from the conch-shells by powdering, boiling and filtering in a very hazardous process. It requires a lot of patience. But this process gives brilliance and premanence to the hue. 'Hingula', a mineral colour, is used for red. 'Haritala', king of stone ingredients for yellow, 'Ramaraja' a sort of indigo for blue are being used. Pure lamp-black or black prepared from the burning of cocoanut shells are used.The brushes that are used by these 'Chitrakaras' are also indigenous and are made of hair of domestic animals. A bunch of hair tied to the end of a bamboo stick make the brush. It is really a matter of wonder as to how these painters bring out lines of such precision and finish with the help of these crude brushes. That old tradition of Odishan painting still survives to-day in the skilled hands of Chitrakaras (traditional painters) in Puri, Raghurajpur, Paralakhemundi, Chikiti and Sonepur.

Bengal school

Main article: Bengal school of art

The Bengal School of Art was an influential style of art that flourished in India during the British Raj in the early 20th century. It was associated with Indian nationalism, but was also promoted and supported by many British arts administrators.

The Bengal school arose as an avant garde and nationalist movement reacting against the academic art styles previously promoted in India, both by Indian artists such as Ravi Varma and in British art schools. Following the widespread influence of Indian spiritual ideas in the West, the British art teacher Ernest Binfield Havel attempted to reform the teaching methods at the Calcutta School of Art by encouraging students to imitate Mughal miniatures. This caused immense controversy, leading to a strike by students and complaints from the local press, including from nationalists who considered it to be a retrogressive move. Havel was supported by the artist Abanindranath Tagore, a nephew of the poet Rabindranath Tagore. Tagore painted a number of works influenced by Mughal art, a style that he and Havel believed to be expressive of India's distinct spiritual qualities, as opposed to the "materialism" of the West. Tagore's best-known painting, *Bharat Mata* (Mother India), depicted a young woman, portrayed with four arms in the manner of Hindu deities, holding objects symbolic of India's national aspirations. Tagore later attempted to develop links with Japanese artists as part of an aspiration to construct a pan-Asianist model of art.

The Bengal school's influence in India declined with the spread of modernist ideas in the 1920s.

Modern Indian Painting

During the colonial era, Western influences started to make an impact on Indian art. Some artists developed a style that used Western ideas of composition, perspective and realism to illustrate Indian themes. Others, like Jamini Roy, consciously drew inspiration from folk art.

By the time of Independence in 1947, several schools of art in India provided access to modern techniques and ideas. Galleries were established to showcase these artists. Modern Indian art typically shows the influence of Western styles, but is often inspired by Indian themes and images. Major artists are beginning to gain international recognition, initially among the Indian diaspora, but also among non-Indian audiences.

Three Girls, by Amrita Sher-Gil, 1935, now at the National Gallery of Modern Art in New Delhi

The Progressive Artists' Group, established shortly after India became independent in 1947, was intended to establish new ways of expressing India in the post-colonial era. The founders were six eminent artists - K. H. Ara, S. K. Bakre, H. A. Gade, M.F. Husain, S.H. Raza and F. N. Souza, though the group was dissolved in 1956, it was profoundly influential in changing the idiom of Indian art. Almost all India's major artists in the 1950s were associated with the group. Some of those who are well-known today are Bal Chabda, Om Swami, V. S. Gaitonde, Krishen Khanna, Ram Kumar, Tyeb Mehta, and Akbar Padamsee. Other famous painters like Jahar Dasgupta, Prokash Karmakar, John Wilkins,Narayanan Ramachandran, and Bijon Choudhuri enriched the art culture of India. They have become the icon of modern Indian art. Art historians like Prof. Rai Anand Krishna have also referred to those works of modern artistes that reflect Indian ethos. Some of the new artists like Geeta Vadhera have had acclaim in translating complex, Indian spiritual themes into the canvas - Sufi thought [1], Upanishads and the Bhagwad Geeta, for

Sneha-village belle, Oil on canvas by John Wilkins(Indian artist)

example. From 1990 to till 2009 the Indian art is growing with powerful expression. one of them is Raj mehta working in lucknow, recent work on women the silent feature of women mind.the city of

nawabs. it has the great history, ruled many kings and the loving place of all emperial power. Raj mehta work in painting and mural. kriti art gallery in varanasi explore his work in India. "Third Eye Series", is a new style of painting brought out by Narayanan Ramachandran, during 1990 to 2010.

Indian Art got a boost with the economic liberalization of the country since early 1990s. Artists from various fields now started bringing in varied styles of work. Post liberalization Indian art thus works not only within the confines of academic traditions but also outside it. Artists like Chittrobhanu Majumdar, A Ramachandran, etc have introduced newer mediums in art. In this phase, artists have introduced even newer concepts which have hitherto not been seen in Indian art. Devajyoti Ray has introduced a the new genre of art called Pseudorealism. Pseudorealist Art is an original art style that has been developed entirely on the Indian soil. Pseudorealism takes into account the Indian concept of abstraction and uses it to transform regular scenes of Indian life into a fantastic images.

In post-liberalization India, many artists have establisghed themselves in the international art market like Anish Kapoor whose mammoth artworks have acquired attention for their sheer size. Many art houses and galleries have also opened in USA and Europe to showcase Indian artworks.

Gallery

Some notable Indian paintings

- Hemen Majumdar's "Lady with the Lamp"
- Rabindranath Tagore's "Self portrait"
- Abanindranath Tagore's Bharat Mata
- Raja Ravi Varma's Shakuntala
- Ramkinkar Baij's "Jakkha 0 Jakkhi"
- Bikash Bhattacharya's "Doll-series"
- Geeta Vadhera's Jogia "Dhoop series"
- Jahar Dasgupta's "Confrontation"
- MF Hussain's "Horses-series"
- Jamini Roy's "Jesus"
- John Wilkins's "Gossip",
- Rakesh Vijay "Persian and Mogul styles"
- Jainul Abedin's "Series on Bengal Famine"
- Sunil Das's "Bull Series"
- Devajyoti Ray's "In Despair"
- Tyeb Mehta's "Mahisasur"
- B. G. Sharma's Krishna miniatures

See also

- Warli Painting
- Painting
- History of painting
- Eastern art history

Further reading

- *Indian Painting*, by Percy Brown. Published by Y. M. C. A. publishing house, 1960.
- *Indian Painting*, by Philip S. Rawson. Published by P.Tisné, 1961.
- *Indian Painting: The Scene, Themes, and Legends*, by Mohindar Singh Randhawa, John Kenneth Galbraith. Published by Houghton Mifflin, 1968.
- *Indian Painting*, by Douglas E. Barrett, Basil Gray. Published by Skira, 1978. ISBN 0847801608.
- *A History of Indian Painting: The Modern Period* [1] by Krishna Chaitanya. Published by Abhinav Publications, 1994. ISBN 8170173108.

External links

- The Arts Trust- Biggest Indian art website [2]
- Paintings of India [3]
- Example of Traditional Indian Paintings and Indian Art Prints [4]

Online exhibits

- Online exhibition from the Virginia Museum [5]
- Metmusuem.org [6]
- OWNWAY Online Creative Exhibitions [7]
- Example of Indian Paintings [8]
- Examples of Gond Tribal Art [10]
- The styles of Indian medieval painting schools [9]

Rangoli

Rangoli is an ancient cultural tradition and folk art from India. The name and style of rangoli in different regions may vary, but the spirit and culture behind it have many similarities. This characteristic gives it its diversity and its various dimensions. Generally this festival, fast, worship, celebration marriage auspicious occasions etc. drought and natural colors are made from. The simple geometric shapes may or deities of the shapes. Their purpose is decoration and Sumngl. They are often made by the women of the house. Traditional artifacts to be made on various occasions concerning the different friendly opportunities - are different. This brought the traditional colors used for dry or wet granulated rice, vermilion, Roli,turmeric, dry flour and other natural colors are used but still in Rangoli also has begun to use chemical colors. Rangoli Dehri the door, and the celebration for the center of the courtyard in between or around certain location is created. Sometimes - sometimes it flowers, wood or any other object Burade or rice, etc. are made from grain.

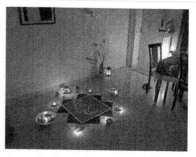

A rangoli painted on the occasion of Diwali, a popular Hindu festival.

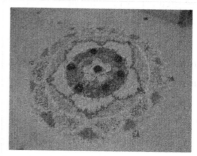

A rangoli made with flowers on the occasion of Onam.

History

Alpana is a name of rangoli. Mohen-jo-daro and Harappa were also Alpana Ommandi meet the mark. Vatsyayan Alpana's work - the formula is described in Chausst arts. The most ancient folk art. Usually in terms of its origin is known that 'Alpana' word Sanskrit 's - 'Oalanpeen word is derived from, Oalanpeen means - to plaster. In ancient times people believed that these funds artistic painting the town and villages - are able to contain cereal is full of magical effects and reserve assets. This approach was Alpana art practiced religious and social occasions. Many fast or worship, which is given the Alpana, Aryan is the era before. Swami Anand Kumar, who are called scholars of Indian art, modern folk art of Bengal's view that the direct link is from 5000 years ago the art of Mohen-jo-daro. Waratchari movement and Bangla folk art and culture scholar Gurushay generator according to Dutt, the lotus flower Bengali women make between their Alpanooan, at Mohenjo-daro of the lotus flower is a replica. Some other scholars are of the opinion that Alpana Astrik people in our culture, such as shaved species come from, which in this country many years before the arrival of Aryans were living. According to the ancient and traditional folk arts of Bangladesh's agricultural era standing. At that time

some people believe that gods and had some magical effects, which in practice would have been a good harvest and Priatatmaaey had run away.[2] of Alpana Inspired by these traditional Aleknoan Acharya Awneendranath Tagore Santiniketan art building with other subjects of painting - this art also made a compulsory subject. Today this art are known as Alpana of Santiniketan. The blonde goddess in art will enjoy the memorable name of the mother are considered Alpana Santiniketan.

The purpose of Rangoli

Rangoli religious and cultural beliefs is the symbol. It is considered an important part of this spiritual process.[3] why the various gifts and sacrifices in the 'altar' are created when creating the माँडने. Rural Anchaloan home - yard Buharkar Llypane still exists after the custom of making rangoli. Land - called the purification of the spirit and prosperity lies behind it. Alpana philosophy of life which symbolizes the impermanence of knowing with full enthusiasm and devotion present wished to live with Sumngl remains constant. The knowing that tomorrow it will be washed, which is the purpose, he wished to be the greatest. Additional house festivals - family occasions or just like any other Manglik say that the art of decorating rangoli is now not only limited to Pujagrah. Women with great passion and enthusiasm in every room of the house and make rangoli at the entrance. The hobby itself the basis of his fiction is already there, eternally - innovative creation is symbolic of the spirit. Rangoli created at the icons such as the swastika, lotus flower, Lakshmiji step (Pegalie) etc. are considered indicators of prosperity and Mangalkamn. Many homes today, ahead of Dewalyoan Rangoli is made daily. Customs - customs Sshajti - सँवारती The art has also become a part of modern families. Introduction of diversified interest in craftsmanship and artistic home - decor created for almost all except the few माँडणो माँडणे are a symbol of human spirit. And thus an important means to realize our cultural feelings are considered. Rangoli symbolizes joy and happiness Rangamayie expressions.[4]

Rangoli different provinces

Rangoli art is an adornment that India has different names in different provinces. Uttar Pradesh in the square Purna, Rajasthan in the Mmandn, Bihar in the Aripan, Bengal Alpana in[5], Maharashtra in the rangoli, Rangavallie in Karnataka, Tamil Nadu, Kollam, ऐपण in Uttaranchal,[6] Andhra Pradesh in the Muggu or Muggulu, HP 'Aroopn', Kumaon in the Alikhthap or Thapa[7], the Kerala in the Kolam, Gujarat in Saathiyo. There are many variations in these Rangolioan. Maharashtra Rangoli their homes on the door in the morning so create an evil force in the house so that they could not enter. [8] India's southern Kerala settled on the edge Onam rangoli on the occasion of flowers used to decorate is.[9] South Indian Province - Tamil Nadu, Andhra Pradesh and Karnataka, the 'column' is some margin but their basics are unchanged. These are decorated in geometric and symmetrical मूल्यतः sizes. For rice flour or slurry is used. The back of the rice flour used to be white and easy availability. Between the thumb and forefinger of dried rice flour by putting a certain cast is dropped.[10] Rajasthan Mandana the word was taken from the corroboration means is decoration. Mmandne various festivals, major

festivals and क can be categorized based on seasons. Different shapes depending on the size of it also can be shared.[11] Kumaon 's "writing beat 'or in a variety of plotting symbols Thapa, artistic designs, Bellbutoan is used. Alikhthap of society apart - separated by different groups - different icons and art media is used.[12] South Indian rangoli usually based on geometric shapes while at the north of the auspicious signs.

Key elements of Rangoli

Rangoli India belong to any province, the folk art, so its elements are taken from the public are common. Rangoli is the most important element Utswdhermita. For this auspicious symbols are selected. Thus the symbol for generations as they are made - and is required to make these symbols. Traditionally new generation learns the art and thus our - my family keeps the tradition intact. [13] rangoli major symbols of a lotus flower, its leaves, mango, Tue vase, fish, different kind birds, parrot, swan, peacock, human figures and foliage are found in almost all India's Rangolioan. Rangolioan to be made on special occasions also undermines some special shapes such as Diwali Rangoli in the Deep, Ganesha or Lakshmi. The second key element is using rangoli incoming material. The same material is used which is easily found everywhere. Therefore this art rich - poor is prevalent in all homes. Normally the major ingredients to make rangoli - Pise rice solution, dried powder made from the leaves color, charcoal, burned soil was, wood sawdust, etc.. Rangoli is the third important element background. Rangoli for the background was clear floor or wall or Llype is used. Rangoli yard in the middle, corners, or as Bell is created around. Dehri gateway on the tradition of making rangoli. God's seat, depending on lamp, place of worship and sacrifice on the altar is the tradition of decorating rangoli. With time, imagination and innovative ideas in Rangoli art is also incorporated. Hospitality and tourism has also had its effect and it has been commercially developed. The colors also convenient because it places such as hotels is being built on its traditional charm, artistry and importance are still remain.

Rangoli creation of

Rangoli is made in two ways. Dry and wet. Both a generous and is created by adding other points. The rangoli made by adding points to the first white paint on the ground in a particular size are made certain point then shaking the points is a beautiful figure takes shape. After creating the desired shape, there are full color. Freehand rangoli image is created directly on the ground.[14] Traditional Mmandn make ocher and gray is used vertically. Rangoli rangoli colors to meet the market diversify the color can be made. Rangoli making trouble for those wanting the freedom to decorate your home Dehri 'Redimad rangoli' sticker found in the market, which desired pasting location for Rangoli patterns can be created. In addition, the market has emerged as plastic shapes but also get points, which put him on the floor putting up paint beautiful shape emerging from the ground comes. Rangoli is the practice of making these items can be used. See some of which cast the flour or colored powder that can be filled. There

are small holes per sample. Slightly off the floor as they collide at certain locations Zrta colors and beautiful piece becomes manifest. Using plastic to make rangoli are also Steeansils.[15] wet Rangoli rice water mixed up in it Peiskara crafted. The solution to the ऐपण, ऐपन or Pithaar called. Use this colorful turmeric is also used to make. In addition to the market to meet colorful rangoli posters, crayons, Febrik and are made from acrylic colors.[16]

A newer trend of making rangolies involves using cement colours with marble powder. This is a rather precise method but requires some previous training. Beautiful portraits can be drawn using this method.

Faith and beliefs

Tamil Nadu it is prevalent myth that Markarie married in the month of Divine Andaal Tihrumal begged the Lord. After long meditation he disappeared in Tihrumal were God. So this month, unmarried girls got up before dawn to welcome God Tihrumal rangoli are Sszati.[17]rangoli on mythology are prevalent in many stories. The first Indian treatise on painting 'pictures symptoms "refers to a legend comes, she follows - the son of a king, priest died. Brahma said to the king that he built on land given sketches of the boy so he could be put to life. Some lines on the floor Akieanchian king, from here or rangoli Alpana was introduced. In this context is another story that Brahma created the craze for the common juice by removing trees that formed the shape of a woman on the floor. Monster was going to beat the beauty of woman, the woman later Urvashi Kaahalai. The shape of rangoli Akieanchian by Brahma was the first form. See also references on Rangoli legendary, such as - Ramayana in Sita 's wedding pavilion where the discussion refers to rangoli there too. Cultural development in the south of Rangoli originated in the era of the Chola rulers.[18]behind the use of rice flour to feed the perception that the ant should. Here it is considered that the columns of the shed to get food to animals other creatures protecting the natural cycle.[19] Rangoli is not removed from the sweep or legs but they mixed with water fountains or mud is removed from the hands . Mithilaanchal no such festival - festival or (Upanan - someone like marriage) ceremony in the courtyard walls and painting the house is not done. Separately for each occasion of ढंग "Aripan" which made different - different spiritual meaning. On the occasion of marriage, groom - bride's cell wall targets "Kaohaber" and "Naina Jogin" such as pictures, which are actually based system, is the pattern of the specifics of painting. [20]

Water and rangoli

Nowadays rangoli artists to have made even through water. For it in a tub or tank with water in stagnant water is poured and leveled. It is trying to wind or water that may not come across any other kind of momentum. Then the charcoal powder is sprinkled. Rangoli with other materials to decorate the artist. Such grand sees rangoli.[21] on the water full of flowers and lamps with the aid of Pankhudiyoan the rangoli is made. To prevent surface water colors instead of charcoal, Disteeanpar or melt the wax is also used.[22] are also made some रंगोलियाँ underwater. It is filled with water in a shallow pot or tray on a saucer then Rangoli is made by putting the oil well. Later on it gently with a slight oil sprayed water at

the bottom of the pot is placed. Rangoli in water due to oil spreads No.[23] Maharashtra's Nagpur resident of Vandana Joshi has mastered making a rangoli. Rangoli making it the world's first female over the water and the 7 February 2004 by the world's largest rangoli Guinness Book of World Records have been registered in your name.[24] The other major artist Prince to make rangoli on water are sandalwood. They Dewas Mita in 17 acres of pools of water to make rangoli on the giant worked wonders.[25]

Rangoli rooted in tradition and modernity

Rangoli Indian folk painting is the most ancient cultural traditions. See the painting of the three major - Land illustration, mural painting and drawing on paper and textiles. [26]The most popular Land graphs, which is known as Rangoli or Alpana. For paintings of Bihar, Madhubani district and Thane Worli is a place called Famous. Their design styles and creative content is the same as Rangoli. Good marks on various occasions with a variety of decorations of the walls are paintings. The third type consists of drawing paper or fabric. ज्यूँति it in Kumaon, Rajasthan or Perchyean called Afr. ज्यूँति where Jiwmaatrkaoan and pictures of deities are made in the same Afr Lokdewatooan lineage of kings and is painted. Andhra - Pradesh and Orissa Pattchitr Kalamkari folk art of similar examples it shows that the tradition of folk culture painted by hand is extremely widespread and ancient. It is also clear that the Indian culture lies at the core of how artistry and elegance.[27]

The artistry and elegance still frequently appears as a good change. With the growth of prosperity today to decorate it is not waiting for the arrival of the auspicious occasions but have made any important occasion is auspicious Rangoli arrange. Whether release of something or hotel promotions - to be spread, Rangoli decoration is deemed necessary. Rangoli Exhibition and rangoli contests addition Nowadays artists have also begun. Some रंगोलियाँ are such that even appear to see the pattern of an artwork. These comprise of modernity and tradition can be easily targeted. Arecardoan making rangoli competitions and also has amazing sequence began. Book World Record off Gineez Vijay Lakshmi Mohan was the first woman to deliver the rangoli, who in Singapore August 3, 2003 made this record.[28] by 2009 the record is broken every year. Also record the make rangoli on water off the World Record Book Gineez have joined.

Indonesian Art

Culture of Indonesia

Indonesian culture has been shaped by long interaction between original indigenous customs and multiple foreign influences. Indonesia is central along ancient trading routes between the Far East and the Middle East, resulting in many cultural practices being strongly influenced by a multitude of religions, including Hinduism, Buddhism, Confucianism and Islam, all strong in the major trading cities. The result is a complex cultural mixture very different from the original indigenous cultures.

Examples of cultural fusion include the fusion of Islam with Hindu in Javanese Abangan belief, the fusion of Hinduism, Buddhism and animism in Bodha, and the fusion of Hinduism and animism in Kaharingan; others could be cited.

Indonesian art-forms express this cultural mix. *Wayang*, traditional theater-performed puppet shows, were a medium in the spread of Hinduism and Islam amongst Javan villagers. Both Javanese and Balinese dances have stories about ancient Buddhist and Hindu

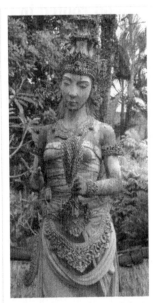

Statue of Dewi Sri in Ubud, Bali.

kingdoms, while Islamic art forms and architecture are present in Sumatra, especially in the Minangkabau and Aceh regions. Traditional art, music and sport are combined in a martial art form called Pencak Silat.

Western culture has greatly influenced Indonesia in modern entertainment such as television shows, film and music, as well as political system and issues. India has notably influenced Indonesian songs and movies. A popular type of song is the Indian-rhythmical dangdut, which is often mixed with Arab and Malay folk music.

Despite the influences of foreign culture, some remote Indonesian regions still preserve uniquely indigenous culture. Indigenous ethnic groups Mentawai, Asmat, Dani, Dayak, Toraja and many others are still practising their ethnic rituals, customs and wearing traditional clothes.

Traditional performing arts

Music

Main article: Music of Indonesia

Indonesia is home to various styles of music, with those from the islands of Java, Sumatra and Bali being frequently recorded. The traditional music of central and East Java and Bali is the gamelan.

On June 29, 1965, Koes Plus, a leading Indonesian pop group in the 1960s, 70s and 80s, was imprisoned in Glodok, West Jakarta, for playing Western-style music. After the resignation of President Sukarno, the law was rescinded, and in the 1970s the Glodok prison was dismantled and replaced with a large shopping mall.

Kroncong is a musical genre that uses guitars and ukuleles as the main musical instruments. This genre had its roots in Portugal and was introduced by Portuguese traders in the fifteenth century. There is a traditional *Keroncong Tugu* music group in North Jakarta and other traditional Keroncong music groups in Maluku, with strong Portuguese influences. This music genre was popular in the first half of the twentieth century; a contemporary form of Kroncong is called Pop Kroncong.

The soft Sasando music from the province of East Nusa Tenggara in West Timor is completely different. Sasando uses an instrument made from a split leaf of the Lontar palm (*Borassus flabellifer*), which bears some resemblance to a harp.

Dance

Main article: Dance in Indonesia

Indonesian dance reflects the diversity of culture from ethnic groups that composed the nation of Indonesia. Austronesian roots and Melanesian tribal dance forms are visible, and influences ranging from neighboring Asian countries; such as India, China, and Middle East to European western styles through colonization. Each ethnic group has their own distinct dances; makes total dances in Indonesia are more than 3000 Indonesian original dances. However, the dances of Indonesia can be divided into three eras; the Prehistoric Era, the Hindu/Buddhist Era and the Era of Islam, and into two genres; court dance and folk dance.

There is a continuum in the traditional dances depicting episodes from the Ramayana and Mahabharata from India, ranging through Thailand, all the way to Bali. There is a marked difference, though, between the highly stylized dances of the courts of Yogyakarta and Surakarta and their popular variations. While the court dances are promoted and even performed internationally, the popular forms of dance art and drama must largely be discovered locally.

During the last few years, Saman from Nanggroe Aceh Darussalam has become rather popular and is often portrayed on TV.

Drama and theatre

Wayang, the Javanese, Sundanese, and Balinese shadow puppet theatre shows display several mythological legends such as Ramayana and Mahabharata, and many more. Wayang Orang is Javanese traditional dance drama based on wayang stories. Various Balinese dance drama also can be included within traditional form of Indonesian drama. Another form of local drama is Javanese Ludruk and Ketoprak, Sundanese Sandiwara, and Betawi Lenong. All of these drama incorporated humor and jest, often involving audiences in their performance.

Randai is a folk theatre tradition of the Minangkabau people of West Sumatra, usually performed for traditional ceremonies and festivals. It incorporates music, singing, dance, drama and the silat martial art, with performances often based on semi-historical Minangkabau legends and love story.

Modern performing art also developed in Indonesia with their distinct style of drama. Notable theatre, dance, and drama troupe such as Teater Koma are gain popularity in Indonesia as their drama often portray social and political satire of Indonesian society.

Martial Art

Main articles: Silat and Pencak Silat

The art of silat was created and firstly developed in the islands of Java and Sumatra. It is an art for survival and practiced throughout Indonesian archipelago. Centuries of tribal wars in Indonesian history had shaped silat as it was used by the ancient warriors of Indonesia. Silat was used to determine the rank and position in old Indonesian kingdoms.

Contacts with Indians and Chinese was further enriched silat. Silat reached areas beyond Indonesia mainly through diaspora of Indonesian people. People from various regions like Aceh, Minangkabau, Riau, Bugis, Makassar, Java, Banjar, etc. moved into and settled in Malay Peninsula and other islands. They brought silat and passed it down to their descendants. The Indonesian of half-Dutch descent are also credited as the first to brought the art into Europe.

Silat was used by Indonesian freedom fighters during their struggle against the Dutch colonists. Unfortunately after Indonesia achieving their independence, silat became less popular among Indonesian youth compare to foreign martial arts like Karate and Taekwondo. This probably because silat was not taught openly and only passed down among blood relatives, the other reason is the lack of media portrayal of the art.

Efforts have been made in recent years to introduce and reintroduce the beauty of silat to Indonesian youth and the world. Exhibitions and promotions by individuals as well as state-sponsored groups helped the growing of silat's popularity, particularly in Europe and United States. Indonesian 2009 Silat movie Merantau is one of Indonesian efforts to introduce silat to international scene.

Another martial art from Indonesia is Tarung Derajat. It is a modern combat system created by Haji Ahmad Drajat based on his experience as a street fighter. Tarung Drajat has been acknowledge as a

national sport by KONI in 1998 and is now using by Indonesian Army as part of their basic training.

Traditional visual arts

Painting

Indonesia is not generally known for paintings, aside from the intricate and expressive Balinese paintings, which often express natural scenes and themes from the traditional dances.

Other exceptions include indigenous Kenyah paint designs based on, as commonly found among Austronesian cultures, endemic natural motifs such as ferns, trees, dogs, hornbills and human figures. These are still to be found decorating the walls of Kenyah Dayak longhouses in East Kalimantan's Apo Kayan region.

Calligraphy, mostly based on the Qur'an, is often used as decoration as Islam forbids naturalistic depictions. Some foreign painters have also settled in Indonesia. Modern Indonesian painters use a wide variety of styles and themes.

Sculpture

Indonesia has a long-he Bronze and Iron Ages, but the art-form particularly flourished in the eighth to tenth centuries, both as stand-alone works of art, and also incorporated into temples.

Most notable are the hundreds of meters of relief sculpture at the temple of Borobudur in central Java. Approximately two miles of exquisite relief sculpture tell the story of the life of Buddha and illustrate his teachings. The temple was originally home to 504 statues of the seated Buddha. This site, as with others in central Java, show a clear Indian influence.

Architecture

Main article: Indonesian architecture

For centuries, the most dominant influences on Indonesian architecture were Indian, although European influences have been particularly strong since the nineteenth century and modern architecture in Indonesia is international in scope.

As in much of South East Asia, traditional buildings in Indonesia are built on stilts, with the significant exceptions of Java and Bali. Notable stilt houses are those of the Dayak people in Borneo, the Rumah Gadang of the Minangkabau people in western Sumatra, the Batak people in northern Sumatra, and the *Tongkonan* of the Toraja people in Sulawesi. Oversized saddle roofs with large eaves, such as the homes of the Batak and the *tongkonan* of Toraja, are often bigger than the house they shelter. The fronts of Torajan houses are frequently decorated with buffalo horns, stacked one above another, as an indication of status. The outside walls also frequently feature decorative reliefs.

The eighth-century Borobudur temple near Yogyakarta is the largest Buddhist temple in the world, and is notable for incorporating about 160 relief panels into its structure, telling the story of the life of the Buddha. As the visitor ascends through the eight levels of the temple, the story unfolds, the final three levels simply containing stupas and statues of the Buddha. The building is said to incorporate a map of the Buddhist cosmos and is a masterful fusion of the didactic, the monumental and the serene.

Minangkabau Rumah Gadang

The nearby ninth-century temple complex at Prambanan contains some of the best preserved examples of Hindu temple architecture in Java. The temple complex comprises eight main shrines, surrounded by 250 smaller shrines. The Indian influence on the site is clear, not only in the style of the monument, but also in the reliefs featuring scenes from the Ramayana which adorn the outer walls of the main temples, and in the votive statuary found within.

Crafts

Several Indonesian islands are famous for their batik, ikat and songket cloth. Once on the brink of disappearing, batik and later ikat found a new lease of life when former President Suharto promoted wearing batik shirts on official occasions. In addition to the traditional patterns with their special meanings, used for particular occasions, batik designs have become creative and diverse over the last few years.

Batik fabric, Yogyakarta

Literature

Main article: Indonesian literature

Pramoedya Ananta Toer was Indonesia's most internationally celebrated author, having won the Magsaysay Award as well as being considered for the Nobel Prize in Literature. Other important figures include the late Chairil Anwar, a poet and member of the "Generation 45" group of authors who were active in the Indonesian independence movement. Tight information controls during Suharto's presidency suppressed new writing, especially because of its ability to agitate for social reform.

In the book *Max Havelaar*, Dutch author Multatuli criticised the Dutch treatment of the Indonesians, which gained him international attention.

Modern Indonesian authors include Seno Gumira Adjidarma, Ayu Utami, Gus tf Sakai, Eka Kurniawan, Ratih Kumala, Dee, Oka Rusmini. A few of their works have translated into other

languages.

Poetry

There is a long tradition in Indonesia, particularly among ethnically Malay populations, of extemporary, interactive, oral composition of poetry. These poems are referred to as *pantun*.

Recreation and sports

Main article: Sport in Indonesia

The ball used in Sepak Takraw.

Many traditional games are still preserved and popular in Indonesia, although western culture has influenced some parts of them. Among three hundred officially recognized Indonesian cultures, there are many kinds of traditional games: cockfighting in Bali, annual bull races in Madura, and stone jumping in Nias. Stone jumping involves leaping over a stone wall about up to 1.5 m high and was originally used to train warriors. Pencak Silat is another popular form of sport, which was influenced by Asian culture as a whole. Another form of national sport is *sepak takraw*. The rules are similar to volleyball: to keep the rattan ball in the air with the players' feet.

Popular modern sports in Indonesia played at the international level include association football and badminton. Indonesian badminton athletes have played in Indonesia Open Badminton Championship, All England Open Badminton Championships and many international events, including the Summer Olympics since badminton was made an Olympic sport in 1992. Rudy Hartono is a legendary Indonesian badminton player, who won All England titles seven times in a row (1968 through 1974). Indonesian teams have won the Thomas Cup (men's world team championship) thirteen of the twenty-two times that it has been contested since they entered the series in 1957. In the hugely internationally popular sport of soccer (football), Indonesian teams have been active in the Asian Football Confederation (AFC).

Sporting events in Indonesia are organised by the Indonesian National Sport Committee (KONI). The Committee, along with the government of Indonesia, have set a National Sports Day on every September 9 with "Sports for All" as the motto. Jakarta has hosted the Southeast Asian Games three times, in 1979, 1987 and 1997, and won gold medals in each of these years. Indonesia has won gold medals at nine of the fifteen games it has attended.

Cuisine

Main article: Cuisine of Indonesia

The cuisine of Indonesia has been influenced by Chinese culture and Indian culture, as well as by Western culture. However in return, Indonesian cuisine has also contributed to the cuisines of neighboring countries, notably Malaysia and Singapore, where Padang or Minangkabau cuisine from West Sumatra is very popular. Also Satay (*Sate* in Indonesian), which originated from Java, Madura, and Sumatra, has gained popularity as a street vendor food from Singapore to Thailand. In the fifteenth century, both the Portuguese and Arab traders arrived in Indonesia with the intention of trading for pepper and other spices. During the colonial era, immigrants from many different countries have arrived in Indonesia and brought different cultures as well as cuisines.

Most native Indonesians eat rice as the main dish, with a wide range of vegetables and meat as side dishes. However, in some parts of the country, such as Irian Jaya and Ambon, the majority of the people eat sago (a type of tapioca) and sweet potato.

The most important aspect of modern Indonesia cuisine is that food must be *halal*, conforming to Islamic food laws. *Haraam*, the opposite of halal, includes pork and alcoholic drinks. However, in some regions where there is significant non-Muslim population, non-halal food are also commonly served.

Indonesian dishes are usually spicy, using a wide range of chili peppers and spices. The most popular dishes include nasi goreng (fried rice), Satay, Nasi Padang (a dish of Minangkabau) and soy-based dishes, such as tofu and tempe. A unique characteristic of some Indonesian food is the application of spicy peanut sauce in their dishes, as a dressing for Gado-gado or Karedok (Indonesian style salad), or for seasoning grilled chicken satay. Another unique aspect of Indonesian cuisine is using *terasi* or *belacan*, a pungent shrimp paste in dishes of *sambal oelek* (hot pungent chili sauce). The sprinkling of fried shallots also gives a unique crisp texture to some Indonesian dishes.

Chinese and Indian cultures have influenced the serving of food and the types of spices used. It is very common to find Chinese food in Indonesia such as Dim Sum as well as noodles, and Indian cuisine such as Tandoori chicken. In addition, Western culture has significantly contributed to the extensive range of dishes. However, the dishes have been transformed to suit Indonesian people's tastes. For example, steaks are usually served with rice. Popular fast foods such as Kentucky Fried Chicken are served with rice instead of bread, and sambal (spicy sauce) instead of ketchup. Some Indonesian foods have been adopted by the Dutch, like Indonesian rice table or 'rijsttafel'.

Popular media

Cinema

Main article: Cinema of Indonesia

The largest chain of cinemas in Indonesia is 21Cineplex, which has cinemas spread throughout twenty-four cities on the major islands of Indonesia. Many smaller independent cinemas also exist.

In the 1980s, the film industry in Indonesia was at its peak, and dominated the cinemas in Indonesia with movies that have retained a high reputation, such as *Catatan Si Boy* and *Blok M* and actors like Onky Alexander, Meriam Bellina, Nike Ardilla and Paramitha Rusady. However, the film industry failed to continue its successes in the 1990s, when the number of movies produced decreased significantly, from 115 movies in 1990 to just 37 in 1993. As a result, most movies produced in the '90s contained adult themes. In addition, movies from Hollywood and Hong Kong started to dominate Indonesian cinema. The industry started to recover in the late 1990s, with the rise of independent directors and many new movies produced, such as Garin Nugroho's *Cinta dalam Sepotong Roti*, Riri Riza and Mira Lesmana's *Petualangan Sherina* and *Arisan!* by Nia Dinata. Another form of recovery is the re-establishment of the Indonesian Film Festival (FFI), inactive for twelve years, and the creation of the Jakarta International Film Festival. Daun di Atas Bantal (1998) received The Best Movie award in the 1998 Asia Pacific Film Festival in Taipei.

Television

Main article: Television in Indonesia

Radio

The state radio network Radio Republik Indonesia (RRI) was founded in 1945. It consists of a network of regional stations located in all thirty-three provinces of the archipelago. In most cities and large towns there are also many commercial stations. Since 2006, several digital radio stations have been based in Jakarta and Surabaya, using Digital Audio Broadcasting (DAB) and Hybrid HD-Radio.

Religion and philosophy

Main articles: Religion in Indonesia and Indonesian philosophy

Islam is Indonesia's main religion, with almost 88% of Indonesians declared Muslim according to the 2000 census, making Indonesia the most populous Muslim-majority nation in the world. The remaining population is 9% Christian (of which roughly two-thirds are Protestant with the remainder mainly Catholic, and a large minority Charismatic), 2% Hindu and 1% Buddhist.

The *Pancasila*, the statement of two principles which encapsulate the ideology of the Indonesian state, affirms that "The state shall be based on the belief in the one and only God".

See also

- Adat
- Demographics of Indonesia
- Tabuik

Further reading

- Kuncaraningrat. (1985) *Javanese culture* Singapore: Oxford University Press,
- Kathleen M. Adams (2006). *Art as Politics: Re-crafting Identities, Tourism and Power in Tana Toraja, Indonesia.*. Honolulu: University of Hawaii Press. ISBN 978-0-8248-3072-4.

External links

- Official government website [1]
- Indonesian Homepage [2]
- Indonesia: Emerald of the Equator [3] - slideshow by *Life magazine*

Indonesian architecture

Indonesian architecture reflects the diversity of cultural, historical and geographic influences that have shaped Indonesia as a whole. Invaders, colonisers, missionaries, merchants and traders brought cultural changes that had a profound effect on building styles and techniques. Traditionally, the most significant foreign influence has been Indian. However, Chinese, Arab—and since the 18th and 19th centuries—European influences have been important.

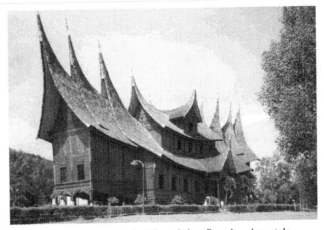

Pagaruyung Palace in the Minangkabau *Rumah gadang* style

Religious architecture

Although religious architecture has been widespread in Indonesia, the most significant was developed in Java. The island's long tradition of religious syncretism extended to architecture, which fostered uniquely Javanese styles of Hindu, Buddhist, Islamic, and to a lesser extent, Christian architecture.

A number of often large and sophisticated religious structures (known as *candi* in Indonesian) were built in Java during the peak of Indonesia's great Hindu-Buddhist kingdoms between the 8th and 14th centuries. The earliest surviving Hindu temples in Java are at the Dieng Plateau. Thought to have originally numbered as many as 400, only 8 remain today. The Dieng structures were small and relatively plain, but architecture developed substantially and just 100 years later the second Kingdom of Mataram built the Prambanan complex near Yogyakarta; considered the largest and finest example of Hindu architecture in Java. The World Heritage-listed Buddhist monument Borobudur was built by the Sailendra Dynasty between 750 and 850 AD, but it was abandoned shortly after its completion as a result of the decline of Buddhism and a shift of power to eastern Java. The monument contains a vast number of intricate carvings that tell a story as one moves through to the upper levels, metaphorically reaching enlightenment. With the decline of the Mataram Kingdom, eastern Java became the focus of religious architecture with an exuberant style reflecting Shaivist, Buddhist and Javanese influences; a fusion that was characteristic of religion throughout Java.

Although brick was used to some extent during Indonesia's classical era, it was the Majapahit builders who mastered it, using a mortar of vine sap and palm sugar. The temples of Majaphit have a strong geometrical quality with a sense of verticality achieved through the use of numerous horizontal lines often with an almost art-deco sense of streamlining and proportion. Majapahit influencess can be seen today in the enormous number of Hindu temples of varying sizes spread throughout Bali (see gallery below). Several significant temples can be found in every village, and shrines, even small temples found in most family homes. Although they have elements in common with global Hindu styles, they are of a style largely unique to Bali and owe much to the Majapahit era.

By the fifteenth century, Islam had become the dominant religion in Java and Sumatra, Indonesia's two most populous islands. As with Hinduism and Buddhism before it, the new religion, and the foreign influences that accompanied it, were absorbed and reinterpreted, with mosques given a unique Indonesian/Javanese interpretation. At the time, Javanese mosques took many design cues from Hindu, Buddhist, and even Chinese architectural influences (see image of "Grand Mosque" in Yogyakarta). They lacked, for example, the ubiquitous Islamic dome which did not appear in Indonesia until the 19th century, but had tall timber, multi-level roofs similar to the pagodas of Balinese Hindu temples still common today. A number of significant early mosques survive, particularly along the north coast of Java. These include the *Mesjid Agung* in Demak, built in 1474, and the *Al-Manar* Mosque in Kudus (1549) whose *menara* ("minaret") is thought to be the watch tower of an earlier Hindu temple. Javanese mosque styles in turn influenced the architectural styles of mosques among its neighbors, among other the mosques in Kalimantan, Sumatra, Maluku, and also neighboring Malaysia, Brunei and the southern Philippines. Sultan Suriansyah Mosque in Banjarmasin and Kampung Hulu Mosque in Malacca for

example displaying Javanese influence.

In 19th century, the sultanates of Indonesian archipelago began to adopt and absorb foreign influences of Islamic architecture, as alternative to Javanese style already popular in the archipelago. The Indo-Islamic and Moorish style are particularly favoured by Aceh Sultanate and Deli Sultanate, as displayed in Banda Aceh Baiturrahman Grand Mosque built in 1881, and Medan Grand Mosque built in 1906. Particularly during the decades since Indonesian independence, mosques have tended to be built in styles more consistent with global Islamic styles, which mirrors the trend in Indonesia towards more orthodox practice of Islam.

Traditional vernacular architecture

Rumah adat are the distinctive style of traditional housing unique to each ethnic group in Indonesia. Despite this the diversity of styles, built by peoples with a common Austronesian ancestry, traditional homes of Indonesia share a number of characteristics such as timber construction, varied and elaborate roof structures, and pile and beam construction that take the load straight to the ground. These houses are at the centre of a web of customs, social relations, traditional laws, taboos, myths and religions that bind the villagers together. The house provides the main focus for the family and its community, and is the point of departure for many activities of its residents. Traditional Indonesian homes are not architect designed, rather villagers build their own homes, or a community will pool their resources for a structure built under the direction of a master builder and/or a carpenter.

Traditional house in Nias; its post, beam and lintel construction with flexible nail-less joints, and non-load bearing walls are typical of *rumah adat*

The norm is for a post, beam and lintel structural system with either wooden or bamboo walls that are non-load bearing. Traditionally, rather than nails, mortis and tenon joints and wooden pegs are used. Natural materials - timber, bamboo, thatch and fibre - make up *rumah adat*. Hardwood is generally used for piles and a combination of soft and hard wood is used for the house's upper non-load bearing walls, and are often made of lighter wood or thatch. The thatch material can be coconut and sugar palm leaves, *alang alang* grass and rice straw.

Traditional dwellings have developed to respond to natural environmental conditions, particularly Indonesia's hot and wet monsoonal climate. As is common throughout South East Asia and the South West Pacific, Indonesian traditional vernacular homes are built on stilts (with the notable exceptions of Java and Bali). A raised floor serves a number of purposes: it allows breeze to moderate the hot tropical temperatures; it elevates the dwelling above stormwater runoff and mud; allows houses to be built on rivers and wetland margins;

keeps people, goods and food from dampness and moisture; lifts living quarters above malaria-carrying mosquitos; and the house is much less affected by dry rot and termites.

Many forms of *rumah adat* have walls that are dwarfed in size by large roof—often of saddle shape—which are supported independently by sturdy piles. Over all traditional styles, sharply inclined allowing tropical rain downpours to quickly sheet off, and large overhanging eaves keep water out of the house and provide shade in the heat. The houses of the Batak people in Sumatra and the Toraja people in Sulawesi (*tongkonan* houses) are noted for their stilted boat-shapes with great upsweeping ridge ends. In hot and humid low-lying coastal regions, homes can have many windows providing good cross-ventilation, whereas in cooler mountainous interior areas, homes often have a vast roof and few windows.

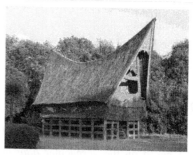

A traditional Batak house in North Sumatra

Some of the more significant and distinctive *rumah adat* include:

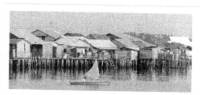

A fishing village of *pile houses* in the Riau archipelago

- **Batak** architecture (North Sumatra) includes the boat-shaped *jabu* homes of the Toba Batak people, with dominating carved gables and dramatic oversized roof, and are based on an ancient Dong-Son model.
- The **Minangkabau** of West Sumatra build the ***rumah gadang***, distinctive for their multiple gables with dramatically upsweeping ridge ends.
- The homes of **Nias** peoples include the *omo sebua* chiefs' houses built on massive ironwood pillars with towering roofs. Not only are they almost impregnable to attack in former tribal warfare, but flexible nail-less construction provide proven earthquake durability.
- The **Riau** region is characterised by villages built on stilts over waterways.
- Unlike most South East Asian vernacular homes, **Javanese** *rumah adat* are not built on piles, and have become the Indonesian vernacular style most influenced by European architectural elements.
- The **Bubungan Tinggi**, with their steeply pitched roofs, are the large homes of Banjarese royalty and aristocrats in South Kalimantan.
- Traditional **Balinese** homes are a collection of individual, largely open structures (including separate structures for the kitchen, sleeping areas, bathing areas and shrine) within a high-walled garden compound.
- The **Sasak** people of Lombok build *lumbung*, pile-built bonnet-roofed rice barns, that are often more distinctive and elaborate than their houses.
- **Dayak** people traditionally live in communal **longhouses** that are built on piles. The houses can exceed 300 m in length, in some cases forming a whole village.

- The **Toraja** of the Sulawesi highlands are renowned for their *tongkonan*, houses built on piles and dwarfed by massive exaggerated-pitch saddle roofs.
- *Rumah adat* on **Sumba** have distinctive thatched "high hat" roofs and are wrapped with sheltered verandahs.
- The **Dani** of Papua live in small family compounds composed of several circular huts known as *honay* with thatched dome roofs.

Palace architecture

Istana (or "palace") architecture of the various kingdoms and realms of Indonesia, is more often than not based on the vernacular *adat* domestic styles of the area. Royal courts, however, were able to develop much grander and elaborate versions of this traditional architecture. In the Javanese *Kraton*, for example, large *penodopos* of the *joglo* roof form with *tumpang sari* ornamentation are elaborate but based on common Javanese forms, while the *omo sebua* ("chief's house") in Bawomataluo, Nias is an enlarged version of the homes in the village, the palaces of the Balinese such as the *Puri Agung* in Gianyar use the traditional *bale* form, and the Pagaruyung Palace is a 3-storey version of the Minangkabau *Rumah Gadang*.

Similar to trends in domestic architecture, the last two centuries have seen the use of European elements in combination with traditional elements, albeit at a far more sophisticated and opulent level compared to domestic homes.

In the Javanese palaces the *pendopo* is the tallest and largest hall within a complex. As the place where the ruler sits, it is the focus of ceremonial occasions, and usually has prohibitions on access to this space.

Colonial architecture

The 16th and 17th centuries saw the arrival of European powers in Indonesia who used masonry for much of their construction. Previously timber and its by-products had been almost exclusively used in Indonesia, with the exception of some major religious and palace architecture. One of the first major Dutch settlements was Batavia (later Jakarta) which in the 17th and 18th centuries was a fortified brick and masonry city.

For almost two centuries, the colonialists did little to adapt their European architectural habits to the tropical climate. In Batavia, for example, they constructed canals through its low-lying terrain, which were fronted by small-windowed and poorly ventilated row houses, mostly in a Chinese-Dutch hybrid style. The canals became dumping grounds for noxious waste and sewage and an ideal breeding ground for the anopheles mosquitos, with malaria and dysentery becoming rife throughout the Dutch East Indies colonial capital.

Although row houses, canals and enclosed solid walls were first thought as protection against tropical diseases coming from tropical air, years later the Dutch learnt to adapt their architectural style with local building features (long eaves, verandahs, porticos, large windows and ventilation openings). The *Indo-European* hybrid villas of the 19th century would be among the first colonial buildings to incorporate Indonesian architectural elements and attempt adapting to the climate. The basic form, such as the longitudinal organisation of spaces and use of *joglo* and *limasan* roof structures, was Javanese, but it incorporated European decorative elements such as neo-classical columns around deep verandahs. Whereas the *Indo-European* homes were essentially Indonesian houses with European trim, by the early 20th century, the trend was for modernist influences—such as art-deco—being expressed in essentially European buildings with Indonesian trim (such as the pictured home's high-pitched roofs with Javan ridge details). Practical measures carried over from the earlier *Indo-European* hybrids, which responded to the Indonesian climate, included overhanging eaves, larger windows and ventilation in the walls.

. At the end of the 19th century, great changes were happening across much of colonial Indonesia, particularly Java. Significant improvements to technology, communications and transportation had brought new wealth to Java's cities and private enterprise was reaching the countryside. Modernistic buildings required for such development appeared in great numbers, and were heavily influenced by international styles. These new buildings included train stations, business hotels, factories and office blocks, hospitals and education institutions. The largest stock of colonial era buildings are in the large cities of Java, such as Bandung, Jakarta, Semarang, and Surabaya. Bandung is of particular note with one of the largest remaining collections of 1920s Art-Deco buildings in the world, with the notable work of several Dutch architects and planners, including Albert Aalbers, Thomas Karsten, Henri Maclaine-Pont, J Gerber and C.P.W. Schoemaker.

Colonial rule was never as extensive on the island of Bali as it was on Java— it was only in 1906, for example, that the Dutch gained full control of the island—and consequently the island only has a limited stock of colonial architecture. Singaraja, the island's former colonial capital and port, has a number of art-deco *kantor* style homes, tree-lined streets and dilapidated warehouses. The hill town of Munduk, a town amongst plantations established by the Dutch, is Bali's only other significant group of colonial architecture; a number of mini mansions in the Balinese-Dutch style still survive.

The lack of development due to the Great Depression, the turmoil of the Second World War and Indonesia's independence struggle of the 1940s, and economic stagnation during the politically turbulent 1950s and 60s, meant that much colonial architecture has been preserved through to recent decades. Although colonial homes were almost always the preserve of the wealthy Dutch, Indonesian and Chinese elites, and colonial buildings in general are unavoidably linked with the human suffering of colonialism, the styles were often rich and creative combinations of two cultures, so much so that the homes remain sought after into 21st century.

Native architecture was arguably more influenced by the new European ideas than colonial architecture was influenced by Indonesian styles; and these Western elements continue to be a dominant influence on Indonesia's built environment today.

Post independence architecture

Early twentieth century modernisms are still very evident across much of Indonesia, again mostly in Java. The 1930s world depression was devastating to Java, and was followed by another decade of war, revolution and struggle, which restricted the development of the built environment. Further, the Javanese art-deco style from the 1920s became the root for the first Indonesian national style in the 1950s. The politically turbulent 1950s meant that the new but bruised Indonesia was neither able to afford or focussed to follow the new international movements such as modernist brutalism. Continuity from the 1920s and 30s through to the 1950s was further supported Indonesian planners who had been colleagues of the Dutch Karsten, and they continued many of his principles.

Let us prove that we can also build the country like the Europeans and Americans do because we are equal

— Sukarno

Despite the new country's economic woes, government-funded major projects were undertaken in the modernist style, particularly in the capital Jakarta. Reflecting President Sukarno's political views, the architecture is openly nationalistic and strives to show the new nation's pride in itself. Projects approved by Sukarno, himself a civil engineer who had acted as an architect, include:

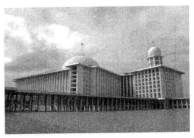

Istiqlal Mosque, the national mosque of Indonesia.

- A clover-leaf highway.
- A broad by-pass in Jakarta (Jalan Sudirman).
- Four high-rise hotels including the famous Hotel Indonesia.
- A new parliament building.
- The 127 000-seat Bung Karno Stadium.
- Numerous monuments including The National Monument.
- Istiqlal Mosque the largest mosque in Southeast Asia.

The 1970s, 1980s and 1990s saw foreign investment and economic growth; large construction booms brought major changes to Indonesian cities, including the replacement of the early twentieth styles with late modern and postmodern styles.

Gallery

World Heritage-listed Borobudur in Java.

Wringin Lawang, the 15.5 meter brick split gate; believed to be the entrance to an important compound in Majapahit capital, its form shows the strong geometric quality of Majapahit, still used in Balinese temples

Prambanan temple in Java.

The Mother Temple of Besakih one of Bali's most significant Hindu temples.

Dalem Agung Padantegal Hindu temple, Monkey Forest, Ubud, Bali.

An Uma, the
traditional communal
house of the
Mentawai.

While the basic form
of this house is
Javanese, particularly
the *joglo* roof and the
lack of stilts, the doors
are distinctly
European; Javanese
architecture is
arguably the
Indonesian style most
influenced by
European styles

See also

- Candi of Indonesia
- Hindu temple architecture
- Category: Banjarese architecture

References

Bibliography

- Beal, Gillian (202). *Island Style: Tropical Dream Houses in Indonesia*. Hong Kong: Periplis Editions Ltd. ISBN 962-593-415-4.
- Dawson, B., Gillow, J., *The Traditional Architecture of Indonesia*, 1994 Thames and Hudson Ltd, London, ISBN 0-500-34132-X
- Helmi, Rio; Walker, Barbara (1995). *Bali Style*. London: Times Editions Pte Ltd. ISBN 0-500-23714-X.
- Schoppert, P., Damais, S., *Java Style*, 1997, Didier Millet, Paris, 207 pages, ISBN 962-593-232-1
- Wijaya, M., *Architecture of Bali: A source book of traditional and modern forms*, 2002 Archipelago Press, Singapore, 224 pages, ISBN 981-4068-25-X

External links

- Asian Historical Architecture, Indonesia Section (Borobudur, Prambanan, and houses and graveyard of Batak Karo). [1]
- Majapahit architecture. [2]
- Visual Database of Modern Dutch Tropical Architecture in Indonesia. [3]
- Archnet Digital Library on Indonesia. [4]
- Architecture of Tana Toraja [5]
- Inside Austronesian Houses: Perspectives on domestic designs for living [6]
- The House in Indonesia Between Globalization and Localization [7] By Peter J.M. Nas, 1998.

Article Sources and Contributors

Eastern art history *Source*: http://en.wikipedia.org/?oldid=387430347 *Contributors*: Oldag07

Buddhist art *Source*: http://en.wikipedia.org/?oldid=388733203 *Contributors*: 1 anonymous edits

Thangka *Source*: http://en.wikipedia.org/?oldid=390528592 *Contributors*: 1 anonymous edits

Bhutanese art *Source*: http://en.wikipedia.org/?oldid=378151253 *Contributors*: Dr. Blofeld

Culture of Cambodia *Source*: http://en.wikipedia.org/?oldid=388232122 *Contributors*: Woohookitty

Visual arts of Cambodia *Source*: http://en.wikipedia.org/?oldid=381474187 *Contributors*: Tommickx

Khmer sculpture *Source*: http://en.wikipedia.org/?oldid=350598790 *Contributors*: Johnbod

Chinese art *Source*: http://en.wikipedia.org/?oldid=390290941 *Contributors*: Philip Trueman

Chinese painting *Source*: http://en.wikipedia.org/?oldid=387619470 *Contributors*: Novicew

Chinese ceramics *Source*: http://en.wikipedia.org/?oldid=390459616 *Contributors*: 1 anonymous edits

Chinese jade *Source*: http://en.wikipedia.org/?oldid=385717532 *Contributors*: Szfski

East Asian calligraphy *Source*: http://en.wikipedia.org/?oldid=388897074 *Contributors*: Kusunose

Indian art *Source*: http://en.wikipedia.org/?oldid=389029560 *Contributors*: 1 anonymous edits

Indian painting *Source*: http://en.wikipedia.org/?oldid=388876489 *Contributors*:

Rangoli *Source*: http://en.wikipedia.org/?oldid=388131159 *Contributors*: Beeblebrox

Culture of Indonesia *Source*: http://en.wikipedia.org/?oldid=389836165 *Contributors*:

Indonesian architecture *Source*: http://en.wikipedia.org/?oldid=382914542 *Contributors*: 1 anonymous edits

Image Sources, Licenses and Contributors

File:Magnify-clip.png *Source*: http://en.wikipedia.org/w/index.php?title=File:Magnify-clip.png *License*: unknown *Contributors*: -

Image:Mantras caved into rock in Tibet.jpg *Source*: http://en.wikipedia.org/w/index.php?title=File:Mantras_caved_into_rock_in_Tibet.jpg *License*: unknown *Contributors*: -

File:Amazing sand mandala.jpg *Source*: http://en.wikipedia.org/w/index.php?title=File:Amazing_sand_mandala.jpg *License*: unknown *Contributors*: -

Image:StandingBuddha.jpg *Source*: http://en.wikipedia.org/w/index.php?title=File:StandingBuddha.jpg *License*: unknown *Contributors*: -

Image:Sri_lanka_aukana_buddha_statue.jpg *Source*: http://en.wikipedia.org/w/index.php?title=File:Sri_lanka_aukana_buddha_statue.jpg *License*: unknown *Contributors*: Mladifilozof

Image:SeatedBuddhaGandhara2ndCenturyOstasiatischeMuseum.jpg *Source*: http://en.wikipedia.org/w/index.php?title=File:SeatedBuddhaGandhara2ndCenturyOstasiatischeMuseum.jpg *License*: unknown *Contributors*: -

Image:Pressapochista1.jpg *Source*: http://en.wikipedia.org/w/index.php?title=File:Pressapochista1.jpg *License*: unknown *Contributors*: -

Image:Song Dynasty Porcelain Bottle.jpg *Source*: http://en.wikipedia.org/w/index.php?title=File:Song_Dynasty_Porcelain_Bottle.jpg *License*: unknown *Contributors*: -

Image:Kuo Hsi 001.jpg *Source*: http://en.wikipedia.org/w/index.php?title=File:Kuo_Hsi_001.jpg *License*: unknown *Contributors*: -

Image:Westindischer Maler um 1550 001.jpg *Source*: http://en.wikipedia.org/w/index.php?title=File:Westindischer_Maler_um_1550_001.jpg *License*: unknown *Contributors*: -

Image:Ch20_asago.jpg *Source*: http://en.wikipedia.org/w/index.php?title=File:Ch20_asago.jpg *License*: unknown *Contributors*: -

Image:Pressapochista2.jpg *Source*: http://en.wikipedia.org/w/index.php?title=File:Pressapochista2.jpg *License*: unknown *Contributors*: -

Image:After Rain at Mt. Inwang.jpg *Source*: http://en.wikipedia.org/w/index.php?title=File:After_Rain_at_Mt._Inwang.jpg *License*: unknown *Contributors*: -

Image:Chrysanthemum porcelain vase with three colors.jpg *Source*: http://en.wikipedia.org/w/index.php?title=File:Chrysanthemum_porcelain_vase_with_three_colors.jpg *License*: unknown *Contributors*: -

File:Buddha-Footprint.jpeg *Source*: http://en.wikipedia.org/w/index.php?title=File:Buddha-Footprint.jpeg *License*: unknown *Contributors*: -

File:SerindianGroup.jpg *Source*: http://en.wikipedia.org/w/index.php?title=File:SerindianGroup.jpg *License*: unknown *Contributors*: -

File:TangBodhisattva.JPG *Source*: http://en.wikipedia.org/w/index.php?title=File:TangBodhisattva.JPG *License*: Public Domain *Contributors*: Ascánder, Binabik155, Gerardus, Gryffindor, PericlesofAthens, Zolo, 2 anonymous edits

File:Seokguram Buddha.JPG *Source*: http://en.wikipedia.org/w/index.php?title=File:Seokguram_Buddha.JPG *License*: unknown *Contributors*: -

File:Goryeo Pagoda.jpg *Source*: http://en.wikipedia.org/w/index.php?title=File:Goryeo_Pagoda.jpg *License*: unknown *Contributors*: -

File:Bodhidarma.jpg *Source*: http://en.wikipedia.org/w/index.php?title=File:Bodhidarma.jpg *License*: unknown *Contributors*: -

File:Buddha 00004.JPG *Source*: http://en.wikipedia.org/w/index.php?title=File:Buddha_00004.JPG *License*: unknown *Contributors*: -

File:Bodhisattva Lokesvara statue.jpg *Source*: http://en.wikipedia.org/w/index.php?title=File:Bodhisattva_Lokesvara_statue.jpg *License*: unknown *Contributors*: -

File:Watyai 02.jpg *Source*: http://en.wikipedia.org/w/index.php?title=File:Watyai_02.jpg *License*: unknown *Contributors*: -

File:Borobodur2.jpg *Source*: http://en.wikipedia.org/w/index.php?title=File:Borobodur2.jpg *License*: unknown *Contributors*: -

File:Prajnaparamita Java.jpg *Source*: http://en.wikipedia.org/w/index.php?title=File:Prajnaparamita_Java.jpg *License*: unknown *Contributors*: -

File:Bundesarchiv Bild 135-S-18-10-29, Tibetexpedition, Tempelfest, Gebetsmauer.jpg *Source*: http://en.wikipedia.org/w/index.php?title=File:Bundesarchiv_Bild_135-S-18-10-29,_Tibetexpedition,_Tempelfest,_Gebetsmauer.jpg *License*: unknown *Contributors*: -

Image:Tibetan Thangka, anonymous, private collection.jpg *Source*: http://en.wikipedia.org/w/index.php?title=File:Tibetan_Thangka,_anonymous,_private_collection.jpg *License*: unknown *Contributors*: -

Image:17th century Central Tibeten thanka of Guhyasamaja Akshobhyavajra, Rubin Museum of Art.jpg *Source*: http://en.wikipedia.org/w/index.php?title=File:17th_century_Central_Tibeten_thanka_of_Guhyasamaja_Akshobhyavajra,_Rubin_Museum_of_Art.jpg *License*: unknown *Contributors*: -

Image:Bhutanese painted complete mandala, 19th century, Seula Gonpa, Punakha, Bhutan.jpg *Source*: http://en.wikipedia.org/w/index.php?title=File:Bhutanese_painted_complete_mandala,_19th_century,_Seula_Gonpa,_Punakha,_Bhutan.jpg *License*: unknown *Contributors*: -

Image:Bhutanese painted thanka of the Jataka Tales, 18th-19th Century, Phajoding Gonpa, Thimphu, Bhutan.jpg *Source*: http://en.wikipedia.org/w/index.php?title=File:Bhutanese_painted_thanka_of_the_Jataka_Tales,_18th-19th_Century,_Phajoding_Gonpa,_Thimphu,_Bhutan.jpg *License*: unknown *Contributors*: -

Image:Hand woven Bhutanese fabrics, Bumthang.jpg *Source*: http://en.wikipedia.org/w/index.php?title=File:Hand_woven_Bhutanese_fabrics,_Bumthang.jpg *License*: unknown *Contributors*: -

Image:Blessing Dance 7.jpg *Source*: http://en.wikipedia.org/w/index.php?title=File:Blessing_Dance_7.jpg *License*: unknown *Contributors*: -

Image:Bayonfacesl.jpg *Source*: http://en.wikipedia.org/w/index.php?title=File:Bayonfacesl.jpg *License*: unknown *Contributors*: -

File:AngkorWat Westview Keiwo.JPG *Source*: http://en.wikipedia.org/w/index.php?title=File:AngkorWat_Westview_Keiwo.JPG *License*: unknown *Contributors*: -

Image:BuddhistMonk02.jpg *Source*: http://en.wikipedia.org/w/index.php?title=File:BuddhistMonk02.jpg *License*: unknown *Contributors*: -

Image:Cambodian girls on bicycle.jpg *Source*: http://en.wikipedia.org/w/index.php?title=File:Cambodian_girls_on_bicycle.jpg *License*: unknown *Contributors*: -

Image:sampeah.jpg *Source*: http://en.wikipedia.org/w/index.php?title=File:Sampeah.jpg *License*: unknown *Contributors*: -

Image:Jade ornament with grape design.jpg *Source*: http://en.wikipedia.org/w/index.php?title=File:Jade_ornament_with_grape_design.jpg *License*: unknown *Contributors*: -

Image:Song-Bodhisattva1.jpg *Source*: http://en.wikipedia.org/w/index.php?title=File:Song-Bodhisattva1.jpg *License*: unknown *Contributors*: -

Image:ChineseVarietyart Platerotate.jpg *Source*: http://en.wikipedia.org/w/index.php?title=File:ChineseVarietyart_Platerotate.jpg *License*: unknown *Contributors*: -

Image:Wall roof modelled as a dragon (Yu Yuan Gardens, Shanghai, China).jpg *Source*: http://en.wikipedia.org/w/index.php?title=File:Wall_roof_modelled_as_a_dragon_(Yu_Yuan_Gardens,_Shanghai,_China).jpg *License*: unknown *Contributors*: -